Eadweard Muybridge

By the same author

The Edison Motion Picture Myth
Beginnings of the Biograph
The Kinetoscope
The Photographs of Thomas Eakins
The Life and Work of Thomas Eakins
Albert Bierstadt: Painter of the American West

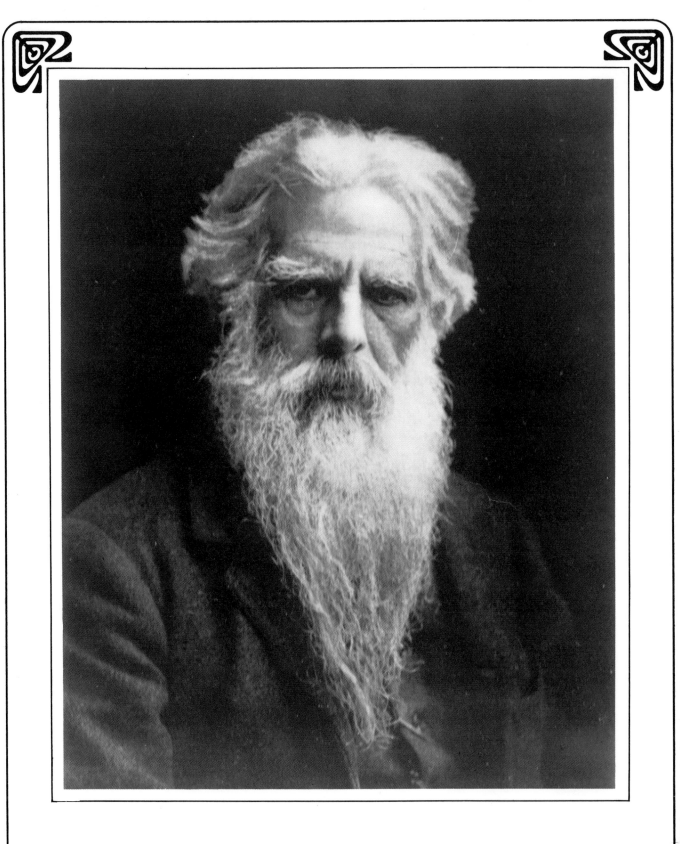

EADWEARD MUYBRIDGE

The Father of the Motion Picture

Gordon Hendricks

Secker & Warburg

London

To Nancy and Beaumont Newhall,
for years of encouragement,
and to Jim Abajian, Leigh Robinson, and David Travers,
friends and helpers in nostalgic San Francisco days

First published in England 1975 by
Martin Secker & Warburg Limited
14 Carlisle Street, London W1V 6NN

SBN 436 19270 5

Foreword

Why a biography of Eadweard Muybridge? Other pioneer photographers took equally celebrated photographs. Tens of thousands of other young men came to America in the nineteenth century to seek their fortunes—and found them. Untold numbers, indeed, may have killed their wives' lovers, with more or less desultory justice.

But, scandal aside, no other photographer had so far-reaching and profound an influence as Eadweard Muybridge. His stimulation of interest in the photography of movement is significant precisely in proportion to the significance of the motion picture itself. We are movie-made children, and Muybridge, who came to America in 1852 to seek his fortune, is to a considerable extent responsible for making us so. His work in California in the 1870s and the *succès d'estime* he achieved at the University of Pennsylvania in the 1880s stimulated interest in the development of the motion picture among scientists, inventors, and artists throughout the world. Their work led directly to the invention of the motion picture.

I came to Muybridge through my study of the beginnings of the motion picture. I found that craftsmen and inventors had been inspired by his pioneer work, and that after they had improved his methods—chiefly by devising apparatus to take motion pictures from a single point of view instead of multiple points of view—the only remaining obstacle was the lack of a continuous, flexible film. This was achieved shortly after Muybridge's work by Balagny in Europe and then by John Carbutt and later George Eastman in America. The modern motion picture was on its way.

My research led to the writing of numerous articles and three books on American motion picture invention.* But all the time, there in the background, towered the figure of Eadweard Muybridge, "the father of the motion picture," whose work had stimulated them all. So it can fairly be said that I have been working on-and-off on a biography of Muybridge from the time I began research into the beginnings of the motion picture in 1955 until the last of the three books was published in 1966. The Muybridge work, incidentally, led me into the history of American painting, first into the life of Albert Bierstadt and then into that of Thomas Eakins, both of whom had been friends and associates of Muybridge.

In the fifteen years or so of intermittent work on Muybridge I have been helped beyond the call of duty by many persons.

* *The Edison Motion Picture Myth* (Berkeley, 1961), *Beginnings of the Biograph* (New York, 1964), and *The Kinetoscope* (New York, 1966). All three books have been reprinted in a one-volume edition by Arno Press, New York.

Harold Anderson and Norman Speiden encouraged work at the Edison Laboratory National Monument, where my inspiration began; Fairman Furness was a generous friend in my Muybridge-Eakins work; Douglas Gorsline did an embarrassing amount of research for me on Marey; Ralph Hansen has been a constant, generous advocate at Stanford University at a time when one was badly needed; LeRoy F. Krusi has given of time and effort in research into the Yellow Jacket disaster of 1874; Lillian Burns, Francis J. Dallett, Leonidas Dodson, and Bernard J. Ford all helped cheerfully and long at the University of Pennsylvania; Marion and Ray Smith helped indispensably with work on Muybridge's family.

Others to whom I am grateful are: Edward R. Anshutz, Marian Aquilera, Joseph Baird, George Barker, Frank Bartholomew, Clara S. Beatty, George F. Beck, Robert Becker, Albert Boni, Barbara Burn, Arthur Carlson, Gerald Carnes, Guido Castelli, H. Cross, Lorraine Dexter, Kenneth B. Dishler, Joan Dugdale, Peter A. Evans, George Freedley, Helmut Gernsheim, Helen S. Giffen, Lloyd Goodrich, James Gregory, James D. Hart, Thomas Heatherstone, Mary V. Hood, Linda Huntington, Ramona Javits, Mrs. M. H. Jones, Bernard Karpel, Michael Loeb, Gerald MacDonald, Kenneth Macgowan, A. Hyatt Mayor, M. J. McCosker, Grayson P. McCouch, Garnett McCoy, Dorothy McCurry, Kneeland McNulty, Robert Newkirk, Eugene Ostroff, Allen Ottley, Richard Pitman, George Pratt, Isadore Rossman, Rodney Rulofson, C. S. Shippy, Albert Shumate, Frank Tietjen, Paul Vanderbilt, Mary Manning Wale, Lura J. Watkins, James Watson, Louise Wollman, and Carl Zigrosser.

Contents

List of Illustrations

The Early Years

Eadweard Muybridge was born Edward James Muggeridge on April 9, 1830, at what is now 30 High Street in the area known as The Bittoms in Kingston-on-Thames, England (Fig. 1). In 1830, High Street was called West-by-Thames Street. When Muybridge was baptized a month later at All Saints' Church, Kingston, his baptism record read: "Edward James Muggeridge, son of John and Susannah Muggeridge of Kingston, corn-dealer, born April last, baptized 9th May 1830."

John Muggeridge had a corn and small-coal business, and had come from a family in Bansted, Surrey, that had been farmers and corn-dealers for generations. He was evidently not born in Kingston, since there is no parish record of his baptism, but his parents, Richard and Jane Muggeridge, were living in Kingston by 1806, when John was nine years old (according to parish records, a brother, William, was baptized there in that year). More children came along in 1809, 1811, 1813, and 1815. By the time the last two were born, their father, Richard Muggeridge, was listed in the Kingston directory as a maltster, a maker of the steeped grain used in brewing, so it was an easy and logical step for Richard's son John, Eadweard's father, to go into the corn business. Another son, Charles James, remained in the malt business, a few doors down the street from 30 High.

Eadweard Muybridge's mother, Susannah Smith, was born in Kingston. The parish records of All Saints' show her to have been born on October 24, 1807, and baptized not quite a month later. How or when she met John Muggeridge and when and where the two were married cannot be determined. Parish records show no marriage in either Kingston or Hampton, across the river where her relatives lived.

John Muggeridge's house and place of business was in the midst of a number of malthouses. Two doors away was The Ram, a public house, and next to The Ram a brewery. The block was also the town's nerve center in another way: the justice, the mayor, and the county court offices were there. Thirty West-by-Thames Street—later 30 High Street—is on the banks of the Thames, and river barges used to tie up at a wharf in the rear. It was John Muggeridge's business to sell barge owners grain and small coal.

In 1830 George IV was in his last year on the throne of England, and at the time of Muybridge's birth was heaving himself laboriously from bed to chair at Windsor Castle, stricken with heart, lung, and bladder trouble as well as by gout—to all of which he was to succumb three months later. Kingston in 1830, near the outset of the Industrial Revolution, was a busy river port. From the beginning of the thirteenth century to 1750 it had been the site of the only

Thames bridge above London Bridge. The Kingston ford had been used since prehistoric times.

Kingston was known to the Romans two thousand years ago, but was particularly significant politically during Saxon times, when it became the seat of Anglo-Saxon government. At least seven Anglo-Saxon kings were crowned in Kingston. What was once thought to be the stone upon which these kings were crowned was installed in the center of town in 1851, when Eadweard Muybridge was twenty-one. Two of the seven kings had been named Eadweard, and it was evidently the occasion of the stone's installation that inspired Muybridge to change the spelling of his first name from Edward to Eadweard. The change in his last name was to come fifteen years later in San Francisco.

Muybridge had an older brother, John, born in 1827, and two more brothers were born after him—George in 1833 and Thomas S. in 1836. George and Thomas were eventually to join Eadweard in business in San Francisco. Muybridge's father died in 1843, when Eadweard was thirteen, and his brother John died four years later. (Both graves have since been covered by construction.) By the time of his father's death Eadweard had been in school for some years. It has been said that he attended Queen Elizabeth's School, which was held in the ancient Lovekyn Chapel (Fig. 2), but this is probably incorrect. It was an institution for young gentlemen, a qualification that young Muybridge did not meet. We can determine from his later life that he had, at any rate, a good basic education in grammar, the literature of England, and mathematics. Evidently he did not study any foreign languages, at least in any depth, since he did not learn French, German, or Italian until he was an adult. We can only guess the extent to which he was self-taught, though it was probably considerable.

It has been said that Muybridge "sought practical training and work in London, where Muggeridges had been stationers and papermakers since the eighteenth century."[1] I have seen no evidence of a stay in London, but it is not unlikely, since Kingston was not far from London. Surrey marriage records show several Muggeridges, Mugridges, and Muggaridges as farmers and husbandmen in the eighteenth century, but only one as a stationer.

But whenever he left his home town and for whatever reason, Eadweard Muybridge, like thousands of other young Europeans of the time, answered the siren call of the New World. Unlike most of the others, however, it was not the lure of California gold that drew him, but the prospect of a commercial career.

In spite of a lack of hard evidence, it must be assumed that Muybridge came to America sometime during 1852. This was the date Muybridge gave to

friends in Kingston when late in life he retired to his home town. It is hard to believe that the year would not have been an unforgettable one, or that he would have had any reason not to be truthful about it.

Yet his name is not to be found on any ship's passenger list for New York in 1852, and he is not listed as a resident of, at least, New York, Philadelphia, Boston, or New Orleans for any year between 1852 and 1856, by which time we know he had arrived in San Francisco. (He wrote later of having watched laborers load cotton bales in New Orleans at one time; Fig. 3.) Passport records do not exist (it was unnecessary for an Englishman to have one until 1914). His home-town newspaper, *The Surrey Comet*, did not publish until 1854, too late for a news item; naturalization records are irrelevant since he never became an American citizen; marriage records were destroyed in the great San Francisco fire of 1906; no family documentation on this point has been found; and no statement either he or his friends ever made is specific beyond the simple fact that he left England for America in 1852.

The first evidence we have that Muybridge had settled in America was an advertisement for a book salesman he placed in a San Francisco paper on April 28, 1856:

> WANTED—A gentleman well qualified to obtain subscribers for a new illustrated standard work. None but a first rate canvasser need apply. E.J. Muggridge [sic], 113 Montgomery street.[2]

We know that Muybridge had been in the city for several months before this advertisement appeared. Silas Selleck, a photographer formerly employed by Brady's Gallery in New York, had known Muybridge before the two arrived in San Francisco, and said that he had seen Muybridge in San Francisco in the autumn of 1855. And Muybridge himself wrote that the year was 1855.[3] The advertisement suggests an established business—Muybridge now had more to do than he could handle himself and was looking for help. The company for which he was acting as agent, the London Printing and Publishing Company, was apparently a book jobber. It was first listed in the New York directory for the same year, 1856, which suggests that Muybridge may have been the company's American entrepreneur.

Soon after his arrival in San Francisco, Muybridge joined a local engraver and lithographer, W.H. Oakes, in selling a lithograph of James King of William, the recent victim of a notorious assassination:*

* San Francisco was now nearly lawless. It was the killing of King, a crusading editor, that triggered the establishment of the celebrated Vigilante Committee on May 14, 1856. After lingering several days, King died on May 20, a hero to San Francisco's law-abiding citizens. His killers were hanged in the public square two days later.

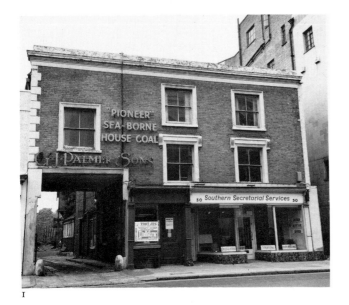

1

Fig. 1. 30 High Street, Kingston-on-Thames, England. 1971. Author's collection. Muybridge was born here in 1830. A century and a half later, the place is still devoted to the river-ocean trade. The passageway at the left leads to a yard that abuts directly on the Thames.

Fig. 2. Lovekyn Chapel, Kingston-on-Thames, England. Author's collection. It has been said that Muybridge attended school here, but that is probably incorrect.

Fig. 3. River steamer at New Orleans, Louisiana. 1850s? Muybridge Collection, the Kingston-on-Thames Library and Museum, Kingston-on-Thames, England.

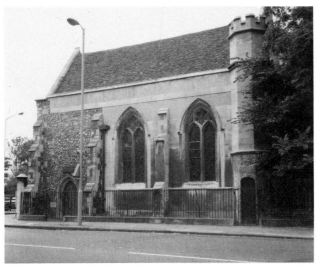

2

SEVERAL ATTEMPTS HAVE RECENTLY BEEN made to furnish the friends of JAMES KING OF WILLIAM, and the public, with a faithful and striking likeness of him; but almost total failure has resulted. The portraits which have been published are insignificant as works of art. . . .

The undersigned proposes to issue, on or about September 1st, a large and beautifully executed portrait of the late Mr. King. This will be drawn on stone, (from a daguerreotype in possession of the family,) by Mr. CHAS. FENDERICH, the well-known artist of this city, formerly of Washington, D.C. . . .

Price of impressions on India Proof Paper, $2 50; on plain White Paper, $2 00. . . .

Address W. H. OAKES, Bulletin Office, or

AGENTS WANTED—In all the principal towns in the interior, to whom a liberal discount will be made. Orders for six or more copies to one address will be sent by Express, charges free.

E. J. MUYGRIDGE [sic],
113 Montgomery street[4]

W. W. Kurtz, a rival publisher, had just issued another portrait of King, drawn, like the one Muybridge announced, from a daguerreotype in the possession of King's family. Evidently this was one of those Muybridge considered "insignificant as works of art."

On September 1, true to his promise, Muybridge issued the King portrait (Fig. 4) and placed another advertisement in the *Bulletin*.[5] The work was given considerable publicity in the local papers since Muybridge had by now become a leading figure in the local bookselling and publishing business. Oakes, his partner, also engraved sheet music and offered it for sale at the "publication office," 113 Montgomery Street.[6]

In September 1856 William Shew, one of the city's leading "dagguerrean artists," moved into Muybridge's building (R. H. Vance, another leading photographer, was already next door), and announced "the finest gallery for artistic purposes ever fitted up on the Pacific coast."[7] The photographic world of San Francisco, one of the liveliest in America, was coming closer and closer to Muybridge. It was natural, in the early 1860s, when he was looking for a change of profession, that he should think of photography.

Meanwhile Muybridge's advertisements for book salesmen continued to appear regularly. The "new illustrated standard work" offered in April (an edition of Shakespeare published by Martin Johnson & Co. of Philadelphia) had done well, for on June 5, 1857, its subscribers were told that the balance of the numbers would soon appear. Now, however, only Muybridge's name appeared in the advertising; Oakes had left the business.

7

What had been "Muggridge" in April 1856 had become "Muygridge" by May 16, 1856. The first spelling may have been a deliberate simplification, or it may have been a typographical error. In any case, it was to remain "Muygridge" until Muybridge took up his new profession of photography in the 1860s.

In September 1857 he showed "a large case of splendid books"[8] at the Mechanics' Fair. Among these must have been his Shakespeare and a three-volume *History of the United States* by Jesse Ames Spencer, which he had advertised earlier in the year. Shortly after the fair, other items were added to his list: a pamphlet on the huge new steamship the *Great Eastern*; Rufus Wilmot Griswold's *The Republican Court, or American Society in the Days of Washington; Appleton's New American Encyclopedia*; histories of China and the Indian Mutiny; Halliwell's Shakespeare; books on Hogarth and the National Gallery of England; Audubon's *Birds of North America* (the Jacob Bien edition); various engravings and, inevitably, photographs.

Muybridge's business was apparently growing, since his advertisements for assistance continued: on March 11, 1858, he advertised for a "smart, industrious BOY,"[9] and on June 22 for a "good smart BOY."[10] The following month he moved around the corner, three doors up from Montgomery, to 163 Clay Street, where his friend Silas Selleck was well established in the photographic business.

Early in 1859 Muybridge's rising fortunes culminated in his election to the board of directors of the Mercantile Library, one of the city's most respected institutions. Only citizens who were thought to be both substantial and civic-minded were elected to its board.

By July 1859 Muybridge's association with the London Printing and Publishing Company had become unsatisfactory—or unnecessary. On July 21 he announced that he was "selling off to close business," and was "about to relinquish the agency" of the company.[11] He must sell out by August 15, he said, although the same announcement was to appear again on August 16, 18, and 20. Yet he did advertise for two salesmen on October 8 from a new address, 115 Battery Street, near the corner of California Street, so we must assume that in spite of his earlier plans to sell out, he continued in the book business. In January 1860, he announced a new edition of Audubon's lithographs from the original copper plates owned by the artist's son. Within two months business had prospered to the point where he was offering to lend money "in sums to suit."[12] By May 10, 1860, he had imported his younger brothers, Thomas and George, from England and had sold the business to

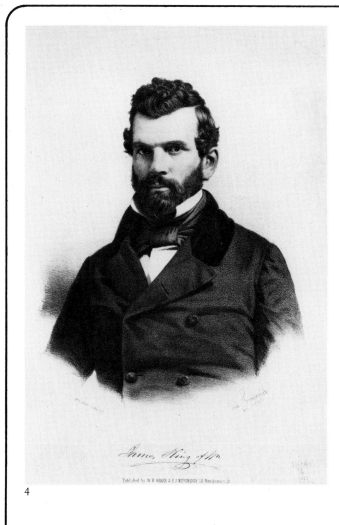

James King of Wm.

Published by W.H. OAKES & E.J. MUYGRIDGE 113 Montgomery St.

4

E.J.Muygridge,
AGENT FOR
The LONDON PRINTING
and PUBLISHING Co.,
113 Montgomery-St.
SAN FRANCISCO.

5

E. J. MUYGRIDGE,
113 MONTGOMERY STREET, SAN FRANCISCO.

AGENT FOR

THE LONDON PRINTING AND PUBLISHING COMPANY,
LONDON, EDINBURGH, DUBLIN, AND NEW YORK; AND

JOHNSON, FRY AND COMPANY,
NEW YORK, BOSTON, AND PHILADELPHIA.

PUBLISHER AND IMPORTER OF

ILLUSTRATED AND STANDARD WORKS.

Has on hand a larger assortment of handsomely gotten up Illustrated Works
than any other house in California; comprising some of the most valuable and
magnificent Works ever issued from the English or American Press, bound in
various styles of elegant and superb bindings, and offered for sale at low prices.

TO GENTLEMEN FURNISHING LIBRARIES!
BOOK PURCHASING AGENCY.

Works upon the Fine Arts, Law, Medical, Scientific, Theological, Architectural,
Mechanical, Civil Engineering, Agricultural, and Miscellaneous Books,

PURCHASED ON COMMISSION

through our Agencies in London, Paris, and New York, and delivered in San Fran-
cisco at the published price, with addition of established rates of commission.
Express charges to the interior of the State to be paid by parties ordering. A
deposit of twenty-five per cent. on value of work required in all instances, the
balance to be paid on delivery.

E. J. MUYGRIDGE,
163 CLAY STREET., SAN FRANCISCO.

Fig. 4. The lithograph of James King of William, by Charles Fenderich. 1856. Sold by Muybridge. The Bancroft Library, University of California, Berkeley.

Fig. 5. Muybridge's bookseller's ticket. 1856–58. The California Historical Society, San Francisco.

Fig. 6. Flyer issued by Muybridge. 1858–59. The California State Library, Sacramento.

Thomas. He was going to visit Yosemite Valley shortly and, on his return, would accept orders for books to be bought on a trip to Europe:

> After my return from the Yosemite I shall, on 5th June, leave for New York, London, Paris, Rome, Berlin, Vienna, etc., and all orders or commissions for the purchase of Works of Literature or Art entrusted to me, will be properly attended to upon the following terms: All amounts under $500 10 per cent; between $500 and $1,000, 5 per cent; over $1,000 2½% per cent.
>
> E.J.M.[13]

Muybridge intended to sail for Europe on the *Golden Age,* which was to leave San Francisco on June 5, but he was apparently too taken by Yosemite to make it. Seven years later he would return to Yosemite as a full-fledged photographer and make his first famous group of photographs.

The *Golden Age* left without Muybridge, but the Overland Stage that departed from San Francisco's Plaza on July 2, 1860, did not. "OVERLAND EASTWARD," The *Bulletin* announced. "The overland mail stage for the East to-day, took eight passengers, and the following to go through: J. F. Churchill, E. J. Muybridge, J. McCarty, and W. Fortman."[14]

It was not an easy ride. The stage took six weeks to get to St. Louis where connections were made with the railroad, and the route was over some of the most rugged terrain in the country. Each trip began promptly at noon on Mondays or Fridays and cost $150 to St. Louis, with passengers "eating themselves" as best they could at 50¢ a meal at way stations. The Pony Express, which had made its first trip three months before Muybridge left, charged $5 for a half-ounce letter; the steamer to New York, $250 for first class, $175 for second, and $125 for steerage. The stage ride was so uncomfortable that it was considered remarkable enough for newspaper comment that a woman should make the journey, and two weeks before Muybridge left, a woman and a *four-year-old child* (the *Bulletin*'s italics) had made the trip. The previous month a seventy-year-old man had been forced to lay over at Los Angeles. He was "fairly done over," the *Bulletin* reported.[15]

But however difficult the trip in a Butterfield stagecoach was for travelers in general, it was to be far rougher for Muybridge and his fellow passengers of July 2, 1860. The route lay south from San Francisco through San Jose and Los Angeles, then eastward through Tucson and El Paso. Between El Paso and Fort Smith, Arkansas, the country was mostly flat. But when the route got into northeastern Texas, into what was known as the Cross-Timbers section, it was another matter. There the country began to roll, with dense forests of post-oak along the way. There were numerous severe slopes, and on one of

these the brakes failed, upsetting the stage and throwing Muybridge out through the luggage carrier at the rear. The *Bulletin* and *The Daily Alta California*, publishing a telegram from Fort Smith, where the injured passengers were treated, had virtually the same account:

> The telegraph line has been completed to Fort Smith, and the following despatch, dated 22d July, is the first received through from that office:
>
> > The Overland mail coach, with San Francisco dates to the 2d of July, arrived at half-past 10 o'clock this morning, with some of the passengers who received injuries at Mountain Station by the running away of a team, the particulars of which are as follows: The stage left Mountain Station with several passengers, besides the driver and Mr. Stout, a roadmaster, in the employ of the Overland Company, who was acting as conductor. On leaving the stable, the driver cracked his whip and the horses immediately started on a run. When they arrived at the brow of the mountain the brakes were applied, but were found to be useless. In his efforts to stop the horses, the driver drove out of the road, and they came in collision with a tree, literally smashing the coach in pieces, killing one man by the name of Mackey, a drover from Cassville, Mo., who was on his return from California, and injuring every other person on the stage to a greater or less extent. Mr. Stout was severely cut in the face, and had his nose completely flattened. He also complained of internal injuries. Several of the injured remained here for rest until the next stage.[16]

The *Alta* made "Mackey," "May," both possibly incorrect, the passenger being, likely, the J. McCarty who got on the stage in San Francisco.

Muybridge himself, years afterward, reported more specifics:

> I left California for an European tour some years ago, in July 1860. I recollect taking supper at a stagecoach [station] on the road. We then got on board the stage, which was drawn by six wild mustang horses. That is the last I recollect of that nine days. After that I found myself at Fort Smith, 150 miles distant, lying in bed. There was a small wound on the top of my head. When I recovered each eye formed an individual impression, so that, looking at you, for instance, I could see another man sitting by your side. I had no taste nor smell, and was very deaf. These symptoms continued in an acute form for probably three months. I was under medical treatment for over a year. I think the doctor's name who attended me at Fort Smith was Dr. Bowie. When I got to New York I was treated by Dr. Parker. I then crossed the Atlantic, taking medicines with me, and there consulted an English physician, Dr. Sir William Garrell [*sic*; actually, Sir William Gull]. When I was in New York my physician gave me up to my friends. I brought an action against the stage company for $10,000 damages. My

physician told me afterward that I was permanently injured. The stage company compromised the suit by paying me $2,500. I have no recollection of the accident myself. A fellow passenger told me after I had recovered consciousness that after leaving that station we had traveled for probably half an hour—we were then just entering the Texas Cross-Timbers. The mustangs ran away. The driver was unable to control them. Just as we were getting to the Timbers I remarked that the best plan would be for us to get out of the back of the stage, because I saw that an accident would take place. He told me that I took out my knife to cut the canvas back of the stage, and was preparing to leave when the stage ran against either a rock or a stump and threw me out against my head. There were two of the passengers killed, and all of them more or less injured. The driver was very severely injured and was unable to proceed with the stage.[17]

Muybridge took the next stage to St. Louis, and the railroad to New York. There, as he later said, he consulted a Dr. Parker and remained in New York for two months, after which he continued on to England, although he is not listed in the passenger lists for any date between August 1, 1860, and January 1, 1861.

The Dr. Parker he consulted—likely Willard Parker—was probably the leading surgeon in New York. He had recently been president of the New York Academy of Medicine and was, at the time Muybridge consulted him, Professor of the Principles and Practice of Surgery and Surgical Anatomy at Columbia College. He was associated with New York Hospital, Bellevue Hospital, St. Luke's, and the New York Dispensary. In which of these capacities Muybridge consulted him is unknown, although it is curious that Muybridge should have consulted a surgeon in New York and a physician in London. In America, however, the distinction between the two was not finely drawn, and Willard Parker is known to have practiced internal medicine as well as surgery. Papers in the New York Academy of Medicine also indicate that he had pronounced ideas on such subjects as temperance—a subject somewhat alien to the practice of surgery. In any case, Muybridge seems to have made a practice of getting the best professional attention he could. Parker, like Gull, told him he must eat no meat for a year.*

Parker's and Gull's appointment books, which might date—and support— Muybridge's account, have not been found. Muybridge must have arrived in New York by the end of August 1860 at the latest, and if he stayed there

* The reasons for not eating meat are obscure in modern medicine, but in Gull's time, as in other periods, meat, which produces urea, was often forbidden under the general idea that when little else could be done one's diet should be restricted.

two months he was in England by the end of the year. Gull was, in 1860, Queen Victoria's physician. Nevertheless he was not in the very first rank, such being reserved for more eminent doctors like Addison, Hodgkins, and Parkinson. But, like Parker in New York, he was extremely well known, and it was to him that the stricken Muybridge turned.

Gull is said to have persuaded Muybridge to change his profession, arguing that he should take up an active, outdoor life instead of one devoted to books. It is too much to claim, as has been often done, that Gull simply told Muybridge to take up photography and that Muybridge followed his directions. He must have talked to Muybridge about the advisability of an active profession and asked him what he would like to do. And considering Muybridge's long, close relationships with photographers, it was natural that he should choose that profession for himself. It is also possible that he had already done photographic work. It is logical, for example, that his Yosemite trip had resulted in photographs—although none has been identified.

It is likely that he had learned something of the technique from his friends Silas Selleck, William Shew, and perhaps H. W. Bradley, another San Francisco photographer, who was to become a partner in the firm of Bradley and Rulofson, one of Muybridge's longest associations. A family memoir indicates that Muybridge had learned something of photography from Selleck years before in New York.

What Muybridge did in the five or six years before he reappeared in San Francisco is clouded in mystery. We do not know, as a matter of fact, if it *was* five or six years. Evidently he practiced photography, for he was to say so in so many words in *The San Francisco Examiner* of February 6, 1881.

He is also known to have taken out two British patents: one in 1860 (No. 2352) for "an improved method of and apparatus for plate printing," and another in 1861 (No. 1914) for "machinery or apparatus for washing clothes and other textile articles,"* which was rather a far cry from photography.

But however long or seriously he may have considered another profession, Muybridge must have returned to San Francisco in the mid-1860s, equipped to engage in his new career as a photographer.

He does not reappear in the city directories until 1867, in the issue published in September, for which the canvassing had been completed in May. His name is not on the steamer lists for all of 1866 and through June 1867, by which time we know he was back in the city. It is unlikely that he

* I am grateful to Joan Williams for having brought these to my attention.

would have again entrusted himself to an overland stage. Anyway, stage travel was now losing out to the water-rail route over the Isthmus of Panama.

Back in San Francisco as a professional photographer, Muybridge apparently joined up with his friend Silas Selleck, since they were both listed at the same address in 1867. Selleck had offered his gallery for sale in August 1865 but was still in business two years later, and it may be that Muybridge's arrival had prevented Selleck's failure.

Muybridge's brother Thomas, who had been left with the book business, left San Francisco for Walla Walla, Washington, in May 1866, and this may indicate the time Eadweard returned to San Francisco. Thomas may have waited for his brother to return before leaving for Walla Walla, where he set up as a dentist. It is likely that the book business had not been successful under Thomas, who, in his brother's absence, set about finding a new trade.*

It is at least possible that Muybridge was the "E.M." who wrote to *The Philadelphia Photographer* late in 1865. If he was, he started his new career by taking portraits:

> Mr. Editor
>
> Dear Sir: As I see a good many photographers contribute their mite towards the filling of the journal, I thought I would avail myself of the same opportunity; but as I am not competent for a teacher, I will do well enough for a scholar for some time to come, when I will, if I profit by others' brains, repay you for what trouble I may cause you. To come to the point, I generally work my collodion rather thin with 7 or 8 grains of iodide and bromide, and 45 or 50 grains in the nitrate bath. This seems to work well enough for tanned faces; but when I come to the ladies, I can get but very little detail in hair, head-dress, &c. I admire detail and don't like intense negatives.
>
> How can I get all the detail needed?
>
> If I use thicker collodion, I cannot get along with dark faces, and I have a good many of those.
>
> Please answer this in your next, and oblige
>
> Yours, truly, E.M.[18]

The editor's response was: "All you have to do is to keep and use two kinds of collodion, old and new. The old for the tanned faces, and the new for the fair sex."

* Thomas advertised for dental business in the Walla Walla newspaper on June 1, 1866. He apparently left Walla Walla two years later for, possibly, Lewiston, Idaho, where his trail fades. Present-day research into possible descendents has been unfruitful. I am very grateful to Lawrence L. Dodd of Whitman College, Walla Walla, for intelligent, enthusiastic help with this problem.

2

Celebrity in San Francisco

The photographs that Muybridge took in Yosemite Valley during five months of the summer and fall of 1867 launched him on his new career as a photographer. They were the most celebrated yet taken of the valley, and certainly among the finest. Only Carleton Watkins' views equaled them in quality or received comparable public acclaim.

There are several reasons to think that Muybridge's 1867 visit to Yosemite must have begun in late June. First, we know that the trip lasted five months and that it was still in progress on November 2, 1867. Second, the waterfalls were in nearly full flow, which would have been unlikely later than June. By July 13 he had arrived at the Yosemite Hotel (Fig. 7), after having spent some time in the Mariposa and Calaveras Big Tree groves and elsewhere near the valley entrance.

The trip resulted in 260 published views, comprising 100 6″ x 8″ views, and 160 views either for the stereoscope or "for the album,"[1] that is to say photographs printed from one or the other of the two stereograph negatives. These were offered from the Selleck-Muybridge address at 415 Montgomery, which was now called the Cosmopolitan Gallery of Photographic Art. The 6″ x 8″ photographs were mounted on 14″ x 18″ tinted cardboard, and are now rare items (Fig. 9). The stereographs are more common, having sold considerably better. The album views are also unusual, since the vastness of Yosemite was actually ill-suited to a 4″ x 2½″ photograph.

A flyer of February 1868, in Muybridge's scrapbook now in the library of Kingston-on-Thames, also announced that the photographs had been taken by "Helios," the pseudonym he now assumed:

YO–SEM–I–TE VALLEY
Cosmopolitan Gallery of Photographic Art
415 Montgomery Street
San Francisco, February, 1868.

Sir:—

I am now preparing for publication twenty views of our world-renowned Yo-Semite Valley, photographed last year by "Helios." For artistic effect, and careful manipulation, they are pronounced by all the best landscape painters and photographers in the city to be the most exquisite photographic views ever produced on this coast, and are marvelous examples of the perfection to which photography can attain in the delineation of sublime and beautiful scenery, as exemplified in our wonderful Valley.

Upon my list of subscribers for the series—among the names of nearly all our best known connoisseurs and patrons of art—are those of Messrs. C. Nahl, Keith, Wandesforde, Norton Bush, Jewett, Kipps, Denny, Van

Vlack, Bloomer, etc., Artists: Messrs. Wh. Shew, Rulofson, Selleck, A. Nahl, Edouart, White, Vaughan, and other Photographers.

The size is most convenient for transmission abroad, for binding, or the portfolio: 6 x 8 inches, mounted on tinted background boards 14 x 18 inches.

The price at which they will be issued ($20 for the series), placing them within the reach of those having only moderate resources, will probably command for them a sufficiently extensive sale to remunerate me for the great expense attending their production.

> Your Obed't Serv't,
> Edw. J. Muybridge
> 415 Montgomery Street.

The *Bulletin* received the flyer, along with a sample set of twenty or thirty photographs that Muybridge was then offering "for transmission abroad, for binding, or the portfolio":

A new Yosemite series has recently been taken by a photographer of this city, who hides his name under the significant classicism of "Helios." These views, 20 or 30 in number, are taken from fresh points, selected with a nice regard to artistic effect, and illustrating the valley and its cliffs and falls more variously than any previous series. There are effects in some of these new views which we have not seen before. The plunging movement and half vapory look of cataracts leaping 1,000 or 1,500 feet at a bound, are wonderfully realized. . . .[2]

Meanwhile, a sampling of the Yosemite views taken could be seen by anyone who took the time to visit the Cosmopolitan Gallery at 415 Montgomery.

The Daily Morning Call was no less—and perhaps even more—excited by the new photographs than the *Bulletin*. Neither paper had praised Watkins so highly:

The views surpass, in artistic excellence, anything that has yet been published in San Francisco, combining, as they do, the absolute correctness of a good sun picture after nature, with the judicious selection of time, atmospheric conditions and fortunate points of view. In some of the series we have just such cloud effects as we see in nature of oil-painting, but almost never in a photograph: the rocky faces of the rugged precipices are partly obscured by floating clouds, and in one of the views the valley is filled with low-hanging mists. In another a rainbow is photographed on the spray of the Nevada Fall. These peculiar atmospheric effects lend a new charm to the pictures, and the patience and skill of the operator who secured them show the devotion of a true artist. The effect of falling water, shown in a photograph of the Lower Yosemite Fall, is also very wonderful, and

cannot be sufficiently admired. Some of the foregrounds are "worked-up," as the landscape painters say, very judiciously and with great care, only that Nature has done the working up and the photographer has been happy in selecting good points of view. This is especially true of a picture of cataracts on the Merced, a wild sylvan scene which pleases while the grander studies only kindle the admiration. . . .[3]

On February 19 *The Daily Alta California* joined the chorus. Not until his motion photographs in the late 1870s was Muybridge to receive such paeans of praise:

> A NEW SERIES OF YOSEMITE VIEWS is being published for subscribers of "Helios." He presents the gorgeous scenes of that locality from points of view entirely different from any heretofore taken. The series consists of twenty pictures showing the grand features of this wild and wonderful piece of Nature's architecture under the varying effects of ever changing atmosphere. In one picture you have before you the long vista of the gorge stretching away in magnificent perspective, palisaded on either side by cliffs, until lost among the mountains that hang like shadows on the distant back-ground. One of the finest of these perspective views is a piece called "The Mariposa Trail," embracing within its scope the lofty precipices and cascades Tis-sa-ack, Tu-tuch-ah-no-lah and Pohono. The view of the Yu-wi-hah or Nevada Fall is a fine piece of Instantaneous photographing. It seems as though the artist had arrested the descending sheet of water until its mottled and foamy surface had paid tribute to his genius. A special rainbow spans the gorge where sunlight catches the cataract's spray. In another are shown . . . Cathedral Rock and the Domes, with fleecy clouds hanging on their breasts. The gauzy mist that half obscures the distant mountains and the strong contrast of sunlight and shade in the nearer objects, all have a very pleasing effect, and strike one as being a true copy of Nature. . . . we are sure that the five months of assiduous labor spent by "Helios" in that place in securing a collection of views that is unsurpassed by any preceding, will find an abundant return in our appreciative community.[4]

In his first Yosemite photographs Muybridge called the various features of the valley by their Indian names. This was cumbersome, both for the traveler and for the photographer, and soon it became common practice to name landmarks after famous people.

Evidently the first issue was of twenty-five views, for at the March 4 meeting of the Photographic Society of Philadelphia, twenty-five photographs were "much admired by the members," and showed "artistic skill in the selection of the views" and "eminent talent in their photographic reproduction."[5] Like the San Francisco newspaper reporters, the Philadelphia gentle-

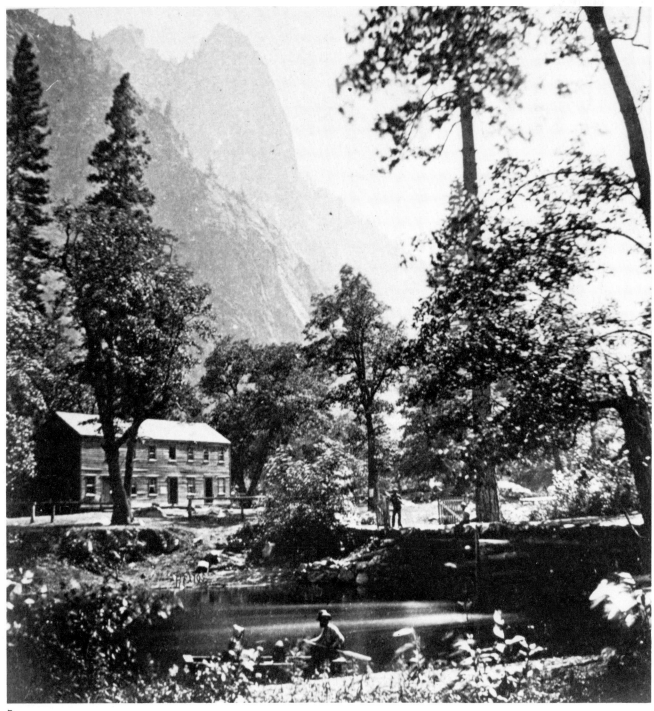

7

Fig. 7. The Yosemite Hotel, Yosemite Valley, California. 1867. Half of a stereograph by Muybridge. The Bancroft Library, University of California, Berkeley. Built in 1859 by J. M. Hutchings and operated by him. Muybridge stayed here for at least part of his 1860, 1867, and 1872 Yosemite visits.

Fig. 8. The Merced River, Yosemite Valley. 1867. From *The Philadelphia Photographer,* November 1869. One of three Muybridge Yosemite photographs used as a frontispiece for that issue. The surface of the water has evidently been retouched.

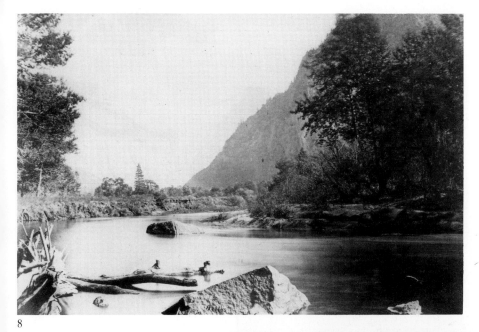

8

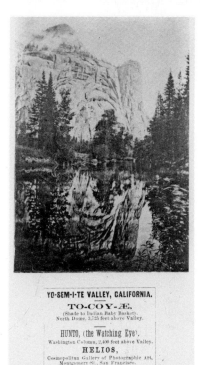

9

YO-SEM-I-TE VALLEY, CALIFORNIA.
TO-CO Y-Æ.
(Shade to Indian Baby Basket).
North Dome, 3,725 feet above Valley.

HUNTO, (the Watching Eye).
Washington Column, 2,400 feet above Valley.
HELIOS,
Cosmopolitan Gallery of Photographic Art,
Montgomery St., San Francisco.

Entered according to Act of Congress, 1868,
by E. J. MUYBRIDGE, in Clerk's Office of
Dist. Court U. S., District California.

Fig. 9. North Dome and Washington Column, Yosemite Valley. 1867. Photograph by Muybridge. The Bancroft Library, University of California, Berkeley. Illustration XII in John S. Hittell, *Yosemite: Its Wonders and Its Beauties* (San Francisco, 1868). This was Muybridge's proof, with a label such as he customarily pasted on his photographs, from which Hittell composed his title.

Fig. 10. The Deserted Village, Mariposa (?), California. 1867. Stereograph by Muybridge. The California State Library, Sacramento. This village was a favorite subject for artists (see Figs. 60 and 61).

Fig. 11. Tourist group in Yosemite Valley. 1867. Stereograph by Muybridge. The California State Library, Sacramento. Nevada Fall is in the background.

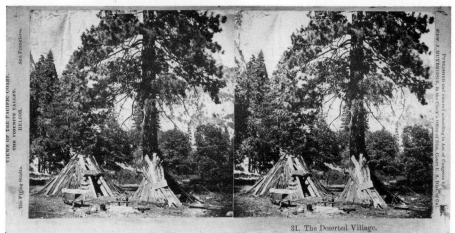

10

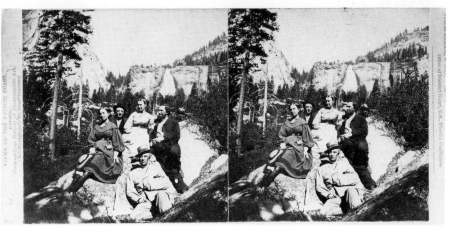

11

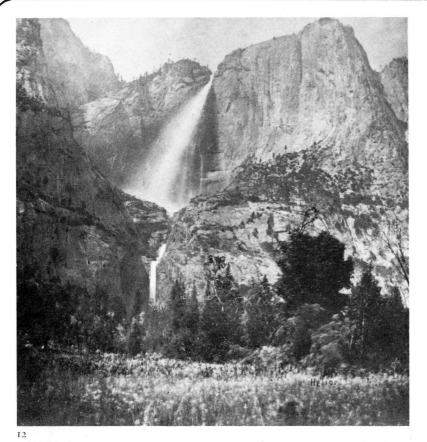

12

14

Fig. 12. Yosemite Falls, Yosemite Valley.
1867. Half of a stereograph by Muybridge.
The Henry E. Huntington Library, San
Marino, California. Note that Muybridge
has scratched "Helios" on the negative at
lower right, as he did on many of his
pictures.

Fig. 13. Lamon's ranch in Yosemite
Valley. 1867. Half of a stereograph by
Muybridge. The Bancroft Library, Uni-
versity of California, Berkeley.
James C. Lamon established a cabin in
the upper end of Yosemite in 1859 and
became the valley's first official home-
steader.

Fig. 14. Mission Bay, from Rincon Hill,
San Francisco. Stereograph by Muybridge.
The New-York Historical Society, New
York, New York. Muybridge's stereo-
graphs were often renumbered and
republished, so the date is uncertain.

Fig. 15. The earliest of several successive
Cliff House buildings, San Francisco.
Photograph by Muybridge. Author's
collection.

Fig. 16. Mills Seminary, Oakland,
California. Photograph by Muybridge.
Author's collection.

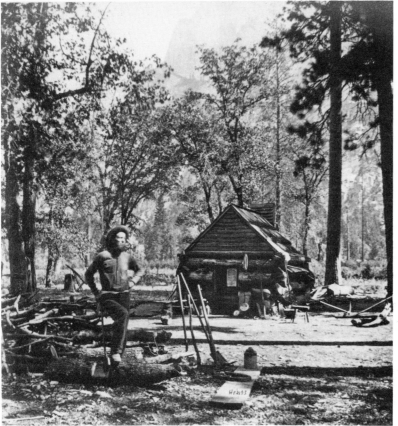

13

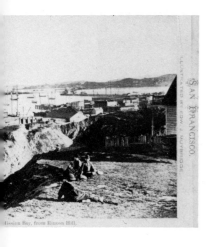

San Francisco
...OW J. HUBBELL.

...ission Bay, from Rincon Hill.

15

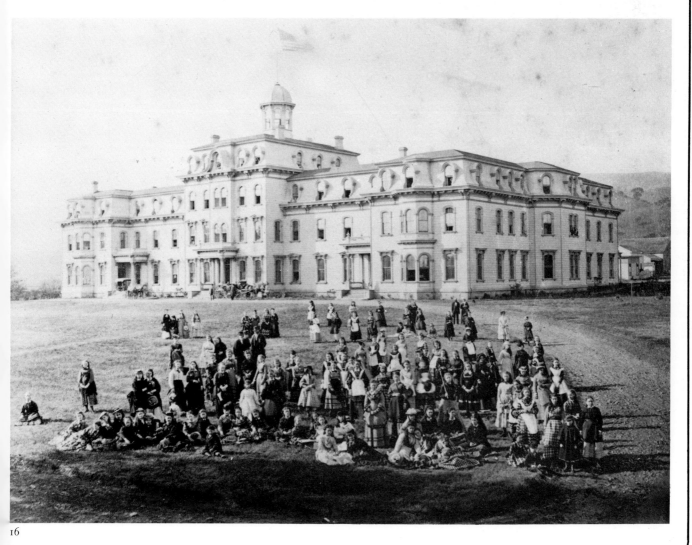

16

men, who were among the most talented amateurs and professionals in the country, laid stress on the selection of points of view, which is, once a modicum of technical experience has been achieved, the principal difference in landscape photography between an artist and a shutterbug.

Shortly afterwards, with his Yosemite photographs ensuring him in one stroke a high place among photographers of long experience and wide reputation, Muybridge offered his services on a free-lance basis in other branches of the profession. On April 22, 1868, he offered to photograph private residences, animals, "or views in the city or any part of the coast."[6] His Yosemite views, he went on to say, are "EXCELLENT." The flyer also announced that he was preparing for publication photographs of San Francisco and other coastal views, as well as mining scenes. A number of these Bay Area views are known (Figs. 14–18). Some are "moonlight" views, made with two negatives; others are homely views, made with no attempt to be artistic. Nearly all show a fine sense of framing. The mining scenes combine an interest in accurate documentation with a highly developed taste for composition (Fig. 19).

One of Muybridge's best-known commissions, and one which earned for him (or on the strength of which he claimed) the title of "official photographer of the United States Government," came to him at this time from the United States Army. General H. M. Halleck, who had been put out to pasture as commandant of the Pacific division of the army after a disastrous Civil War career, was directed in the summer of 1868 to travel to Alaska to make a survey of the territory and, in the process, to arrange for a photogaphic record of what was then generally regarded as "Seward's Folly." After some hesitation over which photographer to hire, Muybridge was chosen, and the group sailed from the Golden Gate aboard the *Pacific* on July 29, 1868.

Both *The Daily Alta California* and the *Bulletin* gave details of the itinerary: Esquimalt on August 4, Nanaimo on August 7, Fort Tongass on August 13, Fort Wrangle on August 15, Sitka—their principal goal and northernmost point—on August 18, and return over approximately the same route, arriving back in San Francisco on September 4, 1868. They stayed in Sitka four days, and many of Muybridge's approximately fifty views of his Alaska excursion were taken in that settlement (Figs. 20–22).

Before he left, Muybridge had written a letter to *The Philadelphia Photographer*, indicating the serious professionalism with which he regarded his work, as well as his appreciation of the importance of keeping himself in the public eye:

I wish to call the attention of glass-bath manufacturers to the fact that they seem to know very little of the requirements of a glass bath. It should be of elliptic shape, two or two and a half inches wide and good depth, and not square as they are now generally made. Will not someone get what the photographers so much want in this direction?
San Francisco E. M. Jr. [*sic*][7]

Shortly after he returned, Muybridge had the distinction of having two of his Alaska photographs transcribed to canvas by H. O. Young, a well-known local painter. The *Bulletin* reported "views of Sitka and Fort Wrangle by Young, which evince marked improvement. . . . Both these Alaska views are selected from a series of excellent photographs taken by Mr. Muygridge [*sic*] during a recent trip to our new territory."[8] A few days later General Halleck paid the photographer a different sort of compliment:

Dear Sir
 I have to acknowledge the receipt of copies of your photographs of the forts and public buildings at Sitka and other military posts, taken for the use of the War Department, and also views of scenery in Alaska. These views besides being beautiful works of art give a more correct idea of Alaska, its scenery and vegetation than can be obtained from any written description of that country

Yours respectfully
Your Obdt Servt
H. W. Halleck
Major Genl. Comg.[9]

Halleck's commendation was quickly taken advantage of by Muybridge, who quoted Halleck's praise in an announcement of a display of the photographs at the studio of H. W. Bradley at 620 Clay Street. Selleck had made the prints and a number of mounted enlargements for the exhibition. The negatives were then sent east to the War Department, which had paid for their production.

At 7:53:30 a.m. on October 21, 1868, San Francisco had the severest earthquake it had recorded. It lasted for eight minutes and resulted in widespread damage. The City Hall, for example, "may be considered a complete wreck."[10] Muybridge lost no time in photographing the ruins, in San Francisco itself and in San Leandro and Hayward, across the Bay, south of Oakland (Fig. 23).

Between November 12 and 14 Muybridge went out to the newly opened Hunter's Point Dry Dock and photographed the ship *Colorado* (Fig. 24). Expanding his market, he offered the *Colorado* photographs at the gallery of

17

18

Fig. 17. San Francisco "by moonlight," from the balcony of the Merchants' Exchange. 1869. Half of a stereograph by Muybridge. The Bancroft Library, University of California, Berkeley. This may have been photographed with his sky shade (see page 27). For better results, Muybridge later used two negatives for his "moonlight" views, one for the land and one for the sky, with a hole scratched out of the sky negative to represent the moon (see Fig. 18).

Fig. 18. Woodward's Gardens, San Francisco, "by moonlight." Photograph by Muybridge. Lantern slide. The Kingston-on-Thames Library and Museum, Kingston-on-Thames, England. The moon hole is obvious. Woodward's was a favorite resort and had an art gallery (Fig. 37), a conservatory, a rotary boat ride (lower right), side shows, and a menagerie—partly live and partly stuffed (see also Figs. 37–39).

A. Gensoul at 211 Montgomery Street. Now he also started selling photographs at Ewing's, an optician's firm down the street from his principal place of business at 415 Montgomery. Ewing sold photographs in a number of categories, and called himself Muybridge's agent.[11]

In March of the next year, 1869, Muybridge contributed an article to *The Philadelphia Photographer*, published in the magazine's May issue, about a new type of sky shade, and described his novel technique in detail with several illustrations (Fig. 26). According to a detailed explanation kindly sent me by Mr. Beaumont Newhall, the "sky shade" was actually a drop shutter *acting* as a sky shade. The shutter was made to move rapidly part way across the lens and stop at the point where a longer exposure was wanted for the landscape. The sky was photographed instantaneously, as it was very light and needed much less exposure; and the land was given a time exposure. "Very ingenious," comments Mr. Newhall. (See Fig. 17.)

No one in San Francisco, and few in America, surpassed Muybridge in the seriousness with which he regarded his work. In November *The Philadelphia Photographer* used three of his Yosemite views as a frontispiece. They tried to print all the issues from one plate, but ended up using three (Fig. 8).

Although he was still selling through Ewing on April 16, and had apparently left Selleck when he returned from Alaska and went to live in Oakland for a year, Muybridge made yet another change of agency on April 24. On that date he invited customers to leave their orders at Nahl Brothers Studio at 121 Montgomery Street. The Nahls were well-known local painters, whose works were then and are still conspicuously represented in collections in the West. Three months later he was advertising himself at 121 Montgomery without reference to the Nahls.

One of Charles Nahl's most prominent patrons was E. B. Crocker—or Judge Crocker as he was called—the brother of Charles Crocker of the "Pacific Quartet" whose herculean efforts and ruthlessness had recently resulted in the spanning of the continent by iron rails. The famous "last spike" had, indeed, been driven into a laurel tie by the poorly aimed hammer of Leland Stanford at Promontory, Utah, the preceding May 10, 1869. Crocker had a magnificent home in Sacramento and was planning an art gallery—both of which still exist in their nineteenth-century splendor—and he commissioned Nahl to paint seven pictures during the following two years. It is probable that during his association with Nahl Muybridge became acquainted with Crocker, and perhaps through him with Leland Stanford. Both men commissioned him to photograph the interiors of their Sacramento mansions.

Crocker thought Muybridge's price of $700 too high, with the result that Muybridge told him to forget the whole matter. Therefore we do not know whether or not the early Crocker photographs are from Muybridge's hand. But the Stanford photographs, evidently produced in 1872, some of which include Stanford's wife, son, and in-laws, have come down to us. Some are remarkable for their psychological penetration and sensitive composition. They are reproduced in Chapter 3.

Later Muybridge claimed to have taken photographs "beneath the waters of the bay."[12] This may have been hyperbole. But it may also have been the result of attempts to take underwater exposures of the celebrated removal of Blossom Rock, a long-time menace to shipping inside the Golden Gate. Blossom Rock was blasted out in December 1869; elaborate preparations were made, and it is likely that these may have included arrangements for underwater photography. But no such photographs have been located. It is possible that, if Muybridge did photograph the explosion, he was not sufficiently proud of the results to publish them.

"Helios" continued to make his rounds and by early 1870 had acquired a specially built wagon for his equipment. This wagon was caught by his lens in a stereograph (Fig. 27). He also photographed his apparatus (Fig. 28). His business in photographing private residences also resulted in excellent work, and on May 25 he photographed the laying of the cornerstone of the new Mint. "A photographer with his flying studio was on hand," the *Bulletin* reported, "and took several views of the scene."[13] At the national convention of the Photographic Association of America, which opened in Cleveland on June 7, Muybridge had much-admired photographs in two different exhibitions.

Shortly after July 1 he traveled up to the Geyser and Russian River country in Sonoma County, possibly returning by way of Calistoga and a newly discovered petrified forest (Fig. 33). A ride with Clark Foss and his celebrated Geysers stagecoach line to and from Calistoga was one of the sought-after experiences of tourists and Californians alike (Figs. 34–36). Foss's register for this time shows such notables as General Tom Thumb and his wife, Schuyler Colfax, J. Pierpont Morgan (possibly a facetious entry), Mr. and Mrs. Charles Crocker, Mrs. Mark Hopkins and relatives, and William H. Seward.

Late in the same month, back in San Francisco, Muybridge visited Woodward's Gardens and photographed the Chinese giant. Perhaps at the same time he took a number of other photographs of Woodward's, including

one of himself in the art gallery and possibly of the young woman who was to become his wife (Figs. 37 and 38).

On August 10, 1870, Muybridge offered his services for the first time as a photographer of horses—a field in which he was to make his principal claim to fame: "Private Residence [*sic*], Horses, Monuments, Ships, etc, are photographed in the best manner by HELIOS' Flying Studio, Muybridge, 121 Montgomery street."[14]

In the San Francisco directory for 1869, where he called himself a "landscape photographer," Muybridge's home was listed as San Jose. In 1870 no home address was given, and, perhaps coincidentally, a photographic gallery at the corner of Santa Clara and First Streets in San Jose was offered for rent in September. San Jose directories, like Oakland directories, show no listings for Muybridge.

For some months Muybridge's advertisements showed him to be the most eager photographer in the area. Other photographers solicited customers for their parlors, but only "Helios" wanted to go afield. The United States Light House Board at this time was looking for a photographer to take pictures of each new lighthouse as it was finished. They had seen some photographs of the Point Arena lighthouse that had been taken by Houseworth and Company, but "Houseworth was not anxious to accept the job."[15] It would cost $400 or $500 to hire a photographer to go aboard the tender *Shubrick* on her annual trip and to take photographs of every lighthouse on the coast, but that was what had to be done. It would be cheaper than hiring two photographers at $10 per day—Houseworth's estimate—to go to each lighthouse separately. "There is no way of getting photographs of light houses, at anything like reasonable rates," one official wrote to another on December 20, 1870, "except to hire a photographer to go on board the Shubrick on the annual trip. . . ."[16]

Muybridge was approached with the proposition early in January 1871 and he accepted it. His acceptance gives interesting details about the financial side of his profession:

> Sir.
>
> In the event of your department providing for my personal expenses, safe transportation for myself and apparatus, and remuneration for my time, chemicals and use of apparatus at the rate of Twenty Dollars per day, for each day or part of a day, during my absence from San Francisco upon any expedition connected with the objects required I will agree to furnish you with two photographic prints, views of all the Light Houses upon this

coast, and such further views as you may direct of other points, without extra charge.

Should additional prints be required I will furnish them at the rate of Two dollars a dozen for stereographs and Six Dollars [illegible] 7 x 9 inches.

Your obdt Servt
Edw. J. Muybridge[17]

The proposal of expenses plus twenty dollars a day was to net Muybridge perhaps seven or eight hundred dollars for the northward trip alone. His first trips began about March 15 and seem to have ended on April 29. Probably on July 31 he went south for another ten days and another two hundred dollars—excellent pay in 1871. This work resulted in a number of attractive photographs of coastal lighthouses, photographs filled with air, space, and loneliness (Figs. 40 and 41).

But now something besides lighthouses was on Muybridge's mind. Sometime during the previous year he had become acquainted with a "petite but voluptuous" young woman "with a sweet face and large, lustrous eyes."[18] Flora Shallcross Stone was only nineteen, and Muybridge was forty, and his iron-gray beard and hair made him look even older. Flora was born on or about March 24, 1851 (her burial record noted that she was twenty-four years, three months, and twenty-six days old when she died on July 18, 1875). Her mother had died when Flora was very young, and she had been raised by a stepmother. An uncle, Captain T. J. Stumpf, later a steamship captain on the Columbia River, took her to California when she was thirteen and placed her in the care of an aunt, a Mrs. Downs, of Marysville. She is said to have attended Mills College—then Mills Seminary—the following year, although Mills records do not support this. There is some contradiction in her biographical data, and another source states that her foster father was a Captain W. D. Shallcross.

In any case, all are agreed that she went to work in a San Francisco store, Ackerman's dollar store on Kearney Street according to one account, and that she met there Lucius D. Stone, a well-known local saddler. In 1867, at the age of sixteen, she married Stone, a marriage that ended in divorce on December 8, 1870. While still married she began to work for Muybridge, retouching photographs in his studio at 121 Montgomery, when he was with the Nahls. Not long after her divorce—on May 20, 1871, or sometime during the previous March (accounts vary)—she married him. She had evidently been spending a considerable amount of time with Muybridge before her divorce, which he in fact paid for, and he may have used her as a model for photo-

graphs (Figs. 33, 35, and 38). While working for Muybridge, she lived just a few doors down the street at 6 Montgomery. After the two were married they lived, successively, at 32 Fourth Street, 560 Howard, 112 Fourth, and finally at 3 South Park, the remarkable architectural complex founded by the celebrated California entrepreneur George Gordon.[19] None of Muybridge's addresses in California still exists, although several in England do.

More San Francisco photographs, a series on a California vintage in Sonoma (Fig. 42), a Farallon Islands series (Figs. 43–45), and other lighthouse pictures rounded out 1871, Muybridge's first year of connubial bliss. It was also a year of increasing recognition. He regularly sent his work to fellow professionals who were in a position to give it publicity, with the result that it is fair to say that he was now no less celebrated than any American—and certainly Western—photographer.

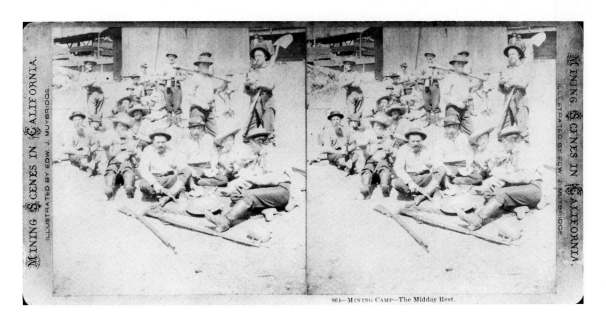

Fig. 19. Mining Camp—The Midday Rest. 1868? Stereograph by Muybridge. The California State Library, Sacramento. Muybridge announced in May 1868 that he was preparing mining scenes for publication.

20

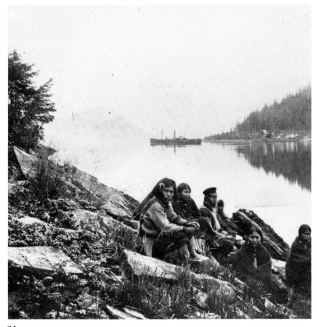

21

Fig. 20. The steamer *Active* at Nanaimo, Alaska. August 7, 1868. Half of a stereograph by Muybridge. The Bancroft Library, University of California, Berkeley.

Fig. 21. Natives in Alaska. 1868. Half of a stereograph by Muybridge. The Bancroft Library, University of California, Berkeley.

Fig. 22. Natives in Alaska. 1868. Photograph by Muybridge. Lantern slide. The Kingston-on-Thames Library and Museum, Kingston-on-Thames, England.

Fig. 23. The reverse of a Muybridge *carte de visite* of the October 21, 1868, San Francisco earthquake, showing his identification of the view. The California Historical Society, San Francisco. "Market st' below Battery st' " is in another hand.

Fig. 24. The *Colorado* in dry dock at Hunter's Point, San Francisco. November 12–14, 1868. Half of a stereograph by Muybridge. The Bancroft Library, University of California, Berkeley.

Fig. 25. Muybridge himself at North Point Dock, San Francisco. Half of a stereograph by Muybridge. The Bancroft Library, University of California, Berkeley.

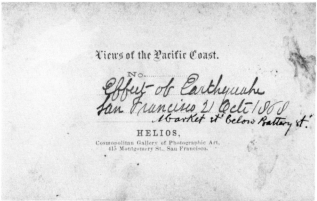

23

22

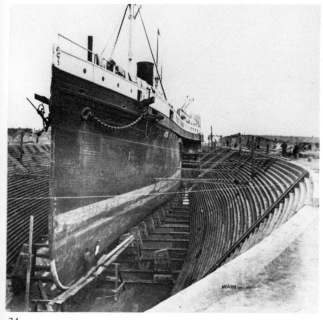

24

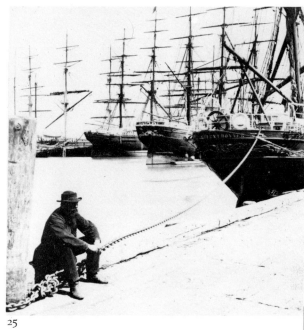

25

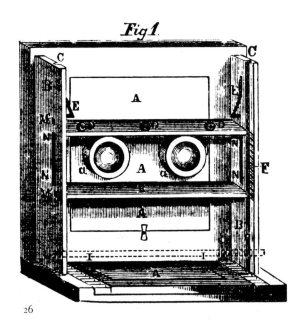

Fig 1.

26

27

HELIOS,
(THE FLYING STUDIO).

Landscapes, Ranches, Buildings, Engineering Works, Ships, Animals, Etc.

PHOTOGRAPHED

in the City, or any portion of the Pacific Coast.

ARCHITECTS', SURVEYORS', AND ENGINEERS' DRAWINGS, COPIED MATHEMATICALLY CORRECT.

The most artistic and comprehensive series of

PACIFIC COAST, YOSEMITE, AND Mammoth Tree Views,

EVER PUBLISHED, OF VARIOUS SIZES, ADAPTED FOR FRAMING, the STEREOSCOPE and the ALBUM.

EDW. J. MUYBRIDGE,

Cosmopolitan Gallery of Photographic Art

415 Montgomery St., San Francisco.

29

28

PHOTOGRAPHIC ILLUSTRATIONS OF THE PACIFIC COAST

VIEWS OF CALIFORNIA, NEVADA, UTAH, IDAHO, MONTANA, WYOMING, ARIZONA, ALASKA, VANCOUVER ISLAND, OREGON;

YOSEMITE, MAMMOTH TREES, GEYSERS; PACIFIC RAILROADS;

MINING SCENES; CHINESE; INDIANS; STUDIES OF TREES AND CLOUDS; MARINE AND MOONLIGHT EFFECTS; ETC., ETC.

EDW. J. MUYBRIDGE,

SALESROOM—111 Montgomery Street. 12 Montgomery Street, San Francisco, California.

30

ILLUSTRATIONS OF THE

HELIOS
FLYING STUDIO

IA, NEVADA, UTAH, IDAHO, MONTANA ALASKA, VANCOUVER ISLAND, OREGON;

31

32

Fig. 26. Illustration from *The Philadelphia Photographer,* May 1869, showing Muybridge's new sky shade.

Fig. 27. The Savings and Loan Society, San Francisco. *Ca.* 1870. Half of a stereograph by Muybridge. The Bancroft Library, University of California, Berkeley. "The Flying Studio" is at the left. A Muybridge stereograph of Maguire's Theatre, San Francisco, also shows "The Flying Studio."

Fig. 28. Muybridge's "Flying Studio" in Yosemite Valley. 1867? Half of a stereograph by Muybridge. The Bancroft Library, University of California, Berkeley. "Helios" is painted on the box between Muybridge's hat and one of his boots, and has been scratched in the negative at lower center.

Fig. 29. The reverse of a *carte de visite* by Muybridge. 1868? The California Historical Society, San Francisco. See Fig. 83 for a photograph of an architect's drawing such as is offered here.

Fig. 30. The reverse of a stereograph by Muybridge. 1872. Author's collection. Some of this blurb is hyperbole: so far as is known, Muybridge never visited Idaho, Montana, Wyoming, or Arizona.

Fig. 31. Enlarged detail of the preceding.

Fig. 32. Ceremonies attending the laying of the cornerstone of the San Francisco City Hall and Law Courts. February 22, 1872. From a 6½″ x 7½″ original by Muybridge in the San Francisco Public Library.

33

34

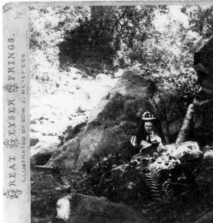

35

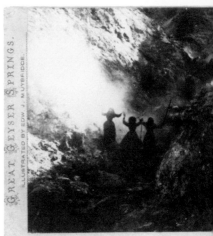

36

Fig. 33. *Stump of Fossil Tree, Petrified Forest near Calistoga*, California. July 1870? Half of a stereograph by Muybridge. The California State Library, Sacramento. The woman at the left may be Flora Shallcross, later Mrs. Muybridge. This petrified forest had only recently been discovered, and Muybridge's party was one of the first to visit it. This was possibly on the way back from the Geysers junket (see Fig. 34).

Fig. 34. *Devil's Tea Kettle,* the Geysers, Sonoma County, California. July 1870. Stereograph by Muybridge. Author's collection. Muybridge scratched the figure of the devil on his negative.

Fig. 35. *The Witch of the Geysers,* the Geysers, Sonoma County, California. July 1870. Stereograph by Muybridge. Author's collection. This may be Flora Shallcross.

Fig. 36. *The Witches' Cauldron— Macbeth, Act IV, Scene I.* July 1870. Stereograph by Muybridge. The New-York Historical Society, New York, New York. The figures look like cutouts, but they are actually women.

Fig. 37. Muybridge himself in the art gallery of Woodward's Gardens, San Francisco. July 1870. Half of a stereograph. The Bancroft Library, University of California, Berkeley. Most of Woodward's paintings were copies of celebrated European originals.

Fig. 38. Flora Shallcross(?) in Woodward's Gardens, San Francisco. July 1870. Half of a stereograph by Muybridge. The Bancroft Library, University of California, Berkeley.

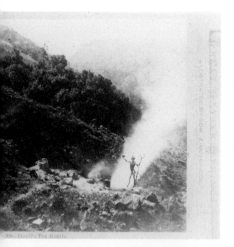

306—Devil's Tea Kettle.

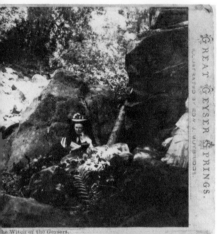

The Witch of the Geysers.

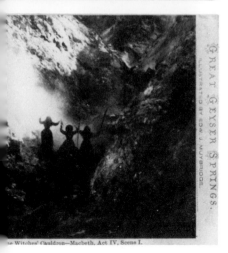

The Witches' Cauldron—Macbeth. Act IV, Scene I.

37

38

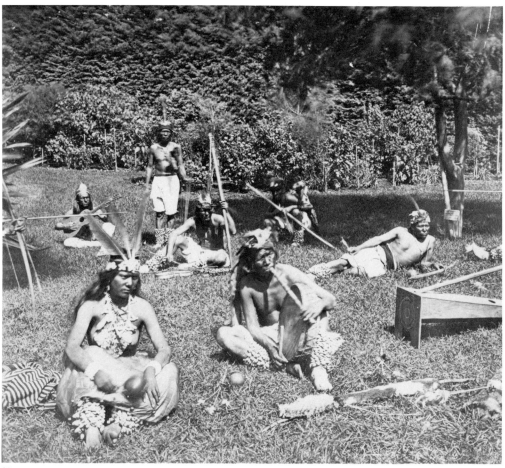

39

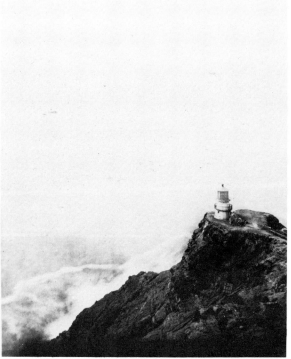

40

Fig. 39. Sandwich (Hawaiian) Islanders in Woodward's Gardens, San Francisco. July 1870. Photograph by Muybridge. Lantern slide. The Kingston-on-Thames Library and Museum, Kingston-on-Thames, England.

Fig. 40. Point Reyes lighthouse, Point Reyes, California. 1871. Photograph by Muybridge. The National Archives, Washington, D.C. The view is from inland, Muybridge explaining that there was no standpoint for a profile view.

Fig. 41. Point Reyes lighthouse, keeper's cottage, Point Reyes, California. 1871. Photograph by Muybridge. The National Archives, Washington, D.C.

Fig. 42. Corking wine bottles at the Buena Vista vineyard near Sonoma, California. Photograph by Muybridge. Courtesy of the Wine Institute. Anger, the superintendent, is third from right. "National Grape" can be seen on the box at the left.

41

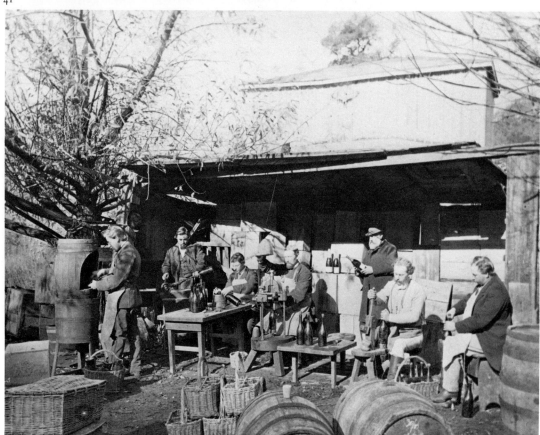

42

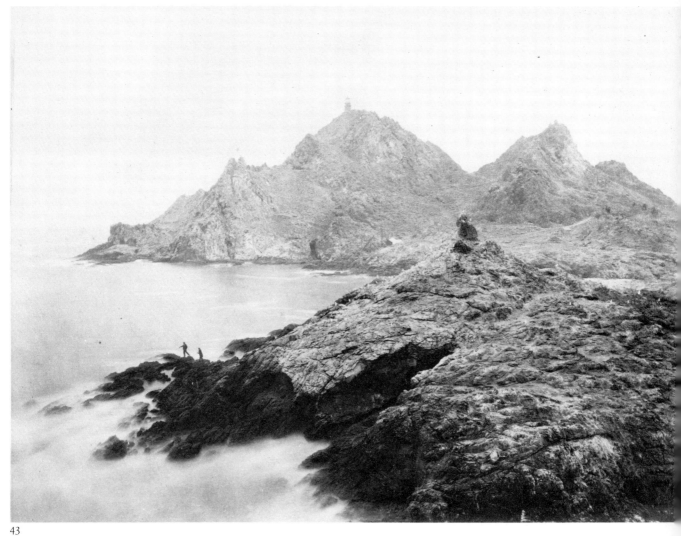

43

Fig. 43. South Farallon lighthouse, Farallon Islands, California. 1871. From 7″ x 9″ original by Muybridge. Coast Guard archives, Washington, D.C. Muybridge identified the landscape features as follows: Point Shubrick, Tower Head, Light House, Parrot Rock, and Gull Peak. The photograph was taken from the Hole in the Wall.

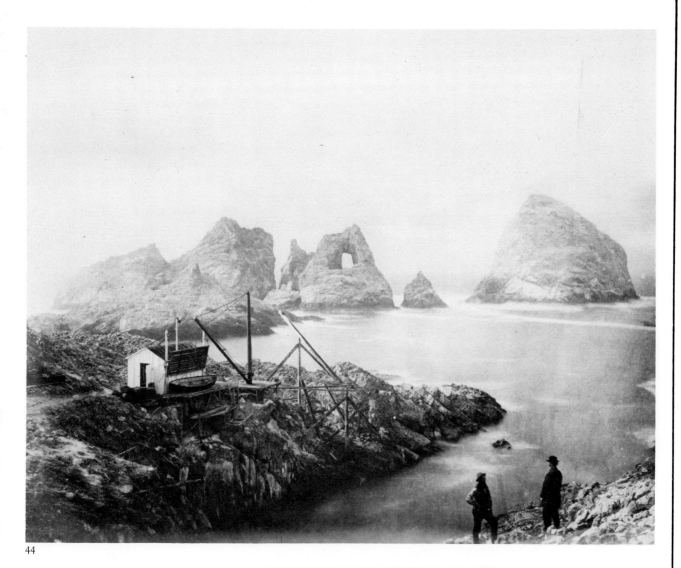

44

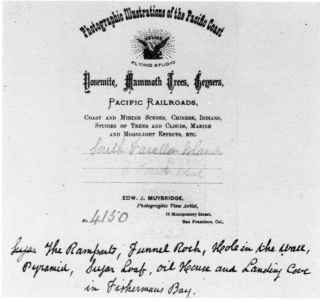

Fig. 44. Landing Cove in Farallon Islands, California. 1871. Photograph by Muybridge. Coast Guard archives, Washington, D.C. The Hole in the Wall is in the middle distance, center.

Fig. 45. The reverse of the preceding, inscribed in Muybridge's hand: "South Farallon Island . . . The Ramparts, Funnel Rock, Hole in the Wall, Pyramid, Sugar Loaf, Oil House and Landing Cove in Fishermans Bay." 1871. Coast Guard archives, Washington, D.C.

Success and Marriage

Muybridge's visit of April 1872 to Sacramento, probably to photograph the Leland Stanford house and family and perhaps also the E. B. Crocker house, was to prove more momentous than anything he had yet done (Figs. 46–52).

He was in Sacramento on April 26 showing his photographs to prospective subscribers, and he announced that he would soon be going to Yosemite and other localities to take 20″ x 24″ negatives from which he would furnish 18″ x 22″ prints mounted on tinted cardboard "on reasonable terms."[1] A reporter for *The Sacramento Union* wrote that he had seen "some very fine large-sized photographic negatives," and the following day *The Sacramento Record* made it clear that what had been seen were prints and negatives both. "Mr. Muybridge proposes," the *Record* reported, "devoting the present season to the production of a series of large-sized negatives illustrating the Yosemite and other picturesque and striking localities in the State." Muybridge did, indeed, proceed to Yosemite and brought back a striking assemblage of new views (Figs. 53–56). There were numerous stereographs and a number of large views that measured—according to the *Bulletin* of March 22, 1873—21½″ x 17½″. He may have been pushed into this new excursion to the valley by Carleton Watkins' recent venture into large Yosemite negative production. Watkins' new photographs were getting considerable publicity, and Muybridge did not want to be left behind.

While in Sacramento, Muybridge met the Stanfords, and evidently they liked him and he them. Stanford, the immensely wealthy former governor of the state and one of the Pacific Quartet that had helped span the country with iron rails, had been for some time a horse fancier. His celebrity—and taste for horses—were well expressed in a local newspaper report of June 5, 1872:

> AN INSANE FREAK.—Governor Stanford's name is getting to be a house-hold word in this State—father of all the railroads, President or Director of a legion of fire and life insurance companies, slow and fast horses (he owns a wonder of a one himself) are called after him, children and patent medicines are named after him, the Big Trees echo his name to the peaks of the Nevadas; hot, cold, mineral and mud springs bubble it up, forgers fancy it and confidence men quote Stanford in their transactions, and free-passers adore it, and "dead-heads" and beggars swear by it. His name is the "great Whangdoodle" to many newspapers and politicians; dogs, cats, saloons and hotels bear it, and we hardly know how the gentleman retains any part of his name, it has been so often used. But what has all this got to do with a poor fellow confined yesterday in the City Prison, who wanted his dinner,

and after mentioning over several well-known persons to bring it to him said "no, they would not do it." "But ah! I have it," said he to the officer in charge; "please go up to Governor Stanford's house and tell him to bring my dinner down immediately; he will bring it, I know." The poor unfortunate was told that his wish would be complied with, and we have no doubt that had the Governor been handy, and known the wants of the poor man, they would have been satisfied.[2]

Stanford was best known in California horse circles as the owner of Occident (whose original name, Wonder, inspired the pun in the above newspaper account). Stanford had first seen Occident drawing a wagon in the streets of Sacramento, and he had bought and trained him to be a record-breaking trotter. Occident's fame had spread nationwide, and in October 1872 all San Francisco, a horse community according to the *Bulletin*, was agog over a match race between Occident and Goldsmith Maid, who had been brought from the East Coast. It is through Occident that Muybridge was first to approach the problem that earned him the title of "father of the motion picture."

Stanford wanted to know more about the movement of horses—and particularly of Occident, who had an unusually long stride—and he felt that photography was the means to this end. When Frederick MacCrellish, publisher of *The Daily Alta California*, suggested to Stanford that he give Muybridge a chance, Stanford agreed. Muybridge wrote many times later that he began his work photographing Occident at Stanford's instance in 1872, and that he got satisfactory results in a few days. It is not known when in 1872 the work was done—it may have been as early as April, when Muybridge may have photographed Stanford's family. In any case, the work was begun before December 23, at which time Stanford and his family left for the East, where they stayed until February 1873.

It has been said that Stanford had bet James R. Keene, a financier, the sum of $25,000 that, at one instant during the stride, all four feet of a trotting horse were off the ground, and that Stanford hired Muybridge to prove he was right. Muybridge himself wrote that it was MacCrellish with whom Stanford bet, but Stanford specialists say that the governor was not a betting man and maintain that it was simply his curiosity about the gait of his horse that initiated the experiments. This leaves unexplained, however, the origin of the betting story.

It was not until 1877 that Muybridge's famous photograph of the collage of Occident trotting was published (Fig. 87), but the results of his 1872 experiments were described by the *Bulletin*, the *Alta*, and the *Chronicle* in

April 1873, at which time Muybridge, who had been working more or less steadily for several months, finally announced the achievement of a successful negative. The papers did not say that they had actually seen any photographs but only that they had been informed of their existence—evidently by Muybridge. The *Alta*'s account was the fullest:

Quick Work

Governor Stanford's fondness for his trotter is well known . . . and he is confident that time will put the brown beauty where he belongs—at the head of the list of trotters. The Governor is a judge of the points of a horse, too, and he appreciated the beauty of movement of "Occident" as highly as the speed he developed in his trials; and appreciating this beauty of movement, he wanted his friends abroad to participate with him in the contemplation of the trotter "in action," but did not exactly see how he was to accomplish it until a friend suggested that Mr. E. J. Muybridge be employed to photograph the animal while trotting. No sooner said than done. Mr. Muybridge was sent for and commissioned to execute the task, though the artist said he believed it to be impossible; still he would make the effort. All the sheets in the neighborhood of the stable were procured to make a white ground to reflect the object, and "Occident" was after a while trained to go over the white cloth without flinching; then came the question how could an impression be transfixed of a body moving at the rate of thirty-eight feet to the second. The first experiment of opening and closing the camera on the first day left no result; the second day, with increasing velocity on opening and closing, a shadow was caught. Mr. Muybridge, having studied the matter thoroughly, contrived to have two boards slip past each other by touching a spring, and in so doing leave an eighth of an inch opening for the five-hundredth part of a second, as the horse passed, and by an arrangement of double lenses, crossed, secured a negative that shows "Occident" in full motion—a perfect likeness of the celebrated horse. The space of time was so small that the spokes of the wheels of the sulky were caught as if they were not in motion. This is considered a great triumph as a curiosity in photography—a horse's picture taken while going thirty-eight feet in a second![3]

Meanwhile, far away in northern California the Modoc Indians were making an heroic effort to keep themselves from being driven out of their homeland by the United States Army, and the whole country was taking sides. The San Francisco papers were full of the matter, and it was natural that the "Helios" flying studio should record the events for posterity. Muybridge had now attached himself to the firm of Bradley and Rulofson at 429 Montgomery Street, the city's largest photographic establishment, after a brief stay at an address of his own at Number 12. He passed through Sacramento on his

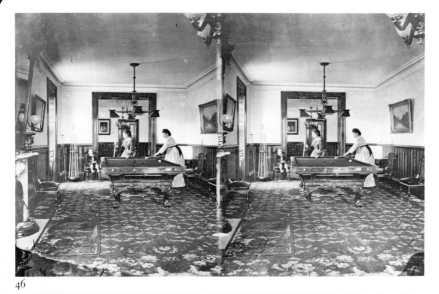

46

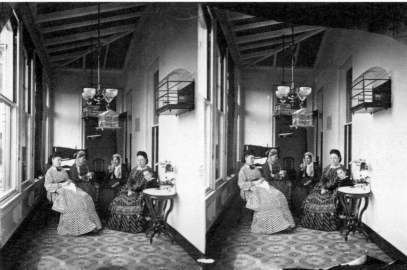

47

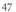

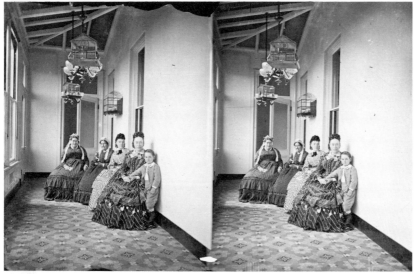

48

Fig. 46. The billiard room of the Stanford house at 8th and N Streets, Sacramento, California, showing—from left to right—Leland Stanford, Jr., Mrs. Leland Stanford, and Anna Maria Lathrop (Mrs. Stanford's sister). 1872. From the original negative by Muybridge in the Stanford University Museum, Stanford, California. Judging from what we know of Muybridge's movements, the age of Leland Jr.—who was born on March 14, 1869—and the state capitol entablature (see Fig. 50), this photograph and the following two were produced in 1872.

Fig. 47. Left to right: Anna Maria Lathrop, Mrs. Dyer Lathrop (Mrs. Stanford's mother), Mrs. Josiah Stanford (Leland Stanford's mother—who is taking snuff?), Mrs. Leland Stanford, and Leland Stanford, Jr., in what may have been the aviary in the Stanford house. 1872. From the original negative by Muybridge in the Stanford University Museum, Stanford, California.

Fig. 48. Left to right: Mrs. Dyer Lathrop, Mrs. Josiah Stanford, Anna Maria Lathrop, Mrs. Leland Stanford, and Leland Stanford, Jr., in the Stanford house. 1872. From the original negative by Muybridge in the Stanford University Museum, Stanford, California. There are interesting changes from the preceding.

way north to the Lava Beds, where the excitement was going on, on April 25, and reached Yreka, the town nearest the Lava Beds, the next day. Like the Alaska and lighthouse views, these photographs had been commissioned by the government, although they were also used for Muybridge's own purposes:

> It is understood here that General Gillem has been directed by the War Department to have prepared photographic views of the different approaches to the lava beds and of Captain Jack's famous cave and fortifications. These views will accompany the official reports of the officers of the Modoc expedition. (E. J. Muybridge, the well-known photographic artist of this city, who has been charged with the execution of this plan, left for the seat of war yesterday with a full battery of chemicals.—Ed. *Chronicle*.)[4]

Between May 2 and about May 11, 1872, Muybridge took approximately seventy photographs of the Lava Beds, the Modocs, and the soldiers sent against them. All were soon put on the market as stereographs by the photographer's new firm, Bradley and Rulofson. Before he left the area, Muybridge gave an interview to *The Yreka Union*:

> MUYBRIDGE'S VIEWS.—Mr. Muybridge, the photographist who was sent by Gen. Schofield with Capt. Lydecker, to take photographic views of the lava bed, informed us on his return that he had taken altogether some seventy views. The negatives will be sent to Bradley & Rulofson of San Francisco, who will finish up the pictures. Of these about fifty will have an interest for the general public; the remainder will be finished up as a part of the report of Capt. Lydecker, and will be of interest or use only in a military or engineering point of view. The views in which the public take an interest will be finished up by Messrs. Bradley & Rulofson, and, we suppose, offered for sale. Mr. Muybridge enjoys the reputation of being a superior artist, and then, being under the auspices of the army, he had furnished him superior facilities for taking all points of interest. His pictures will be awaited with considerable anxiety.[5]

Meanwhile, the new large-sized Yosemite views of the previous summer had been published. Now they were being offered to the public along with the Modoc War photographs. The *Alta* and the *Bulletin* vied with each other in praising Muybridge, and on June 21 *Harper's Weekly* published five of his Modoc photographs in an article on the war (Fig. 57). Late in July the photographer was awarded a medal at the Vienna Photographic Exhibition, and his international reputation as a still photographer was assured. Dr. H. Vogel, perhaps the leading photographic critic of the time, described the 1872 Yosemite photographs as better in cloud effects than either Houseworth's or Watkins'. "Glorious specimens of landscapes," he wrote, "worthy of the

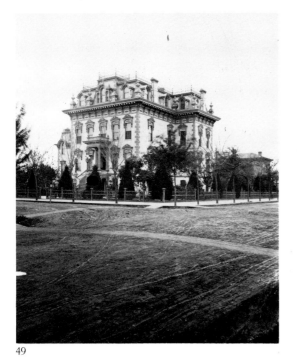

49

50

Fig. 49. The Leland Stanford house at
8th and N Streets, Sacramento, California.
1872. From the original negative by Muy-
bridge in the Stanford University Museum,
Stanford, California.

Fig. 50. The California State Capitol,
Sacramento, from the roof of the Stanford
house at 8th and N Streets. 1872. From a
stereograph by Muybridge. The Henry E.
Huntington Library, San Marino, Cali-
fornia. The statues in the entablature,
which were set early in January 1873, are
not present here; thus the photograph
predates January 1873.

Fig. 51. The Leland Stanford house,
Sacramento. 1872. From the original
negative by Muybridge in the Stanford
University Museum, Stanford, California.
A Stanford equipage is drawn up at the
curb. Taken at a somewhat later time than
Fig. 49, since the trees are leafed out and
a flagpole has been installed in front of
the house.

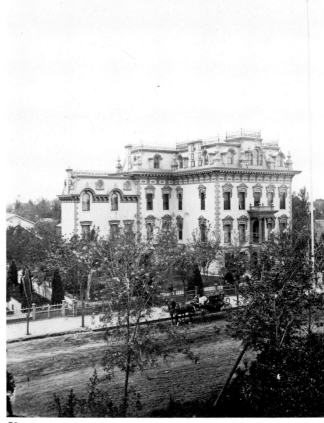

51

magnificent scenery which they represent."[6] The next month, at the American Institute in New York, the Yosemite photographs were described as "beautiful . . . magnificent in size and execution, although taken under such disadvantageous circumstances."[7]

In September the *Costa Rica* went aground off the Golden Gate, and crowds of San Franciscans viewed her from near the Cliff House. Muybridge was among them (Fig. 58). The next month he photographed San Quentin. The same month Muybridge's friend, the painter Albert Bierstadt, returned east after a two-and-a-half-year stay in San Francisco (Fig. 59). Muybridge had photographed him while he was sketching Indians outside Yosemite the previous summer (Figs. 60 and 61).

Sometime this season, also, Muybridge traveled over the route of the new transcontinental railroad and produced a number of views, among which are many well-known examples (Figs. 62–65).

Late in 1873, with Muybridge's professional reputation at its height in San Francisco, Thomas Houseworth and Company, a rival firm, placed in their window a Muybridge photograph—"an old, soiled print from a condemned negative," according to Bradley and Rulsofson.[8] Houseworth replied that it was one of a Muybridge Yosemite series that Bradley and Rulofson had sold to a local subscriber, and that if Bradley and Rulofson did not like it, it was their fault. The series of three newspaper notices was ended by Muybridge with the following:

> A MODERN APPLICATION OF AN OLD FABLE—Aesop, I believe, relates of an Ass that had the impudence to follow a LION, and to bray after him with the intention of annoying and insulting him: The Lion turning his head and seeing him from whence came the insult, conscious of his own power and the estimation placed upon his abilities silently pursued his way, being too much occupied with his own business to allow his honoring so contemptible a detractor with the slightest notice.
>
> MUYBRIDGE[9]

Throughout the winter and the following spring Muybridge continued his energetic schedule. In March Bradley and Rulofson photographed the actress Adelaide Nielson, then visiting the city, and combined her photograph with theirs and Muybridge's, along with numerous Muybridge views, in an advertising card (Fig. 68).

Fig. 52. A Stanford turnout at the Sacramento race track. 1872? From the original negative in the Stanford University Museum, Stanford, California.

On April 15, 1874, a baby boy was born to the Muybridges, and some time later—Muybridge said there was no hurry—he was named Florado Helios, after Flora, Eadweard, and Eadweard's pseudonym. The next week Muybridge's mother died in faraway Kingston, but Muybridge scarcely interrupted his vigorous rounds. Soon he was down on the Peninsula photographing the W. C. Ralston house. Perhaps he began to think that all this separation from his wife might not be pleasant for her, for on June 14 he bundled her and the two-month-old baby aboard the *Oriflamme* for a visit to relatives in The Dalles, up the Columbia River from Portland. The two stayed overnight in Portland, then proceeded up the river. There they stayed until disaster struck.

53

Fig. 53. Muybridge in Yosemite at the base
of a great tree. 1872. Detail of a photograph by
an unidentified photographer working for
Thomas Houseworth and Company of San
Francisco. The Bancroft Library, University of
California, Berkeley. Muybridge is sitting on a
Houseworth box; this has been adduced as
indication that he worked for Houseworth, but
he did not.

Fig. 54. Muybridge on Contemplation Rock,
Glacier Point, Yosemite Valley, California. 1872.
Half of a stereograph. The California Historical
Society, San Francisco. This photograph was
later cited as proof that Muybridge was
unbalanced.

55

56

Fig. 55. *Trail to Union Point,* Yose-
mite Valley. 1872. Stereograph by
Muybridge. Author's collection.

Fig. 56. *A Yosemite Tourist,* Yosem-
ite Valley. 1872. Half of a stereograph
by Muybridge. The Bancroft Library,
University of California, Berkeley.
Published by Bradley and Rulofson.
After Muybridge began his association
with Bradley and Rulofson, his work
became less direct, possibly because
of Rulofson's prodding.

Fig. 57. Page 533 of *Harper's Weekly*
for June 21, 1873, with five engravings
taken from prints of Muybridge's pho-
tographs of the Modoc War sent to
Harper's by Bradley and Rulofson,
Muybridge's publishers: *Modoc Brave
Lying in Wait for a Shot, On the Look-
Out for an Attack on a Picket Station,
Modoc Squaws, Captain Jack's Late
Stronghold,* and *Warm Spring Indians
Scouting.*

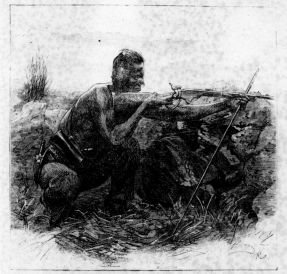

MODOC BRAVE LYING IN WAIT FOR A SHOT.

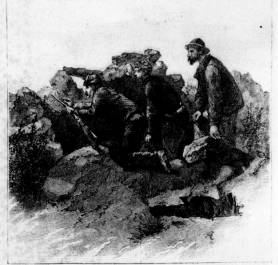

ON THE LOOK-OUT FOR AN ATTACK ON A PICKET STATION.

the cause of the uproar, and at once the whole camp was in commotion. Down the level plain north of the house came a cavalcade of horsemen. The steeds rushed forward at a furious rate, and soon neared the groups of spectators scattered about the premises.— "Captain JACK is captured!" shouted a sturdy sergeant. Again the valley echoed with cheers and yells, as the form of the dreaded chief was recognized among the prisoners. They were soon grouped in a field near the camp, and surrounded by a strong guard. Captain JACK is described as apparently about forty years old, with a large and well-shaped face, full of character and individuality. Even in his worn and ragged dress he looked every inch a chief, and bore himself with a proud and disdainful indifference toward his captors. He paid no attention to those who crowded about him with eager curiosity, and maintained a dogged silence

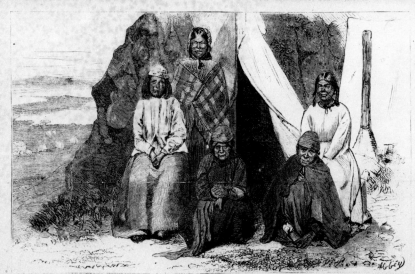

MODOC SQUAWS.

when spoken to. He was mute as a statue.

Before night Captain JACK and SCHONCHIN were ironed together, and, with the other warriors, placed in a small building under guard. Neither Captain JACK nor SCHONCHIN spoke a word or manifested the slightest feeling. SCAR-FACED CHARLEY, however, protested against the indignity in behalf of his fellow-captives, and said that none of them intended to escape, even if the opportunity offered. He obtained but little satisfaction, and retired in disgust.

What to do with the captured Modocs is now an embarrassing question. It is held by the military authorities at Washington that the Modocs could not surrender as "prisoners of war" in the sense known to nations where war is declared in accordance with constituted forms. Not having been so received, they are not entitled to consideration as prisoners of war. The orders issued to

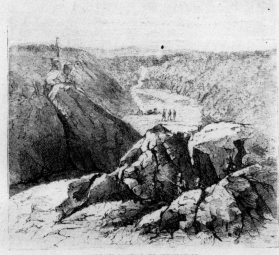

CAPTAIN JACK'S LATE STRONGHOLD.

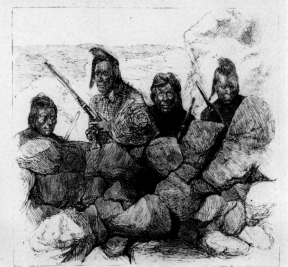

WARM SPRING INDIANS SCOUTING.

PICTURES FROM THE LAVA BEDS.—[FROM PHOTOGRAPHS BY MUYBRIDGE, FURNISHED BY THE COURTESY OF BRADLEY & RULOFSON, SAN FRANCISCO.]

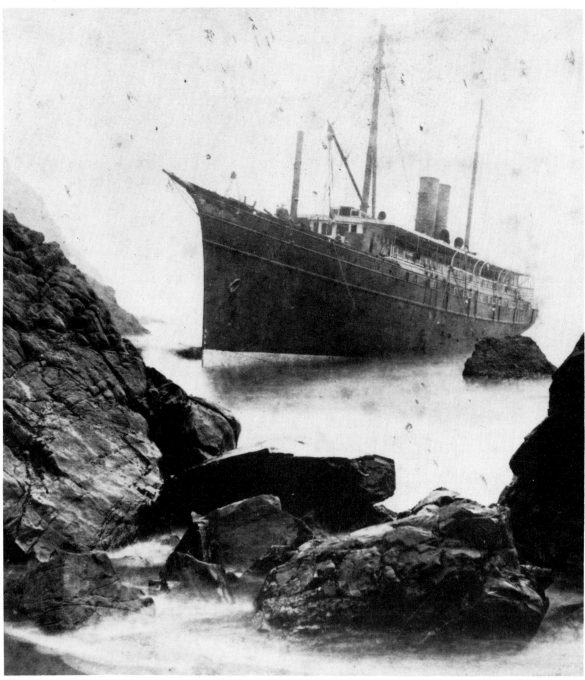

59

60

Fig. 58. The *Costa Rica* aground off the
Golden Gate. September 18–24, 1873. Half of
a stereograph by Muybridge. Author's collection,
courtesy of Albert Shumate. The *Costa Rica,*
which was in the Honolulu trade, went aground
in a fog at 7:10 p.m., September 17, and was
dragged free on September 24.

Fig. 59. Albert Bierstadt at about 42. 1872?
Photograph by Bradley and Rulofson. Author's
collection.

Fig. 60. Albert Bierstadt sketching Indians in
Mariposa (?), California. 1872. Half of a stereo-
graph by Muybridge. The California Historical
Society, San Francisco.

Fig. 61. Albert Bierstadt sketching Indians
in Mariposa (?), California. 1872. Half of a
stereograph by Muybridge. The Bancroft Library,
University of California, Berkeley.

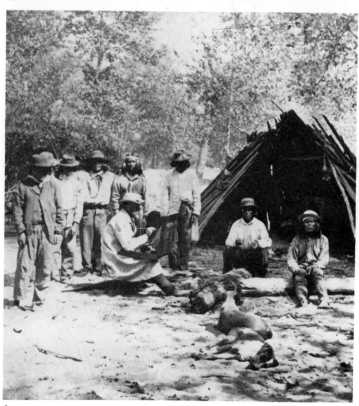

61

Fig. 62. The Devil's Slide, Utah. 1873. Stereograph by Muybridge. Author's collection. One of numerous photographs taken of the right-of-way of the Central Pacific Railroad and the western section of the Union Pacific. Announced by Bradley and Rulofson for the season of 1873.

Fig. 63. Humboldt Palisades, Utah. 1873. Half of a stereograph by Muybridge. The Bancroft Library, University of California, Berkeley.

Fig. 64. Coming Storm, Wahsatch Mts., from the Weber River near Ogden, Utah. 1873. Half of a stereograph by Muybridge. The Bancroft Library, University of California, Berkeley. Apparently taken with a single negative instead of two.

Fig. 65. 1,000 Mile Tree, 1,000 miles west of Omaha, Utah. 1873. Half of a stereograph by Muybridge. The Bancroft Library, University of California, Berkeley. The "1,000-mile tree" is now at Peterson, Utah, and now, as a result of straightening the right-of-way, only 973 miles west of Omaha.

Fig. 66. The School for the Deaf and Blind, Berkeley, California. 1873–74. Photograph by Muybridge. The California Historical Society, San Francisco. Possibly taken at the same time as Fig. 67, after the Bradley and Rulofson association began, and before the photographer went out of circulation on October 17, 1874.

62

63

64

65

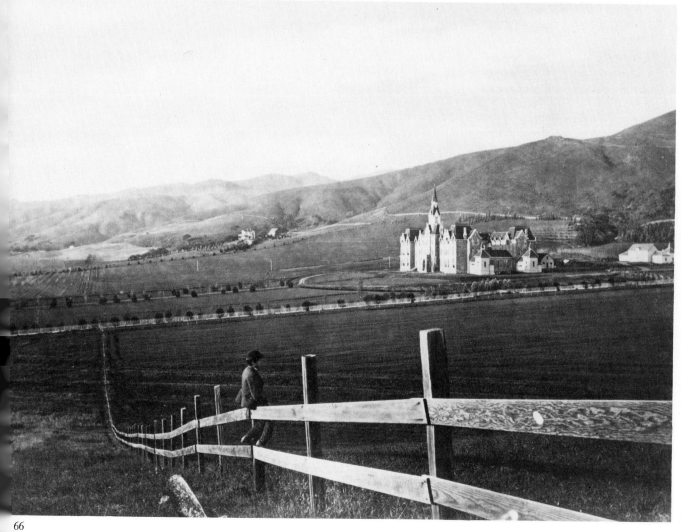

66

67

Fig. 67. One of Muybridge's University of California series, showing Dr. A. A. O'Neil giving an anatomy lecture. 1873–74. Half of a stereograph by Muybridge. The Bancroft Library, University of California, Berkeley. Evidently carefully posed, since no movement is visible and the dissection could not be seen by the students.

Fig. 68. Bradley and Rulofson advertising montage. 1874. The George Eastman House, Rochester, New York. Adelaide Nielson, the actress, who was then visiting the city, is at the left; Bradley is left of top center; Rulofson is below him; and Muybridge is at the right. All of the other photographs are Muybridge's.

Fig. 69. William Rulofson and his family at their home on Sacramento Street, San Francisco. 1871? Half of a stereograph by Muybridge. The Bancroft Library, University of California, Berkeley.

Fig. 70. Unidentified family group in California. Half of a stereograph by Muybridge. The Bancroft Library, University of California, Berkeley.

69

The Larkyns Affair

Disaster was a fellow named Harry Larkyns.

On October 14, 1874, Mrs. Susan Smith, the midwife who had attended Flora Muybridge at the birth of the baby, not having yet been paid for her services after nearly six months, went to Justices' Court and got a $107 judgment against Muybridge for the bill. On October 16 Muybridge met Mrs. Smith at her attorney's office, and in the evening went to her house. There he saw on the wall a photograph of his baby. He turned it over and saw the words "Little Harry." He was also shown some letters. "Oh God! Oh God! Is it possible?" he cried, falling on the floor.

George Harry Larkyns had arrived in San Francisco on November 28, 1872, with a young friend named Arthur Neil, who surpassed most in innocence, and whom Larkyns had met in Salt Lake City while both were on their way to San Francisco. Larkyns told Neil that through some stupid blundering of the express company, all his trunks, clothes, and other effects had gone on ahead to San Francisco, and that meanwhile he was strapped. He was on his way to Yokohama. His grandmother was a very wealthy lady in London, but he did not want to call on her for help. Would Arthur Neil. . . . ? He would. He pressed money on Larkyns, urging him, please, not to feel embarrassed. "Major Larkyns," the *Chronicle* reported later, "did not feel at all embarrassed."[1] "My purse, Major," said Neil, "is at your disposal."

The two pressed on to San Francisco, and on the way Larkyns told Neil that a £1000 letter of credit was waiting for him there. He suggested that the two put up at the Occidental Hotel, then the city's finest. Two days after their arrival, Neil, to whom Larkyns now owed several hundred dollars, suggested that Larkyns redeem his letter of credit and settle the debt. Larkyns hurried off to the bank but was soon back: "How very provoking," he said; "My letter of credit has been sent to Yokohama instead of this place. . . . But I'll tell you what I'll do, my dear fellow, I'll pay you the moment I get there. I'll give you my word of honor as a gentleman. . . ." In the meantime, how about a little advance? Neil, not surprisingly, acceded, and Larkyn's first weekly bill at the Occidental came to $356, which included $127.50 for wine and $156 for carriages.

"It was not long," the *Chronicle* reported, before Larkyns met "a notorious lady in this city named Fanny _____, and upon her he lavished the wealth of Mr. Neil's purse." Other adventures involving other classic confidences are detailed in further *Chronicle* reports. Presently Neil decided to take a trip to the Sandwich Islands (Hawaii) for his health, and Larkyns went along, with Neil again paying the bills. In Honolulu Larkyns lived like a

millionaire at Neil's expense. But now the victim was becoming a bit disaffected. He spoke to several people in Honolulu, all of whom told him he had been badly sold. As a result he told Larkyns that he must straighten up. "Thereupon," the *Chronicle* reported, "the Major retired [and wrote Neil a letter] which, for unblushing effrontery, sublime cheek and exasperating insolence we have never seen equaled."

Again in San Francisco, where he found Larkyns running up bills at the Occidental on the credit he had established with Neil's money, Neil decided to go to law. He filed a complaint against Larkyns for obtaining money under false pretenses. "A warrant was issued," the *Chronicle* reported, "and by sundown yesterday Major Larkyns was breathing the pure air of the City Prison."[2] When the case came to trial the next day the courtroom was crowded with people "eager to see so magnificent a gentleman as the dashing Major and hear the evidence of his wonderful skill in victimizing confiding young gentlemen of means." The *Chronicle* continued: "His career in this city has been brief, but it has been brilliant. . . . Let his fate serve as a warning to such young gentlemen among us who may be living on the credit of expected remittances."

But Neil now came forward and withdrew the complaint after Larkyns signed a confession that he really did owe Neil money, which he promised to pay as soon as he received funds from his alleged rich relative in England.

A less cynical reporter later commented that Larkyns soon demonstrated that he had "a good bottom in him, and was by no means the scheming fellow he had been represented."[3] Larkyns' talents as a translator got him a job at a publisher's, and soon he was writing drama criticism for the *Post* and, by the following summer, had become a correspondent for *The Weekly Stock Report*.*

Larkyns, in his uninterrupted access to San Francisco's social and professional life, visited Bradley and Rulofson's, where he was introduced to Muybridge by Flora, who apparently already knew him. This was shortly after the Neil dénouement in March 1873, at which time Muybridge and his wife had been married two years and had settled in South Park. Larkyns managed to ingratiate himself and was soon calling on the Muybridges at their home.

"The remainder of the story," the *Call* reported, "may be condensed into a few sentences: Muybridge was away from home frequently and

* "Dramatic Sketches" in the *Post* of December 20 and 27, 1873, for example, seem to have been written by Larkyns. *Stock Report* items were published on August 28, September 4, and October 16, 1874.

bestowed more care on business than domestic affairs. Mrs. Muybridge was vivacious and young enough to be his daughter; Harry Larkyns was gay, dashing and handsome, and having permission to escort Mrs. Muybridge to the theatre, he did not neglect the opportunity and abused it."[4]

"Matters went on in this way for more than a year," the *Chronicle* reported.[5] Larkyns rented rooms and told his landlady that his wife was staying with relatives in the city but would soon be living with him. "His wife," of course, was Flora Muybridge. Whenever her husband was out of town she hurried over to Larkyns. As a matter of fact, Muybridge was out of town, possibly to photograph the Ralston house in Belmont, when Florado was born, and it was Larkyns who brought Flora to the home of Mrs. Smith, the midwife, and took them both to South Park, where the baby was born. Muybridge was sent a telegram and hurried home. "Little did Muybridge dream as he bent over the bedside of his wife and caressed her," it was said, "that Larkyns' kisses were yet fresh and hot upon her lips."[6]

Mrs. Smith went on to give juicier details:

Larkyns held her in his arms and kissed and caressed her. Larkyns went for a doctor and brought him to her house. He then went out again. Presently Mr. Larkyns came back to the house, went to Mrs. Muybridge's bed room, stooped over the bed, kissed Mrs. Muybridge and said: "Never mind, baby, it will soon be over." He meant Mrs. Muybridge by "baby." He then went away. He came back in three or four days after her confinement. That was on the 18th April, 1874. Mrs. Muybridge ordered me to bring the baby in for Mr. Larkyns to see. Mrs. M said, "Major, who is the baby like?" He smiled, and said, "You ought to know, Flo." She laughed, and made no answer. Three or four days after Mr. Larkyns was at the house, and said to me after he came out of Mrs. M's room: "Mrs. Smith, I want you to take good care of that baby. I hold you responsible, for I have got two babies now." I laughed, and spoke to Mrs. Muybridge, and said I did not understand this matter of the baby having two fathers. A negro was employed to carry letters from him to her. They wrote to each other two or three times a day. On one of his visits Larkyns was standing at her bedside, and she said: "Harry, we will
REMEMBER THE THIRTEENTH OF JULY:
We have something to show for it." She and Larkyns looked at the baby and smiled. Larkyns used frequently to be in her bed room and stay there for hours.[7]

The *Call* added another detail or two from Mrs. Smith's account:

[Mrs. Muybridge] said that Larkyns was going to take her to England as his wife. She said it was too bad to treat old Muybridge so, but she loved

Harry. Once Larkyns called in the afternoon while Mrs. Muybridge was still in bed. I went into the room, and she lay on the bed with the clothes down to her waist, and Larkyns sat on the bedside. (Much more of this kind of testimony is omitted, as unfit for publication.)[8]

The proverbial last straw, however, may have been something less sensational. Mrs. Smith went on to say that "Major Larkyns [I told Muybridge] sent his old shirts to your house to be repaired and done up. They were sent to the wash with yours, and the colored man who carried letters between him and Mrs. Muybridge came and took his shirts to him after they were washed, and your wife paid for the washing."[9]

With Flora in Oregon with the baby, Larkyns went off to Calistoga and beyond on a trip for the San Francisco *Stock Report*. He was to write an account of the burgeoning quicksilver mines in Napa and Sonoma Counties. He had scarcely arrived on the white-columned veranda of the Magnolia Hotel in Calistoga before he sat down to write Mrs. Smith. This was the first of the letters that the midwife showed Muybridge on that fateful October 16, three and a half months later:

> Dear Mrs. Smith:—You will be surprised to hear from me so soon after I left the city, but I have been so uneasy and worried about the poor girl that I cannot rest, and it is a relief to write about her. . . . If you hear anything of that little lady, no matter what, tell me right out. She may return to the city, and beg you not to let me know; but do not, pray do not, listen to her. Do not be afraid that I shall get angry with her. I will never say a harsh word to her and even if things turn out as badly as possible, and I find she has been deceiving me all along, I can only be grieved and sorry, but I can never be angry with her. . . . I have written to the morning and evening papers in Portland to-day, and advertised in the "personals", so—"Flora and Georgie:*—if you have a heart you will write to H. Have you forgotten that April night when we were both so pale?"
>
> She will understand this. . . . Mrs. Smith, I assure you, I am sick with anxiety and doubt, the whole thing is so incomprehensible, and I am so helpless. I fear my business will not let me go to Portland, and I see no other way of hearing of her. If an angel had come and told me she was false to me I would not have believed it. . . . I cannot help thinking of that speech of hers to you the day before she left, when she begged you not to think ill of her, whatever you might hear. It almost looks as if she had already settled some plan in her head that she knew you would disapprove of. And yet, Mrs. Smith, after all that has come and gone, *could* she be so utterly untrue to me—so horribly false? It seems impossible, and yet I

* "Georgie" was Florado, Larkyns' full name being George Harry Larkyns.

rack my brain to try and find some excuse, and cannot do it. If she **had** nothing to conceal why does she not write? . . . Mrs. Smith, again I beg you to be open and candid, and conceal nothing from me. . . .

Harry Larkyns[10]

Mrs. Smith immediately wrote Flora, telling her of Larkyns' concern for "that little lady," and on July 11 Flora replied. (It was with this letter that she enclosed the Bradley and Rulofson photograph of Florado with its damning inscription.)

Dear Sarah: Yours of the 3rd has just come to hand. I had begun to think you had all forgotten me. I received such a letter from H. L., saying that he heard that I had not gone any farther than Portland. I was so provoked that I wrote a letter and sent it to the Geysers, and which, if he receives it, will not make him very happy. He ought to know me better than to accuse me of such a thing, but I may forgive him. Don't forget to tell him, if he wrote me at Portland, to send and get the letter, as it might be advertised and sent for by someone else. . . . She or any one else may talk about Harry all they please. I am not ashamed to say I love him better than any one else upon this earth, and no one can change my mind, unless with his own lips he tells me that he does not care for me any more. . . . I don't want Harry to come up here, much as I would like to see him, for this is a small place, and people can't hold their tongues.

Mrs. Muybridge

Destroy my letters after reading them, for you might lose one, and it might get picked up.[11]

The morning after he had seen these letters and "Little Harry's" photograph at Mrs. Smith's, Muybridge returned to her house. Mrs. Smith now told him of another little billet-doux: "I was sent . . . with a letter to Major Larkyns, who said to me, 'Why don't the old man go out on the railroad and take pictures?' I said, 'You had better look out,' and he laughed and said: 'Flora and I have fooled the old man so long that we can keep it up still longer.' "[12]

Muybridge then visited the gallery of the San Francisco Art Association, and seemed quite unperturbed to a friend he met there. Later he went to Bradley and Rulofson's. There it was a different story. Rulofson reported:

[I] saw him in elevator of my office on 17th. He was white as marble, and his lips compressed; asked him what was the matter; his answer was a convulsive shake; believe he had gone mad; was afraid of him; told boy to let elevator go up. Reaching the landing of the gallery, I said, "Come, I want to speak to you." He ran round three times, as though changing

his mind as to which door he would go out at. We went into a vacant room; tears and perspiration streamed down his face; he could not speak; asked him what the trouble was; said he, "My poor wife, what will become of her? Make me a promise to settle my business with my wife the same as with me. . . ." He said he had no thought of suicide, it was his honor he wanted to vindicate, and in doing so he might lose his life. I argued with him near an hour, refusing to let him go till he told me what the trouble was; he assured me he was cool, looked at his watch and tore me from the door and went out. Followed and laid hands on him, and he agreed to tell me, and said again he could not tell me, but would do the best to vindicate his name if he died in the attempt. He then told me what was the matter. I tried to talk again against time, as I knew the boat left at 4 o'clock, and he had said that Larkyns was at Calistoga. He looked at his watch; said time was up and tore away from me, as he did before; it was 4 minutes to 4 o'clock P.M. when he left me; my office is 10 minutes walk for me, 12 blocks from boat; my watch was very near city time.[13]

Muybridge made the four o'clock ferry, and arrived at Vallejo in time to catch the evening train up Napa Valley to its terminus at Calistoga, where he had heard Larkyns was staying. But when he arrived in Calistoga he discovered that Larkyns was not there. He ran into W. A. Stuart from the nearby Yellow Jacket ranch. Stuart knew that Larkyns was at the Yellow Jacket but said nothing to Muybridge about it. Instead, seeing at once that trouble was on the way, he started out for the Yellow Jacket to warn Larkyns.

Muybridge then went to a livery stable to hire a rig to take him to Pine Flat, where he now believed Larkyns to be. But the liveryman told him that Larkyns was much nearer—at the Yellow Jacket. Muybridge was without a coat, so he threw a buggy robe over his shoulders and started off. The driver, G. W. Wolf, later testified that as they were driving through the night Muybridge asked him if it would frighten the horses if he fired a pistol. Wolf said no, so Muybridge fired the pistol. "He did not know but what it might be fouled."[14] Muybridge then asked Wolf if he had ever been stopped on the road by robbers, and when Wolf said no, Muybridge said that *he* had. Wolf testified later that Muybridge told him that he would give Larkyns "a reception . . . that will surprise him."

The trip to the Yellow Jacket ranch house took about an hour and twenty minutes that Saturday night in 1874. Northwest over the ridge that separates Napa and Sonoma counties, down the far slope, past Foss Station—and to Knight's Valley ranch house. There Muybridge inquired if Larkyns was indeed at the Yellow Jacket and was told that he was. He turned up the slope the two miles to the ranch house (Fig. 71) and stopped outside the kitchen

door. He strode to the door, knocked so that he could be heard above the murmur of voices inside, and waited for a reply.

It was not long in coming. Although Stuart had arrived and had warned them that Muybridge was looking for Larkyns, one of the company, C. H. McCram, came to the door and asked who it was and what he wanted. "My name is Muybridge," he was told, "I wanted to see Major Larkyns." McCram returned to the parlor, where Larkyns was playing cards with some ladies. He told Larkyns of his visitor. Larkyns got up from the table, went through the kitchen to the open door, and asked who it was that wanted to see him. "I can't see you," he said, and Muybridge replied, "Step out here and you can see me." Larkyns stepped outside the door in time to hear the following announcement: "My name is Muybridge and I have a message for you from my wife." A shot from a Smith & Wesson No. 2 followed. Larkyns, mortally wounded, staggered through the house and out through the back door to a giant live oak that grew just outside (Fig. 72). He fell and was dead within twenty seconds.

Muybridge followed him into the house, apologized to the ladies for the fuss, and was met by a James M. McArthur, who had been asleep in one of the two small rooms at the southern part of the house. McArthur disarmed him. Muybridge then sat down in the parlor, according to one reporter, and began to read a newspaper. Others were outside by the tree with Larkyns and decided to bring him in. A doctor was sent for and Muybridge lent his buggy for the purpose. Dr. S. J. Reid of Calistoga arrived at about one o'clock and pronounced Larkyns dead.

Muybridge was placed in the back seat of a wagon with two others in the front. His feet were tied. Arriving in Calistoga, he was placed in custody at the Magnolia Hotel, there to await transportation on Monday to Napa, the county seat, and indictment and trial.

Larkyns' mortal remains, meanwhile, were taken back to San Francisco, and laid in state in a rosewood casket with silver-plated screws and handles at Lockhart and Porter's undertaking establishment at 39 Third Street. The body was dressed in the business suit Larkyns wore when he left the city. There were bruises on the face and blood on the shirt front, caused by a bullethole about an inch from the left nipple.

Not everyone was sad to see Larkyns dead. One man was heard to drink to the "special Providence" that killed him. He hoped that Larkyns had had no time for repentance, "so that his soul is now in hell."[15] Later, when challenged to a duel by one of Larkyns' friends, he softened his polemic. Another citizen, known as Cuspidor Coppinger, also had little affection for Larkyns.

Larkyns is said to have lost his *Post* job because of Coppinger, with the result that every time he saw him he seized Coppinger's nose and jaw, forced his mouth open, and spit into it. Thus the nickname.

Larkyns' funeral was elaborate, with the choir singing the deceased's favorite hymn—"Flee as a Bird to the Mountains." A "well-known actress of the California Theatre" leapt from her seat, sobbing violently, and placed a bouquet on the coffin. A final eulogy called Larkyns "a gentleman in the finest sense of the word."[16] His body was placed in a vault at the Masonic Cemetery and later buried, probably at Woodlawn, down on the Peninsula.

Meanwhile, the day before, Muybridge had been taken down to Napa

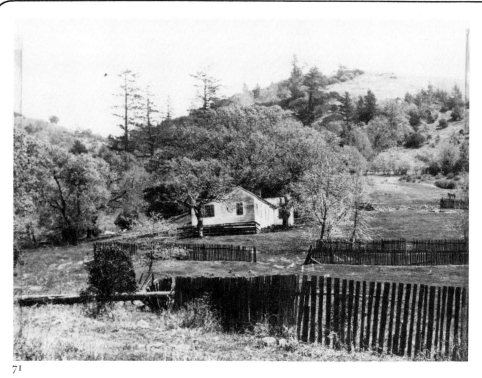

71

Fig. 71. The Yellow Jacket ranch house, near Calistoga, Napa County, California. Early twentieth century. Courtesy LeRoy Krusi. The porch and the rear addition were not present at the time of the murder in 1874.

Fig. 72. Floor plan of the Yellow Jacket ranch house. From *The Napa Reporter,* October 24, 1874. Accounts of the events of October 17, 1874, are sometimes inconsistent with this plan, which is, nevertheless, probably accurate.

E—Door into kitchen; D R—Diningroom; B R—Bedrooms; P—Parlor; O—Door Larkyns fled through to " oak-tree where he fell.

and placed in jail. There he paid his own board, meals being sent in from a hotel across the street. He was given books, papers, and writing materials. A reporter from the *Chronicle,* who was first refused an interview, finally got one the second week of December. His published account changed some of the details of Mrs. Muybridge's association with Larkyns:

[Muybridge] met the reporter in the corridor of the jail with an air of cheerfulness and cordiality. Confinement and care had made him paler than usual, but he appeared to be in good health and excellent spirits. Muybridge is forty years of age, but looks at least ten years older than that. His full, unkempt beard is deeply tinged with gray, and his hair is white. He has mild blue eyes, and a face which a physiognomist would invariably pass by in searching for one likely to do deeds of violence or death. His manner is quiet and reserved, his dress plain to a degree somewhat out of keeping with his profession and standing, and any one unacquainted with him would readily mistake him for a quiet, good-natured old farmer, contentedly earning a comfortable living by the labor of his hands. . . .

He said: "I am quite comfortably situated here. I have one of the best cells in the prison, and have books, papers and writing materials. in plenty. . . . My meals are sent to me from a hotel, and I have everything I want to eat. . . . My health is excellent, I eat heartily, sleep soundly, and am in as good spirits as I imagine it is possible for a man to be while deprived of liberty and with such a charge resting upon him. . . .

I have received a great many letters—piles of them—expressing sympathy. . . . Some of them come from people I do not know. I have received many offers of assistance, in several cases from influential and wealthy men in San Francisco with whom I had previous no personal acquaintance. One of them was in here yesterday and offered to go my bail bond for all he was worth, and to procure others to bail me for $100,000 if I would make the application; but my counsel has advised me to make no application. . . . I am satisfied that I have not lost one friend by my action and I know that I have gained some. There were some misstatements regarding myself. . . . For instance, it was stated that I was in the employ of Bradley & Rulofson. I was attached to their establishment, but was conducting my branch of the business on my own account. . . .

[My wife] told me that the trouble between her and Stone was inequality of age—she is now but twenty-three—incompatibility of temper and cruel treatment of her by him and his mother. I never before this affair knew or heard anything against her chastity. I loved the woman with all my heart and soul, and the revelation of her infidelity was a cruel, prostrating blow to me, shattering my idol and blighting the bright affection of my life. I have no fear of the result of my trial. I feel that I was justified in what I did, and that all right-minded people will justify my action. I

am ready and anxious to be tried to-morrow, if possible. There will be no appeal for delay in my case, I assure you.[17]

To say that "all right-thinking men would endorse his conduct," *The Sacramento Bee* commented on December 29, "is a severe rebuke to those who do not believe in murdering those who offend them."

Flora had returned from Portland about December 4, a few days before her husband was indicted for murder. Three days later she filed for divorce in San Francisco's Nineteenth District Court.

Her case was remarkable—to say the least. Flora charged her husband with infidelity, and alleged that he was otherwise cruel: he looked at her in bed to see that she was there—checking up on her, she said. But the judge "was of the opinion that a husband had a perfect right to look upon his wife when she is asleep, and that such an act could not be construed to be cruelty."[18] Flora was denied alimony, although she told the judge that she had been true to her husband. "We hope that she may prove her case," *The Calistoga Free Press* commented, "but the present outlook is very dark for her."[19]

Darker it was than this reporter imagined. Flora tried again for alimony late in March 1875, testifying that Muybridge made $400 to $600 a month. But she soon fell ill, and died on July 18, 1875, leaving Florado with a French family in San Francisco's Mission District, who soon placed him in the Protestant Orphan Asylum (Fig. 73).* "Poor Flora is a-cold," *The Daily Alta California* reported. She had lingered at St. Mary's Hospital for two weeks, suffering from paralysis, "when death released her from a life that must at least have been a regret."[20]

Muybridge, meanwhile, had come to trial on February 2, 1875. His attorneys were the up-and-coming politician W. W. Pendegast of Napa, and Cameron H. King and E. S. Gottschalk of San Francisco. It has been said that Leland Stanford paid the attorneys' fees, but this has not been substantiated, and it seems unlikely that such an upright member of the community would get involved in a scandal of this kind. The prosecution was conducted by the Napa County district attorney, D. Spencer, and T. P. Stone, a county

* Florado stayed at the Orphan Asylum until he was nine, when he was apprenticed to a harness-maker on the Haggin Grant near Sacramento. He was a gardener-laborer for the rest of his life, evidently well liked by all who knew him (Figs. 74 and 75). Flodie, as he was called, carried an Ingersoll watch, keeping an elaborate gold one at home. He said that his father, the famous Eadweard Muybridge, had given it to him. It is sad to relate that the serial number of the watch indicates that it was not manufactured until some years after Muybridge's death. Florado Helios Muybridge died on February 2, 1944, as the result of an auto accident in Sacramento, where he had lived for some years.

73

74

75

Fig. 73. The Protestant Orphan Asylum, San Francisco. *Ca.* 1873. Half of a stereograph by Muybridge. The Bancroft Library, University of California, Berkeley. Florado Muybridge was placed here in 1875 and left in time for Christmas 1884, when he was about the age of the boys in the picture.

Fig. 74. Florado Muybridge at about sixty-five years of age. Gift of Frank Tietjen.

Fig. 75. Florado Muybridge at about sixty-five years of age. Gift of Frank Tietjen.

judge. Everyone said from the beginning that the prosecution had little chance to make their case against such a brilliant array of defense attorneys. Judge W. F. Wallace of the Seventh District Court presided.

The circumstances of the murder, according to various witnesses, and the character and *vitae* of the principal participants in the tragedy were

discussed in detail during the three days of the trial. Most of this has been referred to already. Muybridge was "cool and collected," the *Post* reported, and, after pleading not guilty, turned to the sheriff and said "with a quiet laugh, 'To kill a man and yet plead not guilty.' "[21] After a fair amount of difficulty, the jury, "mostly old men, gray headed and hard fisted,"[22] was chosen. A number had their own ideas about justifiable homicide as it turned out, but none was making these sentiments clear at the moment.

The defense witnesses tried to make a case for temporary insanity, citing the 1860 stagecoach accident and what they considered to be two instances of Muybridge's erratic behavior—his sitting on the edge of Contemplation Rock in Yosemite (Fig. 54) and his canceling of Judge Crocker's bill when Crocker demurred about it. They also thought it extraordinary that Muybridge would not take photographing jobs that did not appeal to him. Notwithstanding this testimony, the defense did not plead insanity. They pointed to Muybridge's mental stress instead, and suggested that what he did was normal, and that many others would—and, it was inferred, should—have done the same in similar circumstances.

"His whole life was blasted," Pendegast said in his summation.[23]

The jury retired at 10:30 p.m. on February 5 and returned to the courtroom at about noon the following day. They had had quite a night. One romantic account states that there was one holdout, but he was brought to heel when someone pointed out that at that very moment another man might be with his wife as Larkyns had been with Muybridge's.[24] Whatever they thought, the jury brought in a verdict of not guilty, and Muybridge was acquitted. It was the last time in California that an acknowledged murderer was acquitted without an insanity plea.

Now Muybridge's composure left him. His behavior—and the newspaper account of it—were straight from a dime novel:

> At the sound of the last momentous words a convulsive gasp escaped the prisoner's lips, and he sank forward from his chair. The mental and nervous tension that had sustained him for days of uncertain fate was removed in an instant, and he became as helpless as a new-born babe. Mr. Pendegast caught him in his arms and thus prevented his falling to the floor, but his body was limp as a wet cloth. His emotion became convulsive and frightful. His eyes were glassy, his jaws set and his face livid. The veins of his hands and forehead swelled out like whipcord. He moaned and wept convulsively but uttered no word of pain or rejoicing. Such
>
> A DISPLAY OF OVERPOWERING EMOTION
>
> has seldom, if ever, been witnessed in a Court of justice. . . . He rocked to and fro in his chair. His face was absolutely horrifying in its contortions as

convulsion succeeded convulsion. The Judge discharged the jury and hastily left the Court-room, unable to bear the sight and it became necessary to recall him subsequently to finish the proceedings. The Clerk hid his face in his handkerchief. Mr. Johnston and the Prosecuting-Attorney were compelled to leave the room, and some of the jurors hurried away to avoid the spectacle. Others gathered around to calm the prisoner, and all of them were moved to tears. Pendegast begged Muybridge to control himself and thank the jurymen for their verdict. He arose to his feet, and tried to speak out but sank back in another convulsion. He was carried out of the room by Pendegast and laid on a lounge in the latter's office. Dr. Boynton was sent for, and soon arrived, but could do little for the man. Mr. Johnston finally said, sternly, "Muybridge, I sympathize with you, but this exhibition of emotion is extremely painful to me, and for my sake alone I wish you to desist." Muybridge suddenly straightened his form and said, "I will, sir; I will be calm, I am calm now," and then his emotion subsided, so that in a quarter of an hour he was able to go upon the street.[25]

Outside Muybridge was met by a crowd that applauded him vociferously. Never before had there been such excitement in the streets of Napa. After lunch, Muybridge took the 5 p.m. train back to San Francisco. There he mingled freely with his friends, talking about his recent harrowing experience. He also set about immediately to make plans for a photographic survey of Central America, a project that had been under discussion with the Pacific Mail Steamship Company the previous summer, but which had been delayed by the murder and trial.

5

Central America

On the evening of February 27, 1875, the *Montana** slipped her moorings at the foot of Vallejo Street and moved into the stream. Deep within her hold were several large cases bearing the legend "Bradley & Rulofson," brought on board the day before. As she left the harbor the engines slowed and a longboat came alongside. One of the boat's two occupants went aboard the *Montana,* which continued on her way. Muybridge had escaped from the long arm of the divorce-court law.

Negotiations with the Pacific Mail Steamship Company for photographs of the Guatemala coffee industry had begun shortly after the first of the previous year. Photography would have had to wait until the rainy season ended in October, but when October came, plans for the trip were cut short by the steel bars of the Napa County jail. Now, with the jail doors swung wide, Muybridge was off. Flora's divorce action threatened to attach his precious photographic apparatus, and he had had to get it on board secretly.

Panama, in 1875, was still a part of Colombia, which Mosquera, Bolívar's aide-de-camp, had woven into a loose federation of separate states. By now, with the building of the trans-Panama railroad, the cross-Guatemala route for East-West trade had become unpopular, and Guatemala was seeking a revival of prosperity through a rejuvenation of its coffee industry. Panama City, on the Pacific end of the trans-Panama route, was a city of whitewashed brick and adobe, cast-iron ornamentation, and streets alternately flooded or bone dry, through which a population of fifteen thousand Negroes, Indians, mulattoes, and Chinese moved lethargically in one of the most depressed economies in the West. "The desolation," a Canadian traveler wrote, "was simply awful," and the Grand Hotel, where Muybridge probably stayed, "malodorous in many ways."

Readers of *The Panama Star* of March 16, judging from the lethargy that greeted the later appeal for subscriptions, must have scarcely stirred from their siestas to learn that the photographer had arrived:

> We are pleased to welcome to this city Mr. Muybridge, so well known in the art world for the celebrated photographs he has taken of almost every place in California that offered a striking and picturesque landscape. . . . The artistic excellence of the Photographic views of American landscapes as taken by Mr. Muybridge have never been surpassed anywhere. It is

* On March 16 *The Panama Star* reported that Muybridge had just arrived in the city. The *Montana* left San Francisco on February 27, and the only other Panama steamers, the *Granada* and the *Colima,* left on February 11 and March 9 respectively. February 11 was too early and March 9 too late.

gratifying to know that he comes here now to illustrate by views all the curious places that a traveler by the Railroad and the Pacific Mail Company's ships can see or be within reach of in a journey from New York to San Francisco, *via* the Isthmus. We have no doubt Mr. Muybridge will find around Panama many views worthy of his peculiar photographic talent, and which will command a prominent place among the extra-tropical landscapes with which he has already enriched art galleries and expensive illustrated publications in the United States.

In the next several weeks the photographer visited many places within the city and its environs, taking photograph after photograph of local scenes, many remarkable for their technical excellence and nice discrimination of moment, viewpoint, and subject matter. "The ruins," Bayard Taylor had written, "would ravish the eye": the Church of San Felipe, whose "majestic arches spanning the nave are laden with a wilderness of shrubbery and wild vines which fall like a fringe to the very floor"; the ancient walls, once so splendid that it was said that when the king of Spain, looking westward from his palace in Seville, was asked what he was looking at, he replied, "I am looking for the walls of Panama, for they have cost enough to be seen from here"; the Church of San Francisco and its convent, a theater in 1875, where three years later Sarah Bernhardt was to be sent into hysterics by firecrackers set off in her honor in the middle of a performance; Old Panama, with its magnificent savannahs and 350-year-old stone bridge in the midst of virgin forest. In Old Panama Muybridge had to clear away dense jungle growth before he could take pictures.

After six weeks he caught the steamer for Guatemala:

> MR. MUYBRIDGE, the celebrated photographic artist from San Francisco, who has been here for some time back and has made a large collection of negatives of all the buildings, old castles, and picturesque spots to be found in this part of the Isthmus between Aspinwall and Panama, will take his departure today in the steamship *Honduras* for Guatemala. ...We...congratulate all Central Americans, that in Mr. Muybridge they have an artist who will do for their interesting section of America what has never been so well done for it before, either by pen or pencil, in making its beauty known especially to those who will never see them otherwise.... We heartily recommend him to our friends and to all lovers of Art, official or private, in any part of Central America to which he may be able to carry his photographic apparatus, his talents, commendable, social as well as artistic, qualities.[1]

The *Honduras* visited a succession of ports on its trip north: Puntarenas (Costa Rica), Corinto (Nicaragua), Amapala (Honduras), La Unión, La

Libertad, and Acajutla (San Salvador)—all of which were photographed. It finally reached the small port of San José de Guatemala, where the overland trip to Guatemala City, the capital, began. By coincidence an English traveler (with the improbable name of Whetham Boddam-Whetham) arrived in San José from San Francisco at about the same time as Muybridge, and his account of his seventy-mile trip in Central America gives an idea of its arduousness. San José, the Englishman thought, "had no interest except the painful one of being the spot where a drunken commandante had the audacity to imprison and flog a British consul a few years ago."[2] But the trip overland was another matter:

> At one moment one's waggon was up to the axle-tree in deep ruts, at the next jolting over great rocks and stumps of trees . . . bright creepers ran over the road. . . . Here and there an open thatched hut peeped out from a group of banana and orange trees; picturesque enough by itself, but marred by the untidiness and unwashed appearance of its occupants.

Through the state of Escuintla, up the slope of the Sierra Madre, through the village of Palin to the shores of Lake Amatitlán Muybridge went, taking pictures all the way.

In Guatemala City Muybridge climbed the heights of the Cerro del Carmen to take his splendid panorama of the capital and its environs and tramped about the dusty downtown streets to give us a variety of views. Most of the great religious orders had been expelled, and everywhere there were religious buildings occupied by government offices. New civic buildings had appeared, including a remarkable theater that became the subject of a photograph.

Out on the Cerro del Carmen Muybridge could see the ancient city of Antigua and the great volcanoes that rise above it. These monsters had erupted in the previous century, shaking the earth so violently that the government had moved its seat to the firm heights of the plateau. The way to Antigua itself lay over an excellent coach road, and Muybridge was soon on his way. Aldous Huxley found Antigua "one of the most romantic towns in the world . . . everything . . . that is picturesque and romantic in the most extravagantly eighteenth-century style. . . . Piranesis confront you at every corner. . . . It is a thousand pities that his pilgrimage never took Childe Harold as far as Guatemala."[3]

In 1875 Muybridge found Antigua and Guatemala City as fascinating as Huxley would sixty years later. Leaving the city, he traveled south again into the northern tip of Escuintla before turning westward through Naranjo.

Fig. 76. Reception of the Artist by the Jefe Politico—Mazatenango, Guatemala. 1875. The Museum of Modern Art, New York, New York. Muybridge is in the right foreground. He evidently composed the photograph and someone else released the shutter.

In Naranjo or nearby he collected additional photographs before turning north to Lake Atitlán. Solólá and Panajachel lay near Atitlán's northern shore, and the tortuous paths to these villages produced new photographs. By now Muybridge had transferred his heavy equipment to the backs of "well-fed ambling mules," as he recalled years later in retirement.[4] He had high praise for the animal that had become so important to the comfort and economy of Spanish America. He recalled that the amble was a very enjoyable way of riding, and remembered that many times he slept while being carried along.

But now the trip's *raison d'être* was at hand—the great coffee plantations of San Mateos, Las Nubes, and San Felipe. The coffee industry had been in the doldrums since the rise of cochineal, but cochineal was having competition problems of its own and President Berrios decided to reactivate coffee.* The government had granted sweeping privileges to new entrepreneurs, as well as to established plantation owners, and the industry was on its way. It was perhaps the hope of attracting new investments that had persuaded the Pacific Mail Steamship Company, which enjoyed a virtual monopoly in the trade, to commission Muybridge to photograph points of interest in Central America.

At Champerico on the coast Muybridge caught the *Honduras* for the trip back to San José and the trip overland again to the capital. The details

* Cochineal is a red dye made from the bodies of insects that feed on cactus. They were formerly thought to be the seed of the cactus. Cochineal and indigo, Huxley wrote, "were killed by William Perkin and the German chemists" (*op. cit.*).

of this itinerary, as well as of the remainder of the trip, can be reconstructed by an analysis of the negative numbers of his photographs.*

Back in Guatemala City on October 1, he offered the fruits of his labors and got several subscriptions:

ANNOUNCEMENT . . .

I have been occupied during the last seven months in taking photographic views of this Republic; I have the pleasure of informing you that I have formed a collection which includes the most notable public buildings, the most picturesque localities, and the most natural scenes of cultivation of agricultural products.

All this is due to the Pacific Steamship Company which has assumed the costs of this venture for the purpose of making the riches and beauty of this interesting land known abroad.

Through the expenditures of the aforementioned Company as well as the cooperation of the Supreme Government of Guatemala to complete it, I am enabled to offer to the public the said views for half of what they would cost otherwise.

Eduardo Santiago Muybridge†

On October 17 Muybridge again took the road for a two-week trip, and was back in Panama City by the first of November. Again the *Star* announced his arrival and urged the purchase of views:

Mr. E. S. [*sic*] Muybridge, well known in Panama, where he was daily seen a few months ago in the streets and about the walls of the city, with his apparatus for taking photographic landscapes and views, has again returned to this place. Since he left us Mr. Muybridge has made the tour of the Republic of Guatemala during which time he has taken 400 pictures of all that is to be seen remarkable in that country. The most interesting of Mr. Muybridge's labors in this way is perhaps a series of 20 views illustrative of the cultivation of coffee in all its stages from the time the forest is cleared

* It is possible, but not likely, that the Guatemala trip was reversed—that Muybridge disembarked at Champerico, traveled to Guatemala City, San José, back to Panama, and later numbered his negatives from south to north. But the Boston Athenaeum albums, belonging to a Guatemala subscriber, Captain S. V. Storm, show places such as Sololá with numbers preceding the Las Nubes numbers. This suggests that the trip through Guatemala occurred as I have described it—Panama, San José, Guatemala City, the northern coffee plantations, Champerico, and back again to Guatemala City by coastwise steamer and via San José.

† This text, originally in Spanish and translated by Dorothy McCurry, is from Muybridge's clippings scrapbook in the Kingston Library. Investigation in Guatemala has unearthed none of the albums that may have remained there, although Captain S. V. Storm's albums found their way—the Athenaeum does not know how—into the Boston Athenaeum. One of the local contacts, Teo. A. Whitney, was apparently the "Administrator Whitney" of one of the Las Nubes plantations. Another, José Serigiers, was the owner of the hacienda in negative 4360.

away to receive the seed, all along until the crop is ready to be embarked. Those who take an interest in the fine arts and at the same time wish to obtain a series of views . . . can see the specimen pictures, and order the number they desire, which will be sent from San Francisco, where they will be printed under the superintendence of Mr. Muybridge, which is itself a guarantee that they will be the finest specimens of the kind that can be produced by photography.[5]

Early in November, *The Panama Star* reported that Muybridge planned to visit Taboga, an island in the bay:

Having exhausted Panama, Mr. Muybridge will proceed to Taboga, to add to his collection the many striking and picturesque scenes with which that island abounds, and especially in connection with the buildings which yet remain in the Morro, the site of the works of the Pacific Steam Navigation Company before they were removed to their present location, at Callao. On the morning of the 5th instant, Mr. Muybridge took a magnificent picture of the National troops and their officers in the Cathedral Plaza.[6]

The report that Muybridge photographed the troops in the Panama City plaza creates a problem. A photograph showing Muybridge standing before what appear to be "the National troops and their officers in the Cathedral Plaza" is numbered 4262, which places it at the beginning of the trip (Fig. 77). It was obviously an important occasion, not likely to have been staged twice, though local officials elsewhere regularly made special arrangements for Muybridge.

Before leaving Central America, Muybridge piled his apparatus on board the cars of the Panama Railroad and traveled to the Atlantic mouth of the Chagres River, the eastern terminal for trans-Panama trade. There he took photographs of the river explored by Columbus on his fourth voyage, and the adjacent town of Aspinwall. He also photographed the two-hundred-year-old castle of the pirate Henry Morgan.

On November 10 he boarded the *Constitution* for home.* He arrived in San Francisco on November 27 and immediately began the task of processing and mounting prints and binding them into albums. We know that by the end of the year he had gotten subscriptions from San Franciscans, since the title page of one of the albums is dated 1876 (Fig. 78). And by the end of the year he had made lantern slides of some of his Central America photographs, for the *Bulletin* of January 4, 1876, announced a lantern exhibition for the January 7 meeting of the Photographic Art Society of the Pacific, and

* It was probably the *Constitution*, since both the *Granada* and the *City of Panama* left in December.

86

77

78

Fig. 77. *Reception of the Artist—Panama.* 1875. The Museum of Modern Art, New York, New York. Muybridge is in the left foreground.

Fig. 78. Photomontage used as the title page of Muybridge's Central America albums. 1876. The Museum of Modern Art, New York, New York. Muybridge is at the right, above the "Morse's Palace of Art" logo, surrounded by his Central America photographs.

80

81

82

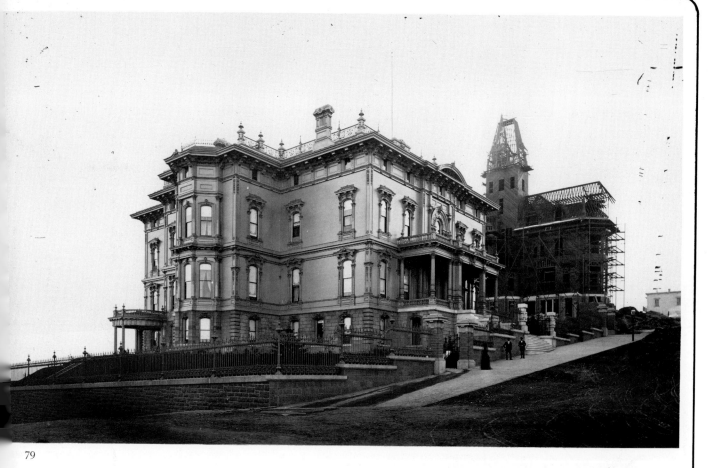

79

83

Fig. 79. The Leland Stanford house at the southwest corner of California and Powell Streets, San Francisco. 1876. Photograph by Muybridge. Stanford University archives, Stanford, California. Only the granite retaining wall remains of this building, which was newly completed at the time of this photograph, and which was destroyed in the 1906 earthquake and fire. The Mark Hopkins house is under construction at the right rear.

Fig. 80. The Pompeian Room in the Stanford house. 1876? Photograph by Muybridge. The San Francisco Public Library.

Fig. 81. Another view of the Pompeian Room in the Stanford house. 1876? Photograph by Muybridge. The San Francisco Public Library.

Fig. 82. Mrs. Stanford's bedroom in the Stanford house. 1876? Photograph by Muybridge. The San Francisco Public Library. It was in this room one evening early in 1905 that Mrs. Stanford drank a glass of mineral water that was later found to have contained strychnine. Although it was said to have been an accident (!), Mrs. Stanford fled to Hawaii, where she died the following year,

apparently, in spite of popular opinion to the contrary, from the effects of old age—not poison.

Fig. 83. The architect's drawing of the Mark Hopkins house on the southeast corner of California and Mason Streets, San Francisco. 1876? Photograph by Muybridge. The California Historical Society, San Francisco. The Mark Hopkins Hotel now stands on this spot, immediately west of the Stanford Court Apartments, where the Stanford house stood.

described it later: "The most interesting feature of the meeting was an exhibition by means of an oxy-hydrogen lantern of photographs taken at Panama, Alaska, Yosemite and elsewhere."[7]

Muybridge, although he sent his pictures to the meeting, was not there himself: "The Secretary was instructed to send an invitation to Mr. Muybridge to attend the next meeting, and that any contribution on his part would be thankfully received."[8]

Muybridge now decided not to return to his former association with Bradley and Rulofson. He set up shop for himself at 618 and 620 Clay Street. This was the address of his old friend Henry W. Bradley, who had also quit Bradley and Rulofson, leaving only his name behind. The 1876 directory, canvassed by May 1, lists Muybridge at 613 Pine Street, the address of the Art Association. The 1877 directory lists him in business at 618 Clay, but with no home address. In his new location Muybridge offered the Central America photographs, 120 for a hundred dollars in gold.[9]

Stanford partisans, who never forgave Muybridge for taking so much credit for inventing the motion picture, have claimed that the Pacific Mail Steamship Company did not commission the Central America trip, but that Muybridge wanted to go, and said that he had been commissioned so that he could avoid paying his own expenses. They also claim that the photographer threatened to sue the steamship company for reneging on the deal. "He attempted to coerce the Pacific Mail S. S. Co. to buy the book from him," a former director of the Stanford Museum wrote, "on the basis of a purported contract . . . he threatened suit but the proof was too conclusive."[10]

In his December 21, 1874, interview with the *Chronicle* reporter, Muybridge had announced this commission publicly, and the steamship company did not contradict his statement. It is also significant that when he left San Francisco, the *Montana,* already under way, slowed down to take him aboard, suggesting official sponsorship. The Stanford protagonists were evidently unaware that the photographer's reputation would have made such a commission perfectly natural.

In May Muybridge gave a selection of the Central America photographs to Mrs. W. W. Pendegast, whose husband, the photographer's defense attorney, had died on February 29. His note to the widow set a seal upon that dolorous memory:

My Dear Madam.
 Your kind note afforded me much happiness in its perusal, although I feel I am entirely undeserving of the thanks you so kindly proffer me.
 It is I who should and do thank you for permitting me to offer you so

slight an acknowledgement of my lasting appreciation of the noble and disinterested generosity shewn me by your late husband when I bowed down by grief and crushed with broken pride so sadly needed the support and friendship I received from him. To my dying day I shall ever cherish his memory as that of the best and dearest friend I ever had. . . .[11]

The use of the word "disinterested" supports the idea that no one—not even Leland Stanford—had paid Muybridge's attorneys' fees during his murder trial. His was a *cause célèbre,* and a lawyer seeking fame might well have seized eagerly on such a brief without charging a fee.

In the Photographic Section of the Philadelphia Centennial Exposition, which opened on May 10, 1876, Bradley and Rulofson exhibited a number of Muybridge's Yosemite photographs to considerable critical praise. And in San Francisco, at the Mechanics' Institute Fair the following month, the first public view of the Central America photographs occurred.

Sometime before the end of the year 1876, to accord with his celebrity, Muybridge sat for a portrait by Benoni Irwin, the eastern painter who was now visiting San Francisco. The portrait has not been found. At some point during the winter—the photographs were shown at the Art Association in February—he copied a number of Norton Bush paintings with felicitous results.

In July of the following year, 1877, Muybridge published the first of two versions of his magnificent panoramas of San Francisco, taken from the turret of Mrs. Mark Hopkins' still unfinished house at the top of the California Street hill (Figs. 83 and 84). The *Bulletin*'s announcement of July 13 seems to have been made by a reporter who had not yet seen the panorama: his one-line praise of it seems perfunctory: "As a picture of the city this is by far the best we have ever seen." Except for two or three conventional "bird's eye" views, there had scarcely been another true "picture of the city," so it was safe to say that this new one was the best yet. The following week the *Alta* had seen the panorama, and had high praise for both the photographer and the city that had inspired him: "[The city's topography had been over-looked] at least by people generally, until Mr. Muybridge discovered and utilized its artistic value. . . . Other States and cities may be greater and in many respects more attractive, but none can equal California and San Francisco in the panoramic scenic effect." The *Alta* article was reprinted in a flyer that Muybridge distributed in September 1877 to publicize his panorama. He published the eleven photographs in a cloth-covered folder, and in cabinet-sized prints of each of the eleven negatives that made up the panorama, and one containing all eleven, with a key at the bottom (Fig. 84).

Some time before the end of the year, probably late October or early

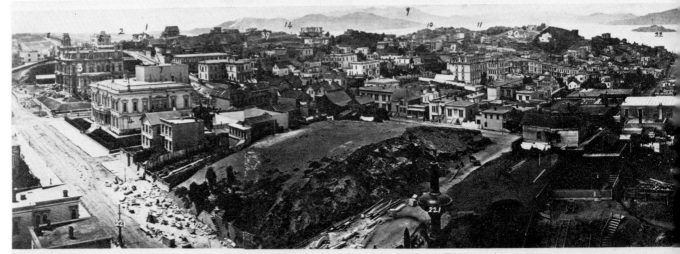

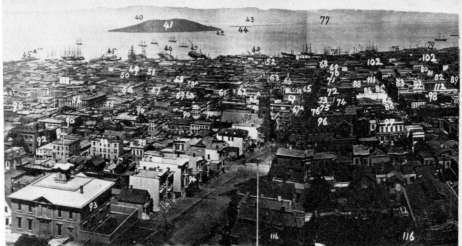

PANORAMA OF SAN FRANCIS[CO]

FROM

CALIFORNIA-STREET HILL.

KEY.

Edward J. MUYBRIDGE,

LANDSCAPE, MARINE, ARCHITECTURAL AND ENGINEERING

PHOTOGRAPHER.

OFFICIAL PHOTOGRAPHER GRAND PRIZE ME[DAL]
of the at the
U. S. GOVERNMENT. VIENNA EXHIBITI[ON]

Reproductions of Paintings, Drawings and Art Manufactures.

PHOTOGRAPHIC ILLUSTRATIONS

Of Alaska, California, Mexico, Central America and the Isthmus of P[anama]

Horses photographed while running or trotting at full speed.

MORSE'S GALLERY, 417 Montgomery [St.]

Copyright 1877, by Muybridge.

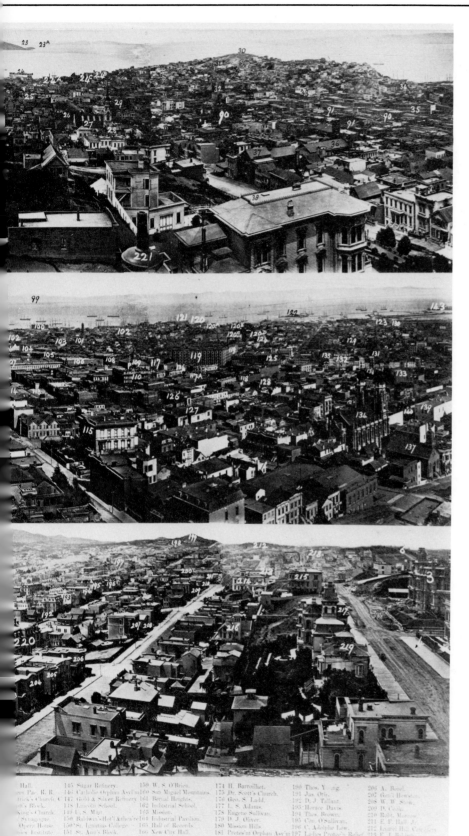

Fig. 84. The first *Panorama of San Francisco.* 1877. Photographs by Muybridge. The Library of Congress, Washington, D.C. The view in the top section ranges from west-northwest at the far left (looking west along California Street) to northeast at the right. The left-hand center section is to the east-northeast and east (with California Street going east in the middle of the picture), and the right-hand center section is to the southeast. The bottom section ranges from south at the left back to west at the right.

November, Muybridge again climbed to the Hopkins house turret and pro-
duced another series of negatives. His first panorama had consisted of eleven
photographs, each 8¼″ x 7⅜″, with an overall length of 7′ 6″; this new one
had thirteen panels, each 20½″ x 16″, with an overall length of 17′ 4″.
Both were sold through Morse at 417 Montgomery Street. The larger work
had a very limited sale: the only ones now known were gifts by the pho-
tographer to such friends as Mrs. Leland Stanford and Mrs. Mark Hopkins.

It has been said that the first panorama was shot on a Monday morning
early in January 1877. But the Monday morning idea seems to rest on no
more secure basis than the fact that someone has hung out a wash; and the
January idea on the angle of the sun, which is low in the south. But I have
been told by an authority on projections that even given precise longitude
and latitude the shadows are insufficient to pinpoint the time of year.
Even the time of day for the fifth panel from the left, the one containing
St. Mary's church, has been given—9:10 a.m. The church clock does show this
time of day, but it has not been established whether or not the clock was
working. A careful search of newspapers has failed to disclose the exact
progress of the construction of the Crocker or Hopkins houses, which might
be conclusive. The absence of any cable-car track on California Street is
academic: the track for this section of the road was still in the future when
Muybridge announced his work on July 13, 1877.

In the second panorama the track is down, making a date of late October
or early November 1877 likely—the track was nearly completed to its term-
inus on November 8. The track was begun at the engine house at the corner
of California and Larkin early in July, and was laid eastward. That panorama
number two was done before the end of the year is indicated by the "1877"
which Muybridge inscribed on the roof of the house four doors north of the
Stanford stable, on the east side of Powell between California and Sacramento
Streets. It was also done near the middle of the day: the chimney of the
Frederick MacCrellish house in panel 13 casts a shadow showing the sun just
before its zenith, and panel 14 just after.

Late in 1877 Muybridge gave another indication of his innovative spirit.
It was proposed that the city of San Jose photograph its public records in
preference to having them copied by hand, the usual procedure. Perhaps it
was the tiny print of the key in the cabinet photograph of the first panorama
that suggested to Muybridge that he could photograph almost microscopic
material. But in spite of strong local support for the project, including that
of *The San Jose Mercury,* the proposal was declined. The writing on the
corners of the pages, the Board of Supervisors said in their statement, was

almost obliterated, and would be quite indecipherable in a photograph. Further, the interlineations, smaller than the main text, would be too small to read if they were reduced to one-sixth their size, the reduction proposed by Muybridge. The cost was also too high—$5892.25 for 16,835 pages at 35¢ a page. They realized that the cost of copying by hand would be higher than that, but at least they would not have to pay for it in one lump sum.

6

Occident in Motion

But it was not the Central American pictures or the panoramas or the microfilm pioneering that brought Muybridge his greatest fame. It was the experiments described by the newspapers back in 1873, when it was announced that he had photographed Leland Stanford's horse Occident at a trot. In a letter written to the editors of the *Alta* on August 2, 1877, Muybridge described the results of further experiments in photographing the famous trotter:

> Editors Alta:
>
> When you did me the honor of asserting to Gov. Stanford your confidence in my ability to make a photograph of "Occident" while he was trotting at full speed—providing I could be induced to devote my attention to the subject—I will candidly admit that I was perfectly amazed at the boldness and originality of your proposition. Having, however, given my patient devotion to the task the Governor imposed on me, and instituted an exhaustive series of experiments with chemicals and apparatus, it affords me pleasure to submit to you a proof that your flattering confidence in the result of my endeavours was not altogether erroneous, and I herewith enclose you a photograph made from a negative which I believe to have been more rapidly executed than any ever made hitherto. The exposure was made while "Occident" was trotting past me at the rate of 2.27, accurately timed, or thirty-six feet in a second, about forty feet distant, the exposure of the negative being less than the one-thousandth part of a second. The length of the exposure can be pretty accurately determined by the fact that the whip in the driver's hand did not move the distance of its diameter. The picture has been retouched, as is customary at this time with all first-class photographic work, for the purpose of giving a better effect to the details. In every other respect the photograph is exactly as it was made in the camera.—I am, yours faithfully,
>
> Edward J. Muybridge

Five days later, Muybridge published in *The Spirit of the Times* the illustration described to the *Alta*, with the following caption:

> OCCIDENT
>
> Owned by Leland Stanford. Driven by Jas. Tennant. Photographed by Muybridge in less than one-thousandth part of a second, while the horse was trotting at the rate of thirty-six feet per second.[1]

The image that appeared in the magazine was a woodcut made by C. Wyttenbach from a combination painting and photograph recently found in the Stanford Museum at Palo Alto (Fig. 88). Muybridge's negative had evidently been projected onto canvas, an outline drawn, and the painting made by the

well-known San Francisco retouching artist John Koch.* The head of the driver is reproduced in a photograph, possibly by Muybridge, pasted on the canvas. It may have been that Muybridge's original photograph was taken so that Stanford could have a painting of his horse running. In other words, Stanford wanted a painting, hired Koch to paint it, and Muybridge took his photograph to help the artist with the painting.

This procedure is stated in so many words in *The Resources of California*:

> About three years ago Leland Stanford, President of the Central Pacific Railroad, desired to have painted a picture of his horse, "Occident," under full headway. Mr. Stanford being dissatisfied with all pictures he had ever seen of horses represented in motion, applied to the well known photographer, Muybridge, to make a photograph of the horse while in the act of trotting at full speed.
>
> The difficulties seemed to the artist insuperable, nevertheless he applied himself to the task with his accustomed acumen and perseverence, and in about a week produced a shadowy, indistinct kind of image, which only served as a proof to Mr. Stanford that his conjectures about the position which the legs of a horse assume when trotting were correct, and to the artist a conviction that he was upon the right track for ultimate success. . . .
>
> It is true, as Muybridge tells us, some portions of the picture have been retouched, to give prominence and a better effect of light and shade to various little matters of detail; but every essential part, even to the wheel, the particles of dust flying from the horse's hoof and the whip in the driver's hand, is perfect in its outline and marvellous in the absolute fidelity, as made by the unerring action of light when controlled by genius.[2]

The Resources of California, like other publications of the time, called the illustration a retouched photograph, and the *Post* reported that the retouching had been done by Koch. But it is a painting taken almost entirely from a photograph. Nevertheless, a number of people had seen the original photograph and thought it so remarkable that no one disputed the claim for successful photography, although some said it had been "gotten up."

When Muybridge's earlier photograph had been first announced in 1873, the *Alta*, the *Bulletin*, the *Chronicle*, and the *Post*, among San Francisco newspapers, simply noted its existence. Now the same papers were exuberant. The *Call* and the *Post* reported that the photograph had been taken in July 1877, and Muybridge himself stated in the *Examiner* of February 6, 1881, that it was a July 1877 negative. But this negative may have been simply his

* Koch, formerly of Addis and Koch, painted ivorytypes for William Shew as far back as 1867. By 1877 he was with Morse at 417 Montgomery Street.

photograph (Fig. 87) of the Koch-Muybridge collage. Whether the collage was based on new photographs of the horse in motion taken in 1877 or on the original—1872?—"shadowy, indistinct" image produced at the outset of the motion work is a mystery.

Everyone concerned—even the editors of *The Photographic News*—was satisfied that Occident had indeed been successfully photographed while trotting at full speed. Most important to Muybridge's work, however, and to the history of photography, Leland Stanford was sufficiently encouraged by the results to decide to underwrite further, greatly elaborated experiments. The *Alta* had reported that Stanford wanted photographs taken of a horse's movements "at all of its stages." Now it was full speed ahead:

> In our mention of the photographs taken by Muybridge of "Occident" at full speed we stated that it was the intention of Mr. Stanford to have a series of views taken to show the step at all its stages, so as to settle the controversy among horsemen about the question whether a fast trotter ever has all its feet in the air at once. Mr. Muybridge has now received his instructions, and will commence his work as soon as he can receive the needful lenses from London, and can have some machinery made here. "Occident" moves 20 feet at one stride, and Mr. Muybridge will have a dozen photographic cameras placed at intervals of 2 feet, making a total distance of 24 feet, a little more than a full stride. The shutters of these cameras will be opened and shut by electricity as the horse passes in front of each, the time of exposure being as before not more than the thousandth part of a second. The twelve pictures will be taken within two-thirds of a second, the time required for travelling 24 feet at a speed of 2.37. Each picture will be taken by a double lens, so as to be adapted for the stereoscope, and will thus furnish the most conclusive proof to connoisseurs that it is faithfully taken by photography and not materially changed by retouching.[3]

Muybridge would commence his work, the *Alta* announced, "as soon as he . . . can have some machinery made here." The questions as to who made this machinery, when it was made, and how important its design was to the ensuing success of Muybridge's work have been points of controversy ever since. There seems to be no doubt that Stanford told Muybridge what he wanted done—that is, photographs taken of moving horses—and that Muybridge decided he would have to set up a dozen fast shutters in front of imported lenses to get what Stanford wanted. It is also clear that Stanford chose Muybridge because of his reputation as a skillful, up-to-date, and technically imaginative photographer. It was only accidental to the history of photography that it was Stanford who wanted the work done, and could afford to have it done. If it had been another rich man in another part of the

world, another photographer would have been chosen. It is difficult to see, however, how a better man for the job could have been found.

It is known that Mrs. Stanford and Muybridge got on well, and that Mrs. Stanford encouraged her husband to continue the experiments. Muybridge wrote Stanford many years later and spoke of Mrs. Stanford's "desire to extend the investigation."[4]

Muybridge made his proposals to Stanford in a letter of August 7, 1877, shortly after he had written his letter to the *Alta*, and shortly before Occident's image was published in *The Spirit of the Times*. Stanford told him to go ahead, and for three years he gave much if not most of his time to the problem.

The *Alta* had reported on August 11 that the shutters of the cameras were to be activated by electricity. It has been claimed that the idea of electricity and its application to the Muybridge cameras was the work of others—among them Francis A. Dent and John D. Isaacs, draftsmen for the Central Pacific Railroad; a man named Palmer, a civil engineer for the railroad; and S. F. Seiler, superintendent of the California Electrical Works in San Francisco. Stanford himself summed it up later by saying that everyone worked together, and that Muybridge

> made the experiments and took the negatives and photographs . . . at the original suggestion and solicitation of [Stanford] and entirely at [Stanford's] expense, and the mechanical inventions . . . were the joint result of the suggestions of [Muybridge, Stanford] and his friends and of the experts, electricians, mechanics and assistants hired and furnished by [Stanford] to assist in making said experiments and in taking said negatives and photographs. . . .[5]

In another place Stanford is not so generous in giving credit to the others:

> I have for a long time entertained the opinion that the accepted theory of the relative positions of the feet of horses in rapid motion was erroneous. I also believed that the Camera could be utilized to demonstrate that fact, and by instantaneous pictures show the actual position of the limbs at each instant of the stride. Under this conviction I employed Mr. Muybridge, a very skilful photographer, to institute a series of experiments to that end. Beginning with one, the number of cameras was afterward increased to twenty-four, by which means as many views were taken of the progressive movements of the horse. The time occupied in taking each of these views is calculated to be not more than the five-thousandth part of a second.[6]

In the same place Stanford refers to the work conducted by Muybridge as "the experiments of Mr. Stanford with instantaneous photography," which is no more correct than to say that the Sistine Chapel ceiling is the work of

85

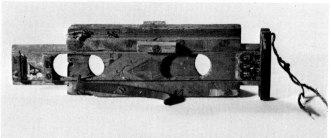

86

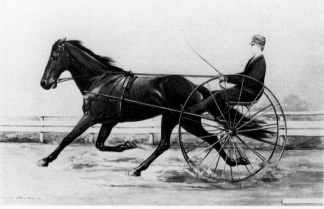

87

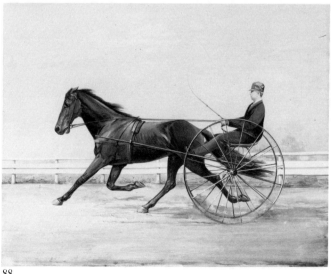

88

Fig. 85. Leland Stanford at about fifty-five years of age. *Ca.*1879. Lantern slide. The Kingston-on-Thames Library and Museum, Kingston-on-Thames, England. Muybridge used this slide of Stanford in his lectures.

Fig. 86. An electrically activated slide shutter, possibly used in the 1877 motion work. The Stanford University Museum, Stanford, California.

Fig. 87. Muybridge's famous photograph of Occident trotting at full speed—actually of the John Koch painting (Fig. 88). The Stanford University Museum, Stanford, California.

Fig. 88. The John Koch painting-collage (the head of the driver is a photograph, possibly by Muybridge). The Stanford University Museum of Art, Stanford Collection, Stanford, California. The painting, based on an original Muybridge photograph of the horse in motion, was evidently rephotographed by Muybridge to produce the print from which the 1877 newspaper engravings were taken (Fig. 87).

Julius II rather than Michelangelo. So far as we know, Julius could not hold a brush, and there is no reason to think that Stanford ever clicked a shutter.

It is perhaps the claims of John D. Isaacs, so forcefully set forth by the motion-picture historian Terry Ramsaye, that have been most often advanced as legitimate. Isaacs later said that Muybridge had shown him a single photograph of Occident taken when a pin was pulled out of a shutter, and that Isaacs had suggested the use of electricity to release the shutters successively. Some time after the 1878–79 work at Palo Alto, according to Isaacs, he met Muybridge at Morse's Gallery in San Francisco and Muybridge told him that his work had been successful. He showed Isaacs his "scrapbook," whereupon Isaacs told him that he "did not see much Isaacs in it; and he bristled right up and said: 'What did you have to do with it, sir? You were only employed as a draughtsman for me.' "[7] Isaacs then threatened to sue Muybridge and was only restrained from doing so by Arthur Brown, his superior at the Central Pacific.

In any case, work on the apparatus was under way for the whole winter of 1877–78, and so far as we know, it was not until June 11, 1878, that the first series photographs were taken successfully. Strings broken by the horse as he trotted in front of the cameras were first used to release the shutters, but these were irregular and besides they frightened the animal and broke his stride. It was then that a special release mechanism was devised (Figs. 93 and 94).

The camera shed was set up on the south side of Stanford's trotting track at his Palo Alto farm. After moving to his great house on California Street hill in San Francisco (Figs. 79–82), Stanford felt the need for a country seat, where he could indulge his great interest in horses. He had accordingly bought, in July 1877, Mayfield Grange, the magnificent George Gordon property of 697 acres on San Francesquita Creek, thirty miles south of San Francisco in Santa Clara County. He built extensive barns and outbuildings and laid out a track for trotters (Figs. 89 and 90). Detailed photographs, probably by Muybridge, were taken of the camera installation (Figs. 91 and 92). The shed stood until 1915, and shortly thereafter was torn down (Figs. 95 and 96).

The June 11, 1878, series was not, as the *Bulletin* reported on June 14, of Occident, but of another Stanford trotter, Abe Edgington (Fig. 98). Four days later Abe Edgington was photographed again, along with some other horses. Much of the San Francisco press was invited down on this second day, and an account in the *Chronicle* detailed the arrangements:

On one side of the track is a rough shed in which are the lenses and cameras, twelve in number, and on the opposite side is a large screen of white canvas stretched over a scantling fence* some thirty feet long and eight feet high, with a backward declination of some sixty degrees. On the upward edge of this canvas are shown the figures one to twenty consecutively, severed by vertical cords at twenty-one inches distant, and at the bottom of this canvas was a board showing horizontal lines that represented four, eight, and twelve inches above

THE LEVEL OF THE TRACK.

About two feet from the same canvas, but on the track, was a slight wooden ledge, and between the two at every number between four and sixteen was stretched a galvanized wire at about an inch from the ground, each wire connected with its numbered lens on the opposite side, the wires being taken underneath the track. The investigation thus far was very simple, as it was apparent that the inner wheel would pass over the projecting wires and by a simple arrangement on the other side would close the circuit. But, then, arose the question as to how this could be utilized to take a picture in the estimated incredible fraction of time of the two thousandth part of a second—in which period the lenses had to be exposed and closed. This was effected by a very ingenious contrivance in the shutters of the camera, to the upper and lower parts of which were adjusted very powerful springs, and when the electric current was arrested they were released, and in crossing they exposed a space of about two inches, and in this space of time that represented but a flash of lightning, the passing figure is fixed on the highly-sensitized glass, even to

THE MINUTEST DETAIL.

The ground over which the experiment was to be made being covered with slack lime, so as to catch even each footstep of the stride, all was duly prepared, and Abe Edgington, with Charles Marvin holding the reins, appeared on the track to show by twelve almost instantaneous photographs the true story of the stride of the horse.[8]

From the start of these 1877 and 1878 experiments it was Muybridge's intent to use the photographs in lectures that he planned to give throughout the world, as the *Alta* reported on July 8, 1878. At the beginning—the first known exhibition of these photographs of motion was on July 6, 1878—the photographs were only slides made of the six-, eight-, and twelve-series photographs. And on that first occasion, they formed only a part of the lecture, the "clever and lucid" lecturer[9] also showing his Central American views and one of his San Francisco panoramas. This lecture, Muybridge's first to include

* Actually, as the *Call* pointed out in its account, the wall was whitewashed.

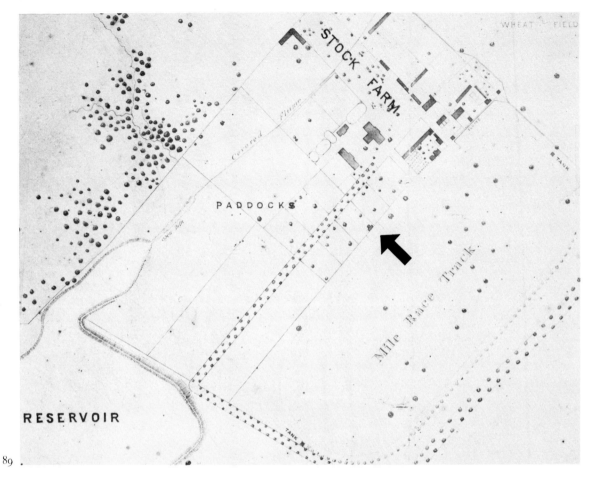

89

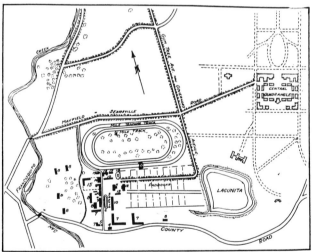

PALO ALTO STOCK FARM

Established 1876 · Discontinued 1903

1. Stock Farm Site
2. Bronze Horse
3. Motion Picture Tablet
4. Superintendent's House
5. Horse-Shoeing Shop and Carpenter Shop
6. Cooling-Off Track
7. Brood Mare Stables
8. Hay Barns
9. Stallion Stable
10. Training Stable Stalls
11. Training Barn
12. Colt Barn
13. Carriage House
14. Feed Mill
15. Kindergarten
16. Miniature Track
17. Office Building
18. Dining Hall
19. Harness Shop
20. Motion Picture Studio

Fig. 89. Detail of a map of the Stanford stock farm at Palo Alto, California. 1880. Stanford University archives, Stanford, California. The heavy arrow right of center has been added to indicate Muybridge's 1878–79 photographic installation. The eucalyptus-lined drive running off-frame at the bottom toward the right leads to Mayfield, the residence built by George Gordon and bought by Stanford in 1877, the year before the motion-picture experiments began here.

Fig. 90. The Palo Alto stock farm, as shown on a reconstructed map in 1926, with the later Stanford University buildings superimposed at the right. From the 1929 semi-centennial pamphlet (see Bibliography). Stanford University archives, Stanford, California. A comparison with the map of Fig. 89, which was unknown when this one was drawn, shows errors in this version.

Fig. 91. The installation at the south center of the mile track of the Stanford stock farm, looking west. 1878. Photograph by Muybridge. From *The Horse in Motion* (1882). The camera shed is at the right, the background wall at the left, and four diagonal cameras on stands at four corners of the track area.

Fig. 92. A closer view of the preceding, showing the wires which tripped the shutters stretched across the track. 1878. Photograph by Muybridge. From *The Horse in Motion* (1882)

90

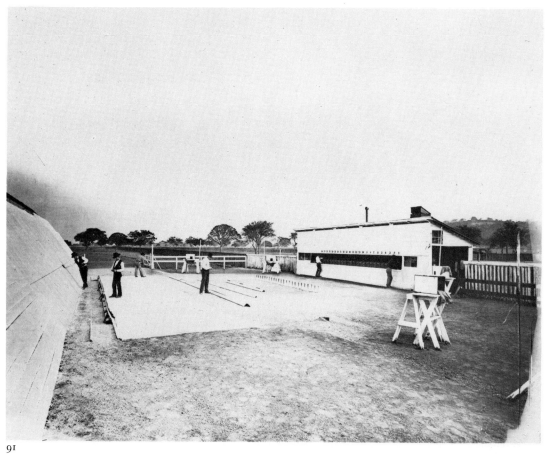

91

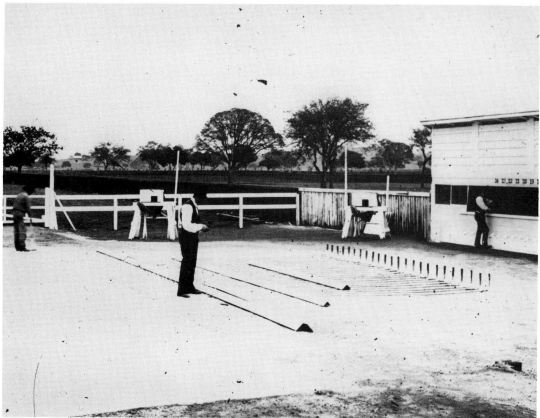

92

Fig. 93. Shutters used in the Palo Alto experiments. Stanford University archives, Stanford, California.

Fig. 94. Patent Office models of the Palo Alto shutter and, schematically, the background wall. The Smithsonian Institution, Washington, D.C.

93

his motion studies, was repeated on July 10 and July 12. *The San Francisco Examiner*'s account of the closing talk alluded to the problem of a trotting horse's feet:

> The closing exhibition of Mr. Muybridge's wonderful photographs of the stride and motion of trotting and running horses, at fleetest speed, will be given this evening, at the Art Association Rooms, on Pine street, just above the market, and below Kearney street. It is, as we have on several occasions remarked, the most surprising invention of the day in photography, and the genius and skill of Mr. Muybridge have enabled turfmen to definitely determine problems long debated without hope or expectation of absolute solution—whether in trotting or running, a horse is ever completely off the ground, and, again, whether the toe or heel first strikes the ground. George Wilkes, Bonner, and other noted turf authorities differ somewhat, but all contend that a horse has never all his feet off the ground, no matter how rapid the speed, and, further, that the toe is first down in the placing of the foot. Mr. J. Cairns Simpson, the able Turf Editor of the *Spirit of the Times* of this city, maintained the contrary opinion, and the thorough soundness of his judgement is now completely affirmed and demonstrated by Mr. Muybridge's famous invention and artistic skill, as every beholder of his photographs will see at a glance. The exhibition at the Art Rooms gives the plates upon a large scale, life size, by camera, so as to make it more entertaining to the audience. He also shows a number of singularly interesting photographs of grand, wild, picturesque, beautiful scenes, mountain, valley, rock and dell, marine and landscape, taken by himself in his years of professional touring in South America, Alaska, and

94

other distant climes. The exhibition is as delighting to ladies as to gentle-men, and is very worthy of a visit.[10]

The first lecture was sparsely attended, but the last, on a Friday evening, "was crowded with an intelligent and fashionable audience, and which was feminine by a pleasant majority."[11]

By the end of the month several magazines, both photographic and scientific, were acclaiming the photographs. *The Scientific American* reported the sensational new photographs on July 27, and several photographic maga-zines discussed it in their August issues. *The Photographic Times* and *Anthony's Photographic Bulletin* praised the results, but *The Philadelphia Photographer*, taking its lead from a deprecatory letter from W. H. Rulofson, Muybridge's former associate, commented that the "wonderful California horse story" had been rather upset by Rulofson's letter.[12] Rulofson, perhaps piqued because Muybridge had left his gallery, derogated Muybridge's work:

> None know better than yourself that the country is full of photographic quacks vending their nostrums, deceiving the credulous, and defrauding the ignorant. California is noted for its "largest pumpkins," "finest climate," and most "phenomenal horse" in the world. So also it has a photographer! the dexterity of whose forefinger invokes the aid of electricity in exposing his plate—a succession of plates, so as to photograph each particular respira-tion of the horse. The result is, a number of diminutive *silhouettes* of the animal on and against a white ground and wall; all these in the particular position it pleased him to assume, as the wheels of his chariot open and

close the circuits. All this is new and wonderful. How could it be other-wise, emanating as it does from this land of miracles? Photographically speaking, it is "bosh;" but then it amuses the "boys," and shows that a horse trots part of the time and "flies" the rest, a fact of "utmost scientific importance." Bosh again.

<div align="right">

Respectfully, your friend,
WM. H. RULOFSON.

</div>

Rulofson did not actually say he doubted the story, but that he thought the results trivial. The rest of the world did not agree with him.

The Photographic News, in England, summed up the matter, assigning praise where it was due, and wishing Muybridge the best:

> It is difficult to say to whom we should award the greatest praise: to Governor Stanford, for the inception of an idea so original, and for the liberality with which he supplied the funds for such a costly experiment, or to Muybridge for the energy, genius, and devotion with which he has pursued his experiments, and so successfully overcome all the scientific, chemical, and mechanical difficulties countered in labours which had no precedent, and which have so happily culminated in such a wonderful re-sult. We hope he will reap the benefits to which his genius and success clearly entitle him.[13]

In quoting from the August issue of *The Resources of California, The Photographic News* omitted the interesting information that the cameras had been made by a division of the Scovill Company in New York, rather than by any European firm.

The Photographic Times took issue with *The Philadelphia Photographer* and called Muybridge's photographs "truly wonderful,"[14] and *Anthony's Photographic Bulletin* published in the same month a letter from Muybridge himself, in which he was mock-modest and hyperbolic at once:

> *Dear Sirs*: I must say the partial success I have met with must be attributed to the extraordinary rapidity and wonderful depth of focus of the Dall-meyer lenses. In my next experiments I intend reducing the exposure to the 5,000th part of a second, and am confident, with some slight modification of my chemicals, to obtain better results than the present.
>
> I have more than sixty lenses of Dallmeyer's manufacture in my equip-ment, and have used them exclusively, within the Arctic Circle and under the Equator, at an elevation of 10,000 feet and beneath the waters of our Bay, with exposures varying from 18 hours to less than the 2,000 part of a second, and must candidly confess I cannot afford to use any other.

<div align="right">

Faithfully, yours,
MUYBRIDGE

</div>

Muybridge may never have managed 1/5000 of a second—certainly he had not done so up to this time; he never photographed within the Arctic Circle, "under the Equator," or, as far as we know, beneath the waters of "our Bay" (at least no such photographs are shown).

For its issue of October 19, 1878, *The Scientific American* reproduced on its cover a series of drawings after photographs by Muybridge of a walking horse and a trotter (Fig. 99). The magazine also announced that six cabinet-size photographs had been issued showing the series photographs, and that readers could buy them from Muybridge at 417 Montgomery Street, San Francisco. It was also suggested that the photographs be used in the zoetrope (see Fig. 116).

It was possibly the *Scientific American* drawings that stimulated Thomas Eakins in far-away Philadelphia to write Muybridge suggesting that he take series photographs of human movement. In a later letter Eakins suggested that Muybridge draw the trajectories of the horses' hooves, and that he dispense with the lines on the background. The trajectories of Sallie Gardner's hooves were drawn, probably by Eakins, and published.* We know that Eakins drew trajectories for Muybridge's horses on glass slides and used them in his classes at the Pennsylvania Academy of the Fine Arts (Fig. 135). In the spring of 1879, encouraged by his patron Fairman Rogers, Eakins began work on *A May Morning in the Park* (*The Fairman Rogers Four-in-hand*), the first known time in the history of art when animals in rapid motion were shown as they really move—not as they had been supposed to (Fig. 176).

By December 14, 1878, the news had become widespread in Europe, and the French magazine *La Nature* published several of Muybridge's horse series. Almost at once Gaston Tissandier, the editor, received a letter from Etienne Jules Marey, the distinguished physiologist and researcher in animal movements. (A list of Marey's works on the subject, virtually his whole life work, is in the Bibliography.) Until now, 1878, Marey had not used photography. He was often to give Muybridge credit for stimulating his interest in instantaneous photography to achieve the results he had imperfectly realized by his graphic method. (See *Développement de la Méthode Graphique*, 1885, an enlargement of his *Machine Animale*, 1878. See note on page 153 for a discussion of an interesting interchange between Marey and Muybridge concerning refinements in Marey's famous photographic gun.)

Marey wrote to *La Nature* in 1878:

* I have discussed the Eakins-Muybridge contacts in some detail in the *Bulletin* of the Philadelphia Museum of Art, Spring 1965.

Dear Friend:—I am lost in admiration over the instantaneous photographs of Mr. Muybridge, which you published in the last issue of *La Nature*. Can you put me in correspondence with the author? I want to beg his aid and support to solve certain physiological problems so difficult to solve by other methods: for instance, the questions connected with the flight of birds. I was dreaming of a kind of photographic gun, seizing and portraying the bird in an attitude, or, better still, a series of attitudes, displaying the successive different motions of the wings. . . .

It is evident that this would be an easy matter for Mr. Muybridge to accomplish, and what beautiful zoetropes he could give us, and we could perfectly see the true movements of all imaginable animals. It would be animated zoology. So far as artists are concerned, it would create a revolution, since we could furnish them with the true attributes of motion; the position of the body in [equilibrium], which no model could pose for them.

You see, my dear friend, that my enthusiasm is overflowing. . . .[15]

In January of the new year, 1879, *The Philadelphia Photographer* had changed its mind about Muybridge's photographs. M. H. Rulofson had since died a tragic death,* and the editors must have felt less compunction in gainsaying him:

Looking at [the Muybridge photographs], and giving them the real sober thought they deserve—*going into them*, as it were—as if you were the driver, is enough to turn your brain. The succeeding positions in No. 1 we can get through without much excitement. There is a great deal more apparent "go" in No. 2, and yet more in No. 3, but when we come to Nos. 4 and 5, we get the "poetry of motion" twelve times intensified in every nerve. We imbibe all the energy of the horse. We stretch our imagination to its maximum, and are forced to cry "*stop*," Mr. Muybridge, you have caught more *motion* in your photographs than any previous camera ever dreamed of. They are truly wonderful, and we congratulate you.

Surely Mr. Rulofson could not have given much thought to the subject when he called these pictures "silhouettes" only, and the claims made for them as "bosh." Mr. Muybridge deserves great credit, and has gained great notoriety for what he has done, and we shall try to induce him some -time to tell us more about it. His address is at the Morse Gallery, 417 Montgomery Street, San Francisco. A note addressed to him will bring

* Early in November 1878 Rulofson went up on the roof of his photographic studios to inspect the construction of a skylight. While there he fell off the roof, and was reported to have called "My God, I am killed" as he fell. Later Ambrose Bierce, with whom Rulofson was embroiled in an argument over *The Dance of Death*, to which Rulofson claimed authorship, said that it was a suicide. For a discussion of the matter and other aspects of Rulofson's career, see Robert Bartlett Haas, "William Herman Rulofson," *California Historical Society Quarterly*, March 1953.

you a descriptive circular with trade prices, or $1.50 each will bring you copies of the groups of positions.

The *Philadelphia Photographer's* correspondent had five of Muybridge's cards in front of him as he wrote. The cabinet photograph showing Sallie Gardner's trajectories had not yet been published. But considering the wide dissemination of these five cards at $1.50 each, Muybridge and Morse must have profited considerably.

In March 1879 Muybridge, answering an inquiry from *The Philadelphia Photographer* as to the details of his method—principally the chemicals used—declined to give the information. He also gave Stanford more credit than he had yet done or was ever to do subsequently:

> *I* have not, nor do not claim any credit for these photographs; whatever praise others may have felt proper to award, has been entirely unsolicited, and to which Governor Leland Stanford is entitled much more than I. He originally suggested the idea, and his persistency and liberal expenditure has accomplished the trifling success we have met with. I am instructed by him to continue the experiments until we have illustrated the subject of animal locomotion about as far as photography can illustrate it. . . .

The results promised for the following autumn were to include many series photographs of men in various characteristic movements, and it does not seem exaggerated to surmise that it was Thomas Eakins' suggestion that led Muybridge to undertake such work. It seems far indeed from any original purpose of either Stanford or Muybridge. With the new summer's work at hand, Muybridge wrote Eakins a letter telling of his plans:

> Dear Mr. Eakins,
>
> I am much pleased to hear the few experimental photos we made last year, have afforded you so much pleasure, and notwithstanding their imperfection have been so serviceable. I shall commence with the new experiments next week and we shall hope to give you something better, than we before accomplished.
>
> Our screen will be upright and divided by vertical and horizontal lines into 12 inch spaces. The cameras will be perfectly level (as indeed they were before) and about 3 feet high. One being opposite each one of the 30 center vertical lines, say 30 out of 60, of which length the background will consist.
>
> I commenced these experiments last year with a clock work arrangement, but relinquished it for the automatic in consequence of the extreme difficulty in getting the clock to run with a speed exactly coinciding with the speed of the horse. . . . I have the clock, and will use it for birds; possibly

for dogs, but for animals under control the automatic arrangements are unquestionably the best.

The track I think we will lay with rubber, painted white, with black stripes corresponding with the vertical lines on the background. After each exposure a map of the track will be made, exhibiting his footprints, to corroborate the photos, and to keep a record of his distance from the cameras. The height and description of the animal will also be recorded.

I invited Mr. Rogers to come out here during the time we shall be at work. The trip will well repay him, not only from the great interest he has manifested in the subject of our experiment but also in the pleasure he would feel in visiting our mountains, and their glorious scenery, and the extensive ranchos and stock farms. Cannot you persuade him to come out. Newport will always be there, but probably our experiments will terminate this summer. . . .[16]

Fairman Rogers, meanwhile, was preparing an article for *The Art Interchange* in which he described Eakins' use of Muybridge's photographs. Eakins, he wrote, "constructed, most ingeniously, the trajectories."[17]

The new photographs were begun the second week of May 1879, and now utilized twenty-four cameras instead of the previous year's twelve. Besides horses, they showed hogs, dogs, oxen, bulls, and even sea gulls brought from the Farallon Islands, thirty miles off the coast of San Francisco.

On August 7, if not before, a group of athletes from San Francisco's Olympic Club came down to the Stanford farm and were photographed from ten o'clock in the morning until four in the afternoon (Figs. 109 and 110). On a later day runners from the club were photographed. On a running jump on August 7 the athlete broke seven hemp strings ascending and seven in descending—an achievement in itself. *The Scientific American* described this feat on September 13, 1879, quoting *The Morning Call* of July 9. One of the newspapers suggested that the new photographing method be used in horse racing to settle disputes that arise in close finishes. Today this use of the camera is routine, but in Muybridge's day it was a pioneering idea.

Muybridge now adapted his new photographs—or rather drawings made from them—to a new apparatus for projection on a screen. This he first called the zoographiscope, then the zoogyroscope, then the zoopraxinoscope—after the classical optical toy the praxinoscope—and finally the zoopraxiscope. His original apparatus still exists in the museum of his home town, Kingston-on-Thames (Fig. 112). Strips for the zoetrope having drawings made from his photographs were soon being manufactured both in America and England (Figs. 115–117). But the projection apparatus was a revolutionary application.

Now audiences were about to see real motion on the screen, not simulated as it had been before in such arrangements as that of Henry Renno Heyl of Philadelphia.*

The first known zoopraxiscope exhibition occurred sometime in the fall of 1879, either at Stanford's Palo Alto house or in his home in San Francisco, before a small group of friends. Stanford had returned early in August from a trip to Europe and was now planning another, this time to show various interested Europeans the results of Muybridge's work.† Muybridge had already patented his photographing process.‡ Now he tried, with Stanford's approval, to patent his new projector, but the Patent Office thought it was not sufficiently innovative, efforts by Stanford's lawyers to the contrary notwithstanding.

Muybridge continued to amuse and amaze Californians by his motion pictures on a screen. On January 16, 1880, he presented his new show in the ballroom of Stanford's San Francisco house before a group of the city's elite, including the Charles Crockers, some of the Flood family, and the governor of the state. Probably on March 21 he showed some of his zoopraxiscopic discs to visitors to Palo Alto, and on May 4 gave a press preview of a series of lectures in the San Francisco Art Association rooms at 313 Pine Street. These exhibitions may fairly be said to mark the official debut of motion pictures on the screen in America. "Mr. Muybridge has laid the foundation of a new method of entertaining the people," the *Alta* commented, "and we predict that his instantaneous photographic, magic-lantern zoetrope will make the round of the civilized world."[18] No one could have foreseen that this prophesy, exaggerated as it may have sounded, was still far too modest.

* Henry Renno Heyl was an Ohioan who moved to Philadelphia in 1863 and there perfected an instrument he called the phasmatrope, the original of which is now in the Franklin Institute in Philadelphia. In it he used separately posed positions of motion. He projected these simulated motion pictures on a screen in the Sunday School room of St. Mark's Evangelical Lutheran Church in 1869, and the following year, on February 5, 1870, in the Academy of Music in Philadelphia.

† Stanford's biographer wrote that Stanford's first trip to Europe was in 1880 (George T. Clark, *Leland Stanford*, Stanford, California, 1931). But the Stanfords were in New York Harbor on a return trip on August 3, 1879, where Mrs. Stanford was wearing "the biggest emeralds you ever saw." On this trip, according to Muybridge himself, Stanford showed the French academic realist painter Meissonier the Palo Alto photographs.

‡ "Improvement in the Method and Apparatus for Photographing Objects in Motion," the shutter, applied for July 11, 1878, and granted March 4, 1879, #212,864; and "Method and Apparatus for Photographing Objects in Motion," the string-release, applied for June 27, 1878, and granted March 4, 1879. Muybridge's zoopraxiscope, like his later zoopraxographic fan (page 218), utilized attenuated figures as Plateau had done before him.

Muybridge spent the rest of the year and up to May 1881 processing, printing, collating, and arranging his 1878–79 photographs in a book called *The Attitudes of Animals in Motion*, which was published in May 1881, the copyright date being May 17. Its preface, however, is dated May 15, which must be a postdating: the book could not have been written, printed, bound, sent to Washington, and copyrighted in two days. Today copies of *The Attitudes of Animals in Motion* are rare (see list of collections).

At the end of *The Attitudes of Animals in Motion* were ten photographs of a horse skeleton posed in successive positions of running. This skeleton had been ordered from Chicago by Dr. J. D. B. Stillman, a friend of Stanford's, who was now engaged in preparing a book based on Muybridge's motion photographs. This book was to be called *The Horse in Motion*, and was the cause of considerable embarrassment to Muybridge when the title page appeared without his name. But that story belongs to the next chapter, when matters came to a head in England.

Fig. 95. The camera shed for the experiments as it was in 1915, looking northwest. From *Sunset Magazine,* November 1915.

Fig. 96. Interior of the camera shed as it was in 1915. From *Sunset Magazine,* November 1915. Two electro-shutters and two baths can be seen.

Fig. 97. Leland Stanford, Jr., at left and Mrs. Leland Stanford, third from left, with three unidentified people at the photographic installation. 1878? Photograph probably by Muybridge. Stanford University archives, Stanford, California. The man at the right has been said to be Mark Hopkins, but Hopkins died on March 29, 1878, several months before the experiments officially began. Perhaps this part of the installation was ready earlier.

95

96

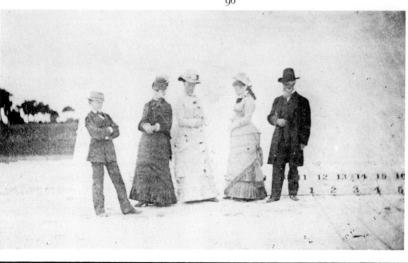

97

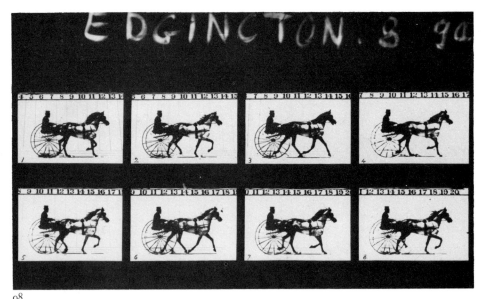

98

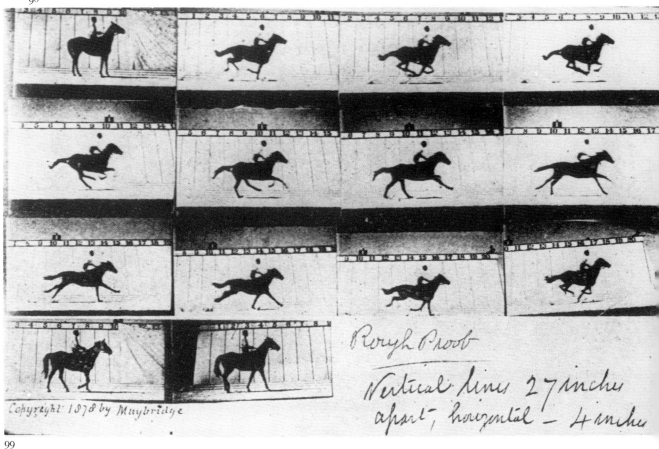

99

Fig. 98. Proof of the Abe Edgington series, the first series produced. June 11, 1878. Photographs by Muybridge. Author's collection.

Fig. 99. Rough proof of Sallie Gardner running. June 19, 1878. From *Sunset Magazine,* November 1915.

Fig. 100. The cover of *The Scientific American,* October 19, 1878. The New York Public Library, New York, New York. An early, conspicuous instance of the publicity given Muybridge's 1878 experiments. Shows Abe Edgington, with driver and sulky deleted, in a 15-minute and a 2:24 gait.

SCIENTIFIC AMERICAN

A WEEKLY JOURNAL OF PRACTICAL INFORMATION, ART, SCIENCE, MECHANICS, CHEMISTRY, AND MANUFACTURES.

Vol. XXXIX.—No. 16.
[NEW SERIES.]

NEW YORK, OCTOBER 19, 1878.

[$3.20 per Annum.
[POSTAGE PREPAID.]

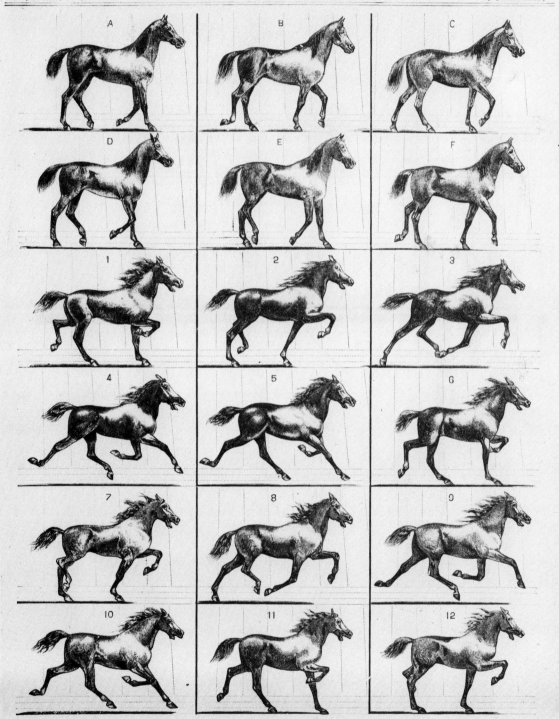

THE SCIENCE OF THE HORSE'S MOTIONS.—[See page 241].

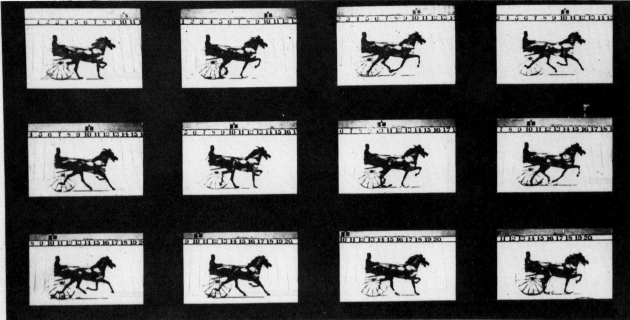

THE HORSE IN MOTION.

Illustrated by

Patent for apparatus applied for.

MUYBRIDGE.

AUTOMATIC ELECTRO-PHOTOGRAPH.

"ABE EDGINGTON," owned by LELAND STANFORD; driven by C. MARVIN, trotting at a 2:24 gait over the Palo Alto track, 15th June 1878.

The negatives of these photographs were made at intervals of about the twenty-fifth part of a second of time and twenty-one inches of distance ; the exposure of each was about the two-thousandth part of a second, and illustrate one single stride of the horse. The vertical lines were placed twenty-one inches apart ; the lowest horizontal line represents the level of the track, the others elevations of four, eight and twelve inches respectively. The negatives are entirely "untouched."

101

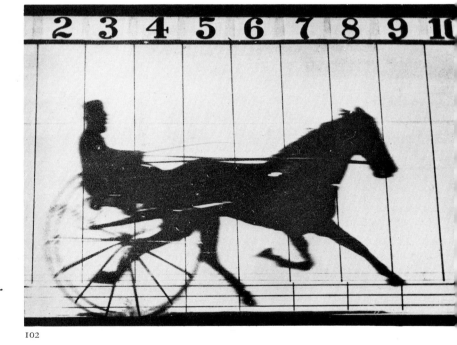

102

Fig. 101. Cabinet photograph of the June 15, 1878, Abe Edgington series. Photograph by Muybridge. The Library of Congress, Washington, D.C. The library's deposit stamp, July 15, 1878, indicates the last possible publication date for this series.

Fig. 102. One of the 1878 series of Occident trotting. Photograph by Muybridge. Lantern slide. The Kingston-on-Thames Library and Museum, Kingston-on-Thames, England.

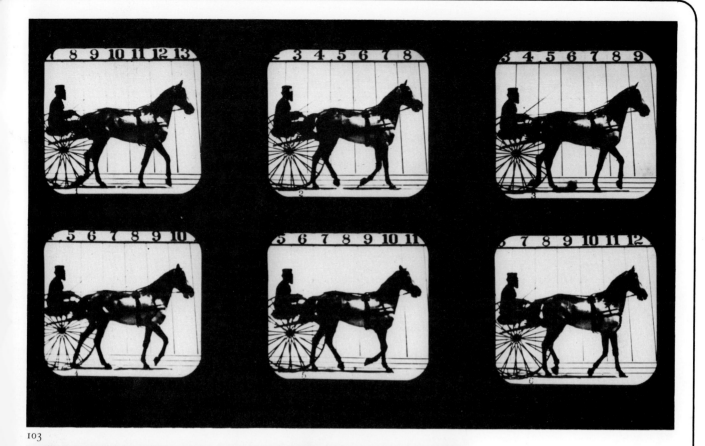

103

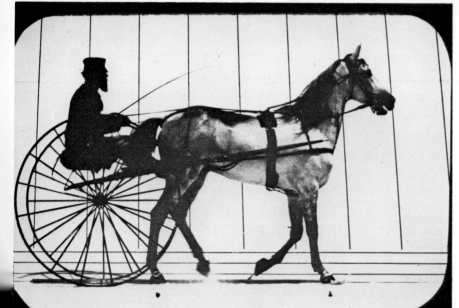

104

Fig. 103. The fourteenth illustration in *The Attitudes of Animals in Motion* (1881). Photographs by Muybridge. The Philadelphia Free Public Library. (As the pages of the various known copies of *The Attitudes of Animals in Motion* [see the list of collections, page 255] are inconsistently numbered, I have chosen the only feasible way to identify the illustrations.)

Fig. 104. The second photograph of the preceding, with background numbers deleted. Lantern slide. The Kingston-on-Thames Library and Museum, Kingston-on-Thames, England.

105

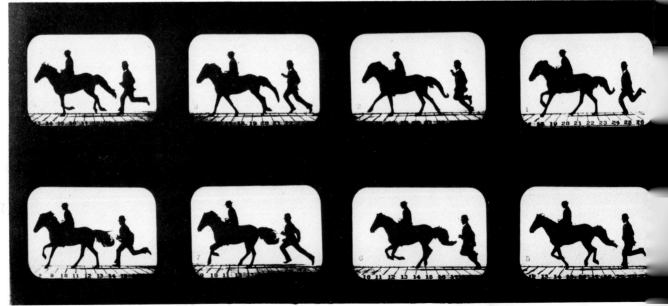

107

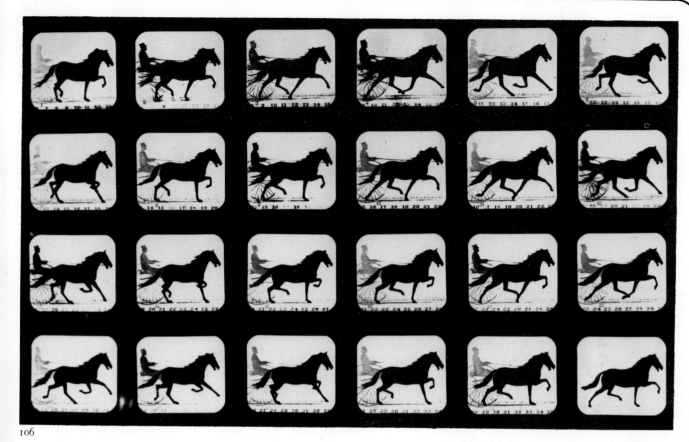

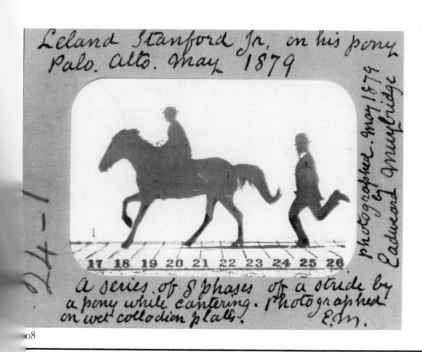

Leland Stanford Jr. on his pony
Palo. Alto. May 1879

photographed. May 1879
by
Eadweard Muybridge

24 - 1

A series of 8 phases of a stride by
a pony while cantering. Photographed
on wet collodion plate.
E.M.

Fig. 105. Muybridge astride a horse in front of the background wall at the Palo Alto installation. 1878–79. Lantern slide. The Kingston-on-Thames Library and Museum, Kingston-on-Thames, England.

Fig. 106. The twenty-sixth illustration in *The Attitudes of Animals in Motion* (1881). 1878. Photographs by Muybridge. The Philadelphia Free Public Library. It is plain here that some of Muybridge's negatives were indistinct and that he intensified crucial figures.

Fig. 107. The twenty-third illustration in *The Attitudes of Animals in Motion* (1881). May 1879. Photographs by Muybridge. The Philadelphia Free Public Library. Leland Stanford, Jr., on his pony.

Fig. 108. The upper right photograph of the preceding series with Muybridge's notations. Lantern slide. The Stanford University Museum of Art, Muybridge Collection, Stanford, California. In 1897 Muybridge sent this slide to David Starr Jordan, Stanford University's first president. "I found . . . a negative," he wrote, "illustrating the stride of a canter by a pony when ridden by the young gentleman from whom your University derives its name. Thinking [it] would interest Mrs. Stanford . . ."

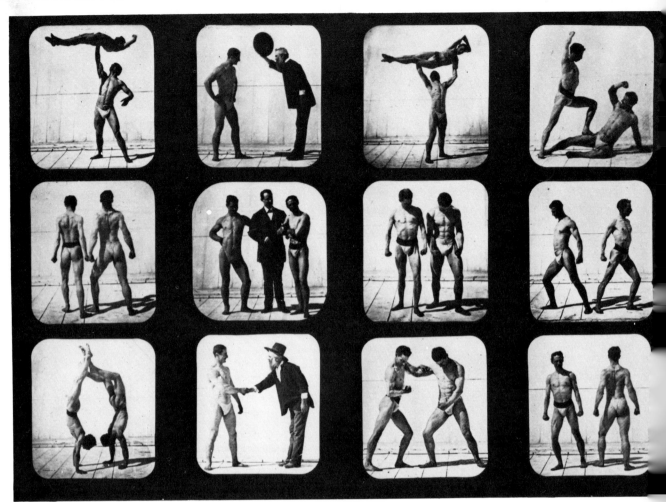

109

Fig. 109. The 123rd illustration in *The Attitudes of Animals in Motion* (1881), showing gymnasts from the Olympic Club of San Francisco with their trainer, W. S. Lawton. August 1879. Photographs by Muybridge. The Philadelphia Free Public Library. Muybridge appears with the club's strong man, L. Brandt, at top center and bottom center.

Fig. 110. Enlarged detail of the preceding, showing Muybridge and Brandt. August 1879. The Philadelphia Free Public Library.

Fig. 111. The 102nd illustration in *The Attitudes of Animals in Motion* (1881), showing Muybridge himself. 1879? The Philadelphia Free Public Library. To be read from upper right.

110

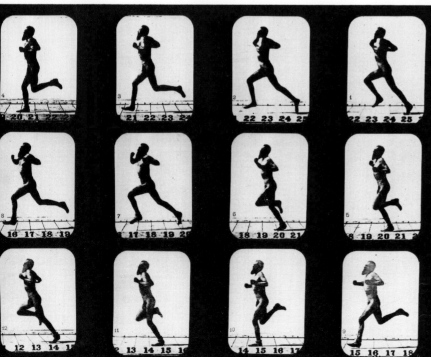

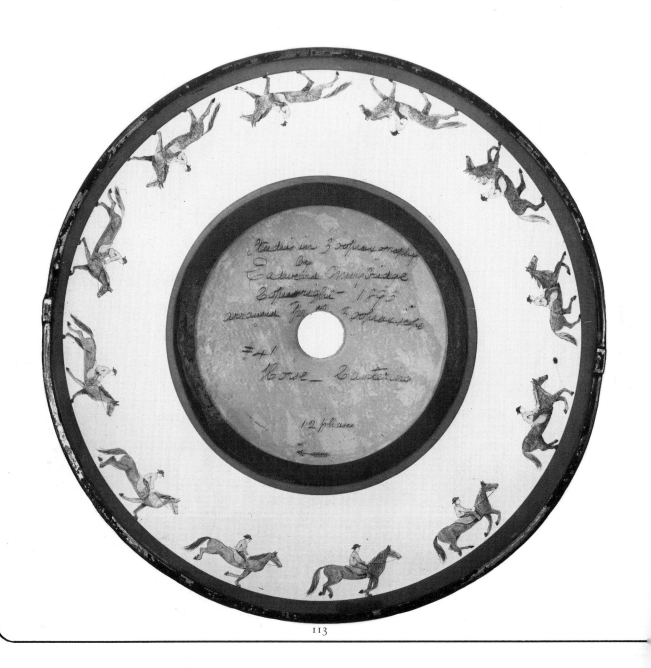

Fig. 112. The zoopraxiscope designed by Muybridge to show drawings from his motion photographs. Photograph probably by Muybridge. Lantern slide. The Kingston-on-Thames Library and Museum, Kingston-on-Thames, England.

Fig. 113. Zoopraxiscope disc used by Muybridge to project motion pictures in the zoopraxiscope. Glass with figures drawn by Erwin F. Faber. The Kingston-on-Thames Library and Museum, Kingston-on-Thames, England. The figures are attenuated to accommodate persistence of vision.

Fig. 114. The reverse of the preceding. Arrows show the direction the disc should turn.

Fig. 115. Box in which Muybridge's zoetrope strips were published and marketed in 1882. Author's collection.

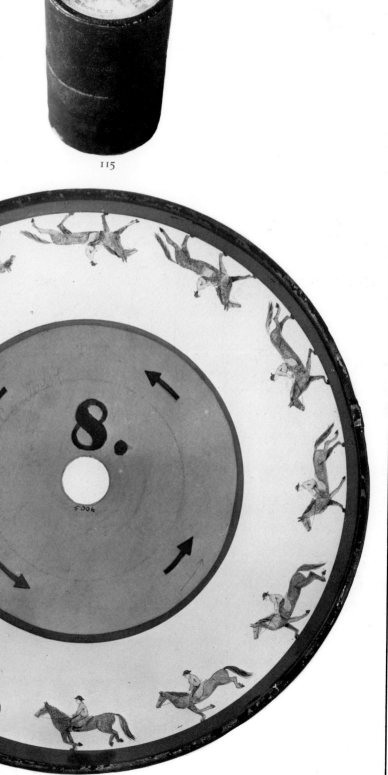

115

114

The ZOETROPE for imparting apparent motion to these figures consists of a card-board cylinder, A—black on the exterior—12 inches in diameter, and about 8 inches in depth, with 13 equi-distant slots b, b, b, near the top, each about ⅒ of an inch wide and 3 or 4 inches long. The lower end of the cylinder is attached to a disc of wood, c, with a small tube, d, closed at the top and forming a bearing for a vertical shaft, e, fastened to a platform, f; this forms a support and axis to the cylinder which is caused to revolve either by the motion of the hand, or by a crank handle, g, and a horizontal shaft, h. A fixed wheel, i, is attached to the horizontal shaft on one side of the support, j, and a friction wheel, k, on the other side. A band of figures, l, l, l, l, is arranged around the inner circumference of the cylinder and looked at through the slots while the instrument is revolving.

The reproductions of the photographs are published in their present form with the object of disseminating a knowledge of the true positions assumed by animals while performing various movements, and correcting the erroneous ideas almost universally prevailing on the subject, it was not therefore considered desirable to alter the features of the original photographs by *retouching* or *improving* the copies.

Being intended for popular use and adapted to the requirements of the ordinary Zoetrope to be obtained at the toy shops, these reproductions are necessarily restricted in the advantages which they may offer for scientific or artistic purposes.

For a more complete investigation of the "Attitudes of Animals in Motion" attention is directed to the ORIGINAL PHOTOGRAPHS now preparing for publication; and for their synthesis to the ZOOPRAXISCOPE invented by the author.

116

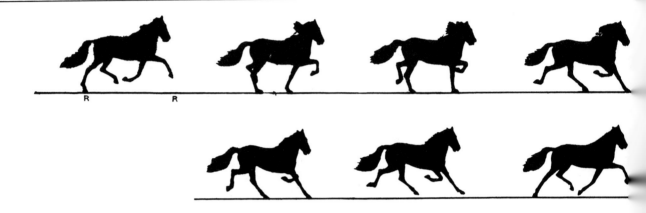

117

With the compliments of
The Author

LIVERPOOL, J. J. ATKINSON, Manchester Street.
NEW YORK, SCOVILL MANF. COMPANY, 419-21 Broome Street.
PARIS, A. MOLTENI, 44 Rue du Chateau d'Eau.

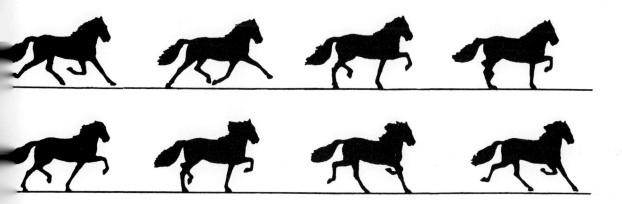

Fig. 116. An instruction and advertising strip enclosed with the preceding. 1882. Author's collection. The original strips were 2⅝″ wide and 38″ long.

Fig. 117. One of the zoetrope strips made from Muybridge's photographs of a running horse. 1882. Author's collection. The time intervals are uneven: e.g., from the left, between the first and second, the fifth and sixth, and the sixth and seventh.

Fig. 118. Cabinet photograph of the eclipse of the sun, January 11, 1880. Photographs by Muybridge. The Stanford University Museum of Art, Muybridge Collection, Stanford, California. The original negatives are in the museum; Muybridge took a number of additional ones and evidently chose for publication in this cabinet photograph those he thought best.

Success and
Scandal in Europe

Leland Stanford was already in Europe when Muybridge started on his own trip abroad in June 1881. Stanford had gone there, perhaps principally, to show *The Attitudes of Animals in Motion* to various interested persons. One of these was the celebrated French academic realist painter J. L. E. Meissonier (Fig. 119), who painted a portrait of Stanford holding Muybridge's new book under his left arm—perhaps the very copy now in the Houghton Library at Harvard (Fig. 120).

Before he left San Francisco, Muybridge was given $2,000 by Stanford's secretary, Frank Shay, to settle accounts. Stanford had been paying part of Muybridge's expenses—all photographic costs and living expenses in Palo Alto (where he stayed at a boarding house)—and this sum was paid as a final settlement. In addition, Muybridge took out the patents in his own name. The apparatus built at Stanford's expense was also given to Muybridge. Everything, according to Shay, came to a total of about $28,000. The apparatus included two magic lanterns at $750 each, the zoopraxiscope at $500, and "a little over three thousand negatives."[1]

It was planned that Muybridge would take his projection apparatus, discs, and slides to Europe, where they were to be exhibited by Stanford. This plan, however, did not materialize, and Muybridge himself gave the lectures. The photographer stopped in New York on his way to Europe. His address was in care of the Scovill Manufacturing Company at 419 Broome Street, whose cameras he had used in his Palo Alto work, and whose skill he had praised publicly.* He wrote Shay on June 27 about his plans:

> Dear Sir.
> I reached New York in due course of time and found your letter with draft enclosed awaiting my arrival, for which please accept my thanks.
> The negatives and apparatus arrived this morning, and I believe in good order.
> I shall sail for Europe as soon as possible, but have not yet determined whether it will be advisable to take the apparatus with me, had the Governor decided to carry out his proposal of giving some Exhibitions in Europe to invited guests, it would have been unquestionably the best course to commence there, as it is I shall not do so, if I can make advantageous arrangements here. . . .
>
> I am
> Yours Faithfully
> Edw. J. Muybridge[2]

* While at the Scovill Company he gave them details of a new magic lantern slide holder, which he patented on December 20, 1881, but assigned to Scovill (U.S. 251127).

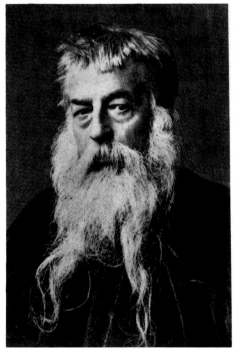

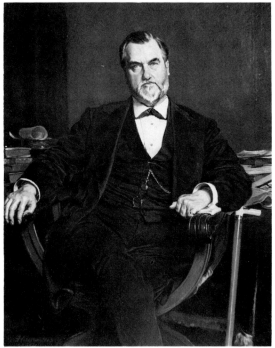

119

120

Fig. 119. The French romantic painter J. L. E.
Meissonier, as he was at about the time he
painted Stanford's portrait and entertained
Muybridge in Paris. The New York Public
Library, New York, New York.

Fig. 120. Meissonier's portrait of Leland
Stanford. 1881. Oil on canvas, 20″ x 15″. The
Stanford University Museum, Stanford, Cali-
fornia. A copy of *The Attitudes of Animals in
Motion,* evidently the copy Stanford had brought
as a gift to Meissonier, which is now in Hough-
ton Library at Harvard, is under Stanford's
left arm.

Fig. 121. Muybridge as he was at about the
time of the Palo Alto experiments. California
State Library, Sacramento.

Muybridge left New York for Liverpool in August 1881. He stopped to visit his home town—where the local paper failed even to mention his arrival in spite of his considerable celebrity—and went on to Paris, where much acclaim awaited him. Marey, for one, entertained Muybridge like a conquering hero (Fig. 122). He invited many of the scientific elite of Paris to his new house on the Boulevard Delessert, where Muybridge showed them the results of his motion work on September 26. The Paris newspaper *Le Globe,* in a somewhat facetious account, described what the guests saw:

M. Marey, Professor of the College of France, yesterday invited to his new house on the Trocadéro, Boulevard Delessert, some foreign and French savants. . . . The attraction for the evening consisted of the curious experiments of Mr. Muybridge, an American, in photographing the movements of animated beings.

Among those invited were M. Helmholtz, . . . Col. Duhousset, . . . Nadar, Gaston Tissandier. . . .

The sitting was prolonged until late, but we regretted that the time had come, when it did, to bid adieu to M. Marey and Madame Vitbort, who did the honors of the evening so charmingly.

Finally, let us address an inquiry to Messieurs Marey and Muybridge. Would it not be practicable by the zoetrope process to give a little additional speed to the Paris carriage horses? We should not require elegance of movement, but hurried journalists would be under lasting obligations to the inventor of some such contrivance.[3]

Duhousset had himself done considerable work in motion (Fig. 123); Nadar (Félix Tournachon) was perhaps the most famous photographer in the world; Gaston Tissandier was the writer for *La Nature* who had given Muybridge's work its first European publication (Fig. 124), and who was to write a detailed account of the Marey *soirée* for the April 1, 1882, issue of the same journal.

On October 1, 1881, Mr. and Mrs. Leland Stanford arrived in Paris for a visit. Stanford was not well, and Muybridge wrote Shay that the governor's stay in Paris had been "entirely devoid of pleasure":

Dear Mr. Shay.

You have probably been informed at the time of writing this, that the Governor and Mrs Stanford, left Paris on Saturday, with the intention of sailing from Liverpool 1st Decr. I saw them off on the cars, and much regret the state of the Govs health left so much to be desired; however, for the last week, he has been rapidly improving, and we have every hope he will have a comfortable voyage, and land in New York, if not entirely well, at least with every prospect of immediate restoration. His residence in

Paris has been entirely devoid of pleasure . . . but if the CP and SP [Central Pacific and Southern Pacific] can spare him, I believe he proposes to return next spring; by that time I shall hope to be in full operation, experimenting with new subjects that will practically exhaust the scope of the investigations. Whether these will take place in France or England is yet in the hidden arcana of the future.

I have happily obtained a recognition among the artists and scientists of Paris which is extremely gratifying, and were honor all I am seeking, I need have no apprehension. . . . I forward a notice of a reception at the residence of Meissonier to whom the Gov paid $10,000 for a portrait of size about 10 x 12 inches.* Many of the most eminent men in art science and letters in Europe were present at the exhibition. . . . Happily I have strong nerves, or I should have blushed with the lavishness of their praises. . . .

I shall shortly visit England for the purpose of inducing some wealthy gentlemen (to whom I have letters of introduction) to provide the necessary funds for pursuing and indeed *completing* the investigation of animal motion; and in framing an estimate of the probable cost, can have no better basis than the cost of the work already accomplished.

Will you therefore at your *very earliest convenience* favor me with the total amount of money paid to me, upon my account 1. Cash paid for apparatus and materials. . . . 2. Cash paid to Muybridge for personal use NOT *including* the $2000 the Gov gave me. 3. Cash paid for wages of assistants. 4. The total cost of buildings and making the track at Palo Alto. . . .

I have not written to San F. before, because I had accomplished nothing; I have been waiting the disposition of the Governor since the 1st Octr; not absolutely idle for I have been collecting materials for a work upon the Attitudes of Animals in Motion as illustrated by the Assyrians, Egyptians, Romans, Greeks, and the great masters of modern times. . . .

<div style="text-align: right">Yours Faithfully
Muybridge</div>

Please don't delay sending statement.[4]

The Meissonier *soirée* mentioned by Muybridge had occurred two days earlier, on November 26, at the painter's studio at 131 Boulevard Malesherbes. The guests constituted another sort of elite than that invited to the Marey *soirée*. Now two hundred celebrated figures in French art arrived to hear— and see—the California horse story. Among these famous artists were Léon Bonnat, J. B. E. Detaille, Alexandre Cabanel, A. M. de Neuville, and Jean Léon Gérôme. "M. Meissonier, who is a great lover of truthfulness in art," *The London Standard* reported, "was almost as pleased at the hearty applause

* Muybridge may have been correct about the cost of the portrait, but he was wrong about its size, which was 20" x 15".

136

which the demonstration met with from his guests as the inventor himself."[5] Alexandre Dumas, who was also there, exclaimed, when he saw a California landscape that Muybridge also showed, "It's marvelously arranged." To which Meissonier replied, "Nature *composes* . . . well."[6]

The Meissonier projectionist was not Muybridge, but the well-known optical technician Molteni. In later lectures in England, Ernest Webster was the projectionist. In both the Marey and the Meissonier *soirées* the hosts did the commenting since Muybridge did not speak French.

The Meissonier contacts resulted in a new project, unfortunately never realized. Meissonier, Marey, Muybridge, and an as yet unidentified investor were to join forces in a new book which would describe, in text and illustrations, motion in art from early times to the present. Meissonier and Muybridge thought Stanford should be asked to participate, and this subject, among others, was the burden of a letter Muybridge wrote to Shay on December 23, 1881. It had not been a month, and Shay had scarcely received the November 28 letter. But Muybridge was anxious:

> Dear Mr. Shay.
> On the 28 Novr last I wrote requesting the favor of your furnishing me with a statement. . . .
> This statement I wished to place before some gentlemen, in my appli-

Fig. 122. William Kennedy–Laurie Dickson (left) and Etienne Jules Marey in Paris. *Ca.* 1898. Author's collection. Dickson was the aide to Thomas Edison who did most of the "Edison" work in motion pictures.

Dans le spécimen que nous offrons, nous avons tenu à l'exactitude *fac simile* des contours et à maintenir les chevaux dans l'ordre de progression des photographies. Plus d'équivoque maintenant, surtout quand il s'agira de la locomotion ordinaire, pour expliquer la position des membres du cheval, dont les particularités de succession et d'ensemble constituent les allures. C'est ici la nature prise sur le fait. Ainsi le numéro 1 nous représente le cheval au *pas* sur sa base latérale de droite, formée par les deux pieds à terre à *l'appui*, éloignés l'un de l'autre de la longueur d'un pas complet.

Cette pose indique bien à l'artiste que lorsque deux membres sont en l'air du même côté, ils sont très-rapprochés l'un de l'autre, car cela ne peut se voir que lorsque le pied postérieur, tendant à se placer sur la trace de l'antérieur, est sur le point d'arriver à son but, en se mettant sur la foulée de ce dernier qui vient de quitter le sol. Cette foulée partage en deux parties égales l'espace limité par les membres à l'appui. La photographie nous montre l'instant, très-court, pendant lequel tout le poids du

FIG. 7. — CHEVAL AU GRAND TROT.

cheval repose sur le bipède latéral, opposé à celui qui est en l'air *au soutien*.

Passons maintenant à la base diagonale droite, présentée par le numéro 2. Les deux membres qui la constituent, par leur appui, sont rapprochés de la demi-longueur du pas et les pieds en l'air éloignés l'un de l'autre. Dans le numéro 3, nous voyons que le pied droit de devant a dépassé le milieu de la phase du *soutien*, qui va seulement commencer celui de derrière, qui lui est opposé diagonalement ; les trois pinces, également espacées l'une de l'autre, touchent encore le sol. C'est cette dernière attitude, nº 3, qui a été choisie par Meissonier dans le tableau auquel nous faisions allusion en commençant cet article, et, depuis lui, les peintres Gérôme, Lewis-Brown, Detaille, Goubie, Guesnet, et, parmi les sculpteurs, Rouillard, Isidore Bonheur et le regretté Cuvelier, se rangèrent franchement du côté de la vérité.

Avant de passer à l'explication des autres fac-simile, disons que, dans la progression, la vitesse du jeu des membres d'autant plus grande que l'équilibre est plus instable : c'est pour ce motif que le pas est l'allure la plus lente, le poids du corps se trouvant supporté alternativement, ainsi que nous venons de le voir, par les divers membres appuyés au sol, soit latéralement, soit diagonalement.

La masse de l'animal est élevée sur quatre supports articulés qui la soutiennent et la font mouvoir ; la myologie enseigne que les muscles la font fléchir et s'étendre pour soutenir et appuyer.

On appelle *soutien*, l'action de la jambe soulevée et portée en avant, en arrière, de côté. L'*appui* se dit de l'effort de la jambe pressant le sol, en quelque sens que ce soit, le membre se mouvant autour du

FIG. 10. — CHEVAL AU GRAND GALOP.

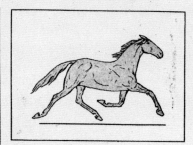

FIG. 6. — CHEVAL AU GRAND TROT.

sabot fixé sur sa foulée ; la progression a surtout lieu sur les appuis qui établissent les *bases diagonales* ; ils offrent plus de solidité, étant les plus rapprochés du centre de gravité. La position d'écartement des *bases latérales* ne s'équilibrant pas avec ce centre, la durée en est moins perceptible à l'œil.

On remarquera que l'empreinte des deux pieds du même côté, dans le *pas*, répond précisément au milieu de l'espace qui sépare les empreintes successives des deux autres.

Le cheval attelé à une voiture faisant 106 mètres à la minute, dont nous venons de donner trois poses successives, complète l'exemple de l'allure *calme* et *basse* du *pas ordinaire*. L'animal ne quittant pas le sol, elle est dite *marchée* et *diagonale*, en ce sens qu'on saisit mieux les appuis diagonaux que ceux latéraux.

La direction nous étant donnée, nous voyons dans l'exemple nº 3 que trois pieds posent à terre un temps très-minime ; ce contact avec le sol constitue un triangle isocèle dont l'espace entre le bipède latéral gauche serait la *base* ; celle-ci équivaudrait à la longueur du pas complet. La hauteur de ce triangle est très-petite et tend à se réduire encore à mesure que l'allure s'accélère.

La question de l'espace parcouru peut aussi trouver ici sa solution, en mesurant dans le numéro 1, de la pince du membre de devant à celle de derrière de la base latérale droite. Prenant aussi sur le numéro 3 la même mesure sur la base latérale gauche, nous avons une longueur identique, qui est exactement celle du cheval, de la pointe de l'épaule à la pointe de la fesse.

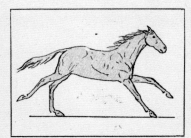

FIG. 9. — CHEVAL AU GRAND GALOP.

Il ne faudrait pas cependant conclure que cette limite d'écartement soit toujours la même pour un cheval accélérant le pas : dans ce dernier cas, je crois, en m'appuyant sur de nombreuses expériences, qu'on se rapprochera de la vérité en limitant l'amplitude du pas à une longueur égalant deux fois la tête de l'animal, plus les deux tiers de cette mesure.

Examinons maintenant les numéros 4 et 5 : c'est le *trot* dans les données ordinaires de deux cents mètres à la minute ; son action est ici parfaitement définie dans les deux périodes que nous présentons ; numéro 4 est l'*appui* ; numéro 5, la *projection*. L'animal entame cette allure par un bipède diagonal, c'est-à-dire que les pieds opposés diagonalement se *lèvent* en même temps, se *soutiennent* et viennent ensemble à l'*appui* pour résister et projeter ce bipède en avant ; tandis que, les autres membres libres ayant gagné de l'espace dans la direction, arrivent à leur tour sur le sol pour y supporter le corps et lui imprimer un nouveau mouvement.

C'est cette période de projection, pendant laquelle les quatre pieds ont quitté terre, nº 5, que choisissent ordinairement les dessinateurs pour représenter le cheval au trot, chaque bipède n'attendant pas, pour se lever, que l'autre se pose.

Presque tous les artistes commettent la faute, lors-

qu'ils veulent faire un cheval au *pas*, de donner l'allure du trot raccourci de la première période, que figure le numéro 4. Les photographies exactes du *pas*, nºs 1, 2, 3, dont nous venons de faire l'explication ne doivent plus laisser de doute sur les positions respectives des extrémités.

Au *trot*, les *battues* sont régulièrement espacées : les quatre pieds n'en accusent que deux ; chaque bipède diagonal arrivant ensemble constitue une seule battue. Cette allure est la meilleure pour gagner du terrain et soutenir une longue course.

Un cheval bien conformé, allant sur un chemin horizontal, devrait, dans le *trot*, placer le pied de derrière sur la trace de celui de devant. De nombreuses observations me firent constater que la pratique de cette allure, quoique assez vive, amenait généralement une foulée du membre postérieur se marquant en arrière du membre antérieur ; c'est cette différence plus ou moins marquée qui constitue le *petit trot*, toujours motivé par une lourde charge, un terrain ascendant et l'excès de fatigue.

Dans le *grand trot*, les foulées des membres posté-

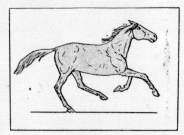

FIG. 8. — CHEVAL AU GRAND GALOP.

rieurs précèdent celles de devant ; on peut obtenir ainsi une vitesse égale à celle du galop, et parcourir en peu de temps un très-grand espace. Les Anglais nomment cette allure vive le *trot volant*, dans lequel les battues sont inégales, et le trot finit par être décousu.

L'exemple de célérité que nous donnons numéro 6 est un cheval dans la période de *projection*. Le numéro 7 le représente arrivant à l'*appui* animé d'une vitesse de sept cent vingt-sept mètres à la minute.

Le *galop* est représenté par onze figures photographiques ; pour donner une idée de cette allure d'une jument faisant onze cent quarante-deux mètres à la minute, nous inscrivons quatre de ses poses, fig. 8, 9, 10 et 11, noires silhouettes, dont nous avons scrupuleusement conservé les contours, en rétablissant seulement le dessin des membres, afin d'en faire comprendre le mécanisme, nous conformant *strictement* à l'explication donnée par M. Muybridge.

Telle extraordinaire que paraîtra la collection de ces mouvements aux artistes qui voudraient les étudier sérieusement, je puis affirmer que la succession de ces silhouettes, placée dans un *animateur* (ancien phénakisticope) donne, une fois la rotation imprimée au cylindre, chaque image se mouvant et accomplissant l'action tout entière des périodes de l'allure du galop. J'en ai fait moi-même l'expérience ainsi que pour *le pas* et *le trot*.

Heureux de présenter au public un document de cette importance, nous dirons, avec M. Tissandier, que c'est pour les artistes un précieux complément aux intéressants travaux de physiologie graphique du docteur Marey sur la locomotion, et un pas de plus dans la voie qui amènera à constater une vérité si difficile jusqu'à présent à vérifier.

DUHOUSSET.

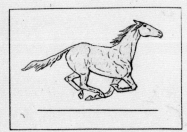

FIG. 11. — CHEVAL AU GRAND GALOP.

cation to them for providing the means for another series of investigations into the attitudes of animals in motion. . . .

I suggested addressing your reply to London, but since then some very important events have transpired which will render an extended stay in Paris necessary; and at the same time relieve me of the anxiety under which as you well know I have for a long time been existing.

M. Meissonier exhibits the greatest interest in the work. . . . Notwithstanding the large prices obtained for his pictures, unfortunately M. Meissonier is far from rich; but his influence with wealthy people is immense; and one of his friends has expressed a desire to associate himself with M. Meissonier, Professor Marey and myself in the instituting of a new series of investigations which I intend shall throw all those executed at Palo Alto altogether into the shade. I have been experimenting a great deal and have no doubt of its successful accomplishment.

You know that upon the completion of the work at Palo Alto, after so embarrassing a time,* I hoped to be in a position, to devote my attention to the development of the ideas which have created so great a sensation . . . thanks to the friendship of M. Meissonier there is now an opportunity of its realization.

Using the photographs I propose to make next year as his text, M. Meissonier intends to edit and publish a book upon the attitudes of animals in motion as illustrated by both ancient and modern artists . . . a most elaborate work, and exhaustive of the subject. It is to be the joint production of Meissonier, Professor Marey, "the capitalist," and myself. . . .

Both [Meissonier] and I considered it appropriate to invite the Governor to join us . . . which we have done by letters. . . .

One of the conditions of the agreement is, that Meissonier is to have control of the results . . . copyrights. . . . In consideration of which I shall receive payment for the time I was occupied at my ordinary rate of payment for work in California, this will of course be quite a sum. M. Meissonier himself is not actuated by any selfish motives, neither do I suppose is his friend (who the "friend" is I do not know) for he assures me he is very rich. . . .

I have had several other propositions made me, among others from Goupil, the fine art publisher. . . . I am desirous of being free from any financial management, or operations, and devote my time unreservedly to work. . . .

If in the course of your travels you should next summer find yourself

* Muybridge was evidently in need of funds when he finished the work at Palo Alto. His income as a free-wheeling, free-lance photographer had been substantial. But during his work for Stanford, other sources were sharply reduced and he had to depend on the latter's largesse for even his personal expenses. This was later referred to scornfully by Stanford protagonists in the lawsuit, but it was evidently unavoidable: Muybridge's work for Stanford left him little time to do anything else.

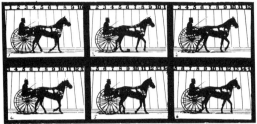

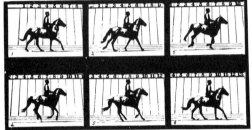

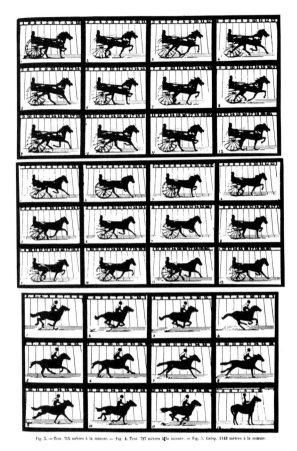

Fig. 124. Pages 24 and 25 of *La Nature,* September 28, 1878, showing the five series of photographs received by its editor, Gaston Tissandier, who said they "could not be overpraised." The first known European publication of Muybridge's motion experiments.

in Paris; make me a visit to my Electro-photo studio in the Bois de Boulogne* and I will give you a welcome. . . .[7]

The "Electro-photo studio" in the Bois de Boulogne was actually something planned if the new project turned out as hoped. But it did not turn out, and Muybridge was soon off to England to enjoy fame in his native land. On March 13 at 5 p.m. he lectured in the theater of the Royal Institu-

* Marey's studio was in the Bois de Boulogne, and Muybridge was evidently anticipating joining him there.

tion (after a rehearsal the week before); on March 16 he lectured at the Royal Academy of Arts, and on the 18th at the Savage Club, where he was elected to honorary membership; on April 4 he spoke at the Royal Society of Arts, and on the 5th at the South Kensington Museum. Everywhere his work caused the greatest interest and astonishment. The Prince and Princess of Wales and their three children, as well as the Duke of Edinburgh, Alfred Tennyson, Sir Frederick Leighton, Thomas Huxley, William Gladstone, John Tyndall, and Sir Lawrence Alma-Tadema were much taken with the lectures. The little princesses laughed heartily, it was said, at some of the pictures, and their father repeatedly asked questions, and borrowed a copy of *The Attitudes of Animals in Motion* to take home. "Mr. Muybridge has, indeed," *The Photographic News* commented, "arrived in London at a fortunate time. Several invitations have been extended to him to assist at fashionable 'at homes' and other gatherings of the *élite*, and to bring his wonderful photographs with him."[8] More than one person responded to Muybridge's appeal for support for further work in England, for which he offered his services gratuitously.

In Liverpool on June 5, on his way back to America, he lectured at the Liverpool Art Club. Before sailing, he told the reporter for *The Liverpool Mercury* that a Robert C. Johnson of San Francisco was now the fourth member of the proposed Marey-Meissonier-Muybridge project.* Johnson came into the picture after an offer of financing by the president of the Royal Society of Arts had been made and withdrawn. The cause of the withdrawal was described by Muybridge himself, many years later. It had obviously been a shock:

> Early in the year 1882 [Muybridge wrote Stanford] I gave a Lecture at the Royal Institution of Great Britain, when I took the opportunity of giving you, what I think you will consider was full and generous acknowledgment for your co-operation and assistance in my work.
>
> This lecture brought me into contact with many persons distinguished in Science or Art or holding the highest rank in Society.
>
> Mr. Spottiswoode—the President of the Royal Society of London invited me to prepare a monograph on Animal Locomotion to be published in the "Proceedings" of the Society, and promised to provide the funds for an exhaustive investigation of the subject to be made under the auspices of the Society.

* A Robert C. Johnson, "capitalist," was listed in San Francisco directories of the time at 120 Sutter Street.

Fig. 125. Title page of *The Horse in Motion* (1882), from which Muybridge's name was excluded. Author's collection.

Fig. 126. Plate XII in *The Horse in Motion* (1882), showing a horse skeleton. Author's collection. This skeleton was gotten from the Chicago stockyards by J. D. B. Stillman, the author of the book, and posed and photographed by Muybridge, who had published the entire series the previous year in *The Attitudes of Animals in Motion.*

Fig. 127. Plate LXVI of *The Horse in Motion* (1882), showing a walking horse from one lateral and four diagonal points of view. Engraving taken from *The Attitudes of Animals in Motion* (1881). Author's collection. See Figs. 91 and 92 for the position of the cameras for the diagonal shots.

THE

HORSE IN MOTION

AS SHOWN BY INSTANTANEOUS PHOTOGRAPHY

WITH A STUDY ON ANIMAL MECHANICS

FOUNDED ON ANATOMY AND THE REVELATIONS
OF THE CAMERA

IN WHICH IS DEMONSTRATED THE THEORY OF QUADRUPEDAL LOCOMOTION

By J. D. B. STILLMAN, A.M., M.D.

EXECUTED AND PUBLISHED UNDER THE AUSPICES OF

LELAND STANFORD

BOSTON
JAMES R. OSGOOD AND COMPANY
1882

125

I was invited to give several private and public repetitions of the Lecture given at the Royal Institution. And altogether a brilliant and profitable career seemed opened to me in London.

In response to the invitation by the President I wrote a monograph on Animal Locomotion, and submitted it to the Council of the Royal Society.

This monograph was examined, accepted and a day appointed for its presentation to the Fellows, and for its being placed in the records of the Society.

I have in my possession a proof sheet of my monograph, printed by the Society, (as is its custom) before [its] being placed on the record of its "Proceedings."

About three days before the time appointed for the reception of my monograph by the Fellows, I received a note requesting my presence at the Rooms of the Society.

Upon my arrival I was conducted to the Council Chamber, and was asked by the President in the presence of the assembled Council, if I knew anything about a book then on the table having on its title page, the following

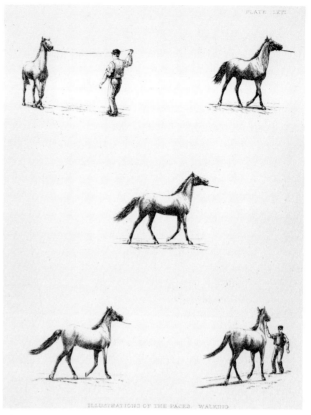

The Horse in Motion
by
JDB Stillman MD

Published under the auspices of
Leland Stanford

there being no reference thereon to Muybridge [Fig. 125].

I was asked whether this book contained the results of the photographic investigation of which I had *professed* to be the author. That being admitted I was invited to explain to the Council how it was that my name did not appear on the Title page, in accordance with my professions.

No explanation of mine could avail me in the face of the evidence on the title page, and in the book before the Council, I had no proof to support my assertions.

My monograph was refused a place on the records of the Royal

Society until I could prove to the satisfaction of the Council my claim to be considered its original author, and until this day it remains unrecorded from the lack of evidence which would be acceptable to the Council, which evidence is at your command.

The doors of the Royal Society were thus closed against me, and in consequence of this action, the invitations which had been extended to me were immediately cancelled, and my promising career in London was thus brought to a disastrous close.

My available funds being exhausted I was compelled to sell the four original photographic copies of

> "The Horse in Motion"*

which I had printed at your request and for your purposes, and with the proceeds of their sale I returned to America.[9]

Soon after his arrival in England, and before his lecture at the Royal Institution, Muybridge wrote to Dr. J. D. B. Stillman, who had planned a book based on the Palo Alto photographs. He had already written from Paris late in 1881 proposing that the two of them collaborate on a book, but had had no reply. He had also had no reply from Stanford about the governor joining him and his Paris friends on the project then proposed. "You are, I suppose," Muybridge wrote Stillman from London, "still writing away . . . if you succeed in getting the work in the market before 1883 I shall consider you very fortunate, who have you arranged to publish it?"[10]

I meet a number of R. A.'s this evening at the house of Alma Tadema [he wrote]. . . . I have had a very agreeable interview with Lord Roseberry [sic, Lord Rosebery, Gladstone's foreign minister] and with a number of other distinguished wealthy men. I anticipate no difficulty in pursuing the investigations on a large and more comprehensive scale than has yet been done and to an exhaustive conclusion, (and I think it probable my anxiety, and financial embarrassment, now of some years duration, is over). . . .† I am promised every facility for work in Paris, but whether I shall commence there or in England I have not yet fully determined. The Prince of Wales takes a great interest in the matter and I am promised an introduction to him on Monday. . . .

Yours Faithfully.
Muybridge.

* Muybridge means *The Attitudes of Animals in Motion*.

† It seems at least possible that although many people had rallied around Muybridge at the time of the Larkyns murder, he was not able afterwards to pursue his profession as vigorously as before. It was one thing to condone what he had done, but quite another to have a murderer in your house, at your ranch, or in your family circle.

Stillman evidently did not like Muybridge personally and did not answer the letter. At about this time, copies of Stillman's book, which had been published in Boston by Osgood and Company at Stanford's expense, arrived in London and Muybridge saw that the title page of the book had omitted any reference to his name. The title page that Muybridge had approved before he left California must have been changed by Stillman with or without Stanford's knowledge. In spite of a very casual acknowledgment in the text of Muybridge's contributions, many of the illustrations were drawn from his photographs (Figs. 126 and 127). When the book's publication was announced in *La Nature*, Muybridge fired off a letter to the editor:

> IN NATURE, vol. xxv. p. 591, you notice the publication of a work entitled "The Horse in Motion," by Dr. Stillman, and remark: "the following extract from Mr. Stanford's preface shows the exact part taken by each of those concerned in the investigation." Will you permit me to say, if the subsequently quoted "extract" from Mr. Stanford's preface is suffered to pass uncontradicted, it will do me a great injustice and irreparable injury. At the suggestion of a gentleman, now residing in San Francisco, Mr. Stanford asked me if it was possible to photograph a favourite horse of his at full speed. I invented the means employed, submitted the result to Mr. Stanford, and accomplished the work for his private gratification, without remuneration. I subsequently suggested, invented, and patented the more elaborate system of investigation, Mr. Stanford paying the actual necessary disbursements, *exclusive* of the value of my time, or my personal expenses. I patented the apparatus and copyrighted the resulting photographs for my exclusive benefit. Upon the completion of the work Mr. Stanford presented me with the apparatus. Never having asked or received any payment for the photographs, other than as mentioned, I accepted this as a voluntary gift; the apparatus under my patents being worthless to any one but myself. These are the facts; and on the face of these I am preparing to assert my rights.
>
> 449, Strand, W. C., April 26 E. J. MUYBRIDGE[11]

When he returned to America, Muybridge did assert his rights in a lawsuit against Stanford, filed in Boston, where the Stillman book had been published. He asked for $50,000 damages. The Osgood books were attached but immediately released under a $10,000 bond. After a considerable amount of testimony taken in San Francisco, the following summer of 1883, the case was settled in Stanford's favor. The following September, the frustrated Muybridge sued Osgood, the publisher. Meanwhile he had lost much financial support for his work.

It is likely that Stillman and others—if not Stanford as well—were put off by Muybridge's evident self-assurance, and even, one might say, his arrogance. But Muybridge's arrogance, if such, was overshadowed by Stan-

ford's and Stillman's own in giving Muybridge so little credit for *The Horse in Motion*. "I employed Mr. Muybridge," Stanford wrote, and that was all that was said of the overwhelmingly significant work that Muybridge had done. It must have been painfully embarrassing to Muybridge to be thought an imposter in the eyes of the prominent persons who had hitherto lauded him extensively. Besides demolishing his reputation in England, it may also have damaged his case in France. There must always have been, in the minds of those who saw *The Horse in Motion*, at least the shadow of a doubt as to who had done what, and the suspicion that Muybridge's claim to major credit for the Palo Alto photographs was questionable.

The
Philadelphia
Years

Help, however, was soon to arrive from another source.

Muybridge sailed from Liverpool for America on the *Republic* on June 13, 1882, and arrived in New York on June 25. "He proposes to gratify, during the coming season," *Anthony's Photographic Bulletin* reported, "the American public with an exhibition of his remarkable productions, of which we hope to give timely notice."[1]

Muybridge's celebrity continued unabated. On July 29, 1882, *Andrews' American Queen* had on its cover a potpourri of drawings from his photographs (Fig. 179); newspaper articles continued to mention his work; and he began a series of lectures in the East that far exceeded his San Francisco ones in popularity. On August 22 he lectured in Newport, Rhode Island, where he may have counted among his audience Fairman Rogers, Thomas Eakins' friend and Philadelphia patron, who owned a great house in Newport; on October 19 he was at the Society of Arts at the Massachusetts Institute of Technology; on the 23rd at Union Hall, Boston; on November 17 at the Turf Club in New York (the present Manhattan Club in Madison Square); on November 28, and again on December 22, at the National Academy of Design—where he gave or sold to the Academy a copy of *The Attitudes of Animals in Motion*. On January 9, 1883, he lectured at the Union League Club in New York; on February 12, at the Academy of the Fine Arts in Philadelphia; the Franklin Institute on February 13; the Academy of Music on February 15; and again at the Academy of the Fine Arts on February 16. Although he was giving each of these organizations—and cities—their first look at motion pictures on a screen, it was the latter appearances that were the most significant. The Philadelphia art establishment got a look at what he had to offer, heard his proposals for further investigation, and shortly decided to put up the money to bring him to Philadelphia to carry them on.

The preparations for the Academy of the Fine Arts lectures give an insight into the mechanics of the lectures he gave. He wrote the Academy from New York on February 3:

> . . . at the suggestion of Mr Fairman Rogers, [I] write to ask you if you will be kind enough to attend to the following particulars, necessary for the successful exhibition of the Zoopraxiscope.
> 1st Upon arrival of the apparatus by Express, to have it carefully stored in some easily accessible place.
> 2nd To have a table constructed as per accompanying drawing and specifications.
> 3rd To see Mr R Munnie of 621 Commerce St, (the agent of the New

York Calcium Light Company) and request him to have delivered at the Academy on *Monday* MORNING, 2 *pairs* of Cylinders (2 oxygen, 2 Hydrogen) each pair capable of running full headway for 3 hours, I think I usually have the "25 feet cylinders." Couplings to accompany cylinders. Also that he furnish 2 capable and handy men to attend to the 2 lanterns used, it is necessary both of these men should be accustomed to run a magic lantern, and change the pictures; and it will also be necessary they should be at the Academy on Monday afternoon to receive instructions how to manage the apparatus which is of peculiar construction; we shall thus avoid any hitch during the lecture. . . . I shall probably also require these *same men* on the next evening . . . and also on Thursday evening.

4th Should the issuance of the invitations come within your province, I shall be obliged by your having the Philadelphia press *well* represented. . . .

<div align="right">

Faithfully yours

Eadweard J Muybridge

</div>

The letter also included rough sketches of the table he wanted for his projector (Fig. 128) and of the throw. The specifications read:

An undressed roughly built, strong table 6 feet long, 4 feet wide on top, 6 feet high. with a platform (for men to stand on) 3 feet from the ground, 2 feet wide along each side of the length, and on *one* end. Some kind of cheap drapery should be hung around the table for its better appearance.

This table will have to be placed 45 feet from where the screen will be hung, *if this distance is convenient it will be best*, but if absolutely necessary it can be farther off or nearer.

My screen is 16 feet square, the bottom of which—if the floor of the room is level—should be not less than 4 feet from the ground.

If the screen can be suspended, 2 feet from the wall so as to hang inclined back at the bottom it will be much the best, thus, if there is no means of hanging the screen it will be necessary to have 2 pieces of scantling, say 2 inches square, or 2 x 3 and 20 feet long to support it.[2]

For a while Muybridge thought that it would be better to use the small room at the top and in the back of the Academy lecture hall—which is today much as it was in 1882—because otherwise the angle of the throw would be objectionable. A letter of February 6 discusses this and other production matters:

It will be *possible* to avail ourselves of the small room for the lanterns, (the window I presume is in the centre) the screen however will have to be tilted in an objectionable manner the source of light being too near the ceiling.

128

129

130

Fig. 128. Muybridge's sketch of the table he wanted built for his lecture at the Pennsylvania Academy of the Fine Arts, Philadelphia. From a February 3, 1884, letter in the Academy archives.

Fig. 129. Copy of a page of Muybridge's July 17, 1882, letter to Marey, giving suggestions for a fenestrated-wheel camera. The California State Library, Sacramento. This is a transcription by a member of the U.S. Embassy staff in Paris, whose imprint can be seen.

Fig. 130. *The Successive Phases in the Motion of a Man Running,* by Marey. From *The Scientific American,* September 9, 1882. Produced, according to the accompanying text, by the method described in Muybridge's July 17, 1882, letter.

I think the table I suggest will be preferable . . . 44 feet from the surface of the screen; the screen is of canvas covered with paper. . . .

The platform on the rear of the table is to support the 4 cylinders of gas . . . it will perhaps be as well to have a slight rehearsal after dark. . . .

Your lecture room is apparently 63 feet long by 40 feet wide, by having the table . . . placed as in accompanying plan a comparatively small portion of the room will be unavailable to the audience.

If necessary I can run the table back against the wall—or as far back as the lantern lens.—which will be 7 $^6\!/_{12}$ feet [*sic*] above the floor—will be able to cover the screen. . . .

We shall have to content ourselves with a projection of about 14 feet square, the table . . . not more than 40 feet. . . .[3]

The audience for the first Academy lecture consisted largely of art students. Thomas Eakins, of course, was also there. But everyone liked it so much that the word got about, and by the time Muybridge gave his second lecture on the following Friday evening, a considerable part of the Philadelphia art establishment was there. Among these must have been Edward Coates, the Academy president; James L. Claghorn, the prominent collector; Fairman Rogers, George Corliss, the Academy secretary; and a Lippincott or two. These were men who felt that art should be encouraged and artists patronized—as long, of course, as they did not get out of hand. Rogers and the Academy paid the expenses of both lectures; Muybridge gave his services for nothing.

Muybridge returned to New York for more lectures at the Photographic Section of the American Institute, Cooper Union, and elsewhere. Meanwhile, the *Journal* of the Franklin Institute published his February 13 lecture. Its title was the same as that given at the Royal Society of Arts—"The Attitudes of Animals in Motion"—and the same as the title of his book. But the text had been changed.

Muybridge must have been living on the proceeds of the sale of his photographs (whatever private means he may have had have not come to light) and an occasional lecture fee. Now, also, he published zoetrope strips from his photographs, announced early in November 1882 (Figs. 115–117). These were very popular as a parlor entertainment.

Meanwhile, Muybridge, whose lawsuit against Osgood and Company was still under way, announced another book—*The Attitudes of Man, the Horse, and other Animals, in Motion*. This was to be published by the Scovill Manufacturing Company, which had made his Palo Alto cameras, and whose address at 419 Broome Street in New York he was still using as his mailing address. There would be a hundred 8″ x 10″ photographs in it, with sub-

scribers being given an additional twenty-four and the privilege of watching the photographs being taken. It was also announced that the book would not be published unless there were two hundred subscriptions of $100 each. The photographs could be selected by each subscriber from a much larger number to be taken.

Marey had been solicited to write an essay for the book and he had also been sent a sketch of a photographic apparatus that appears to have been crucial to his work (Figs. 129 and 130). Photographic publications, indeed, were consistently giving Muybridge credit for much of Marey's recent success.*

H. W. Vogel, the celebrated photographic scientist, now also gave Muybridge credit for stimulating Ottomar Anschutz to do his first work. Anschutz, however, used the new dry plates, whereas Muybridge had used wet collodion. For his next work, however, Muybridge also used dry plates. Vogel prophesied this in *The Philadelphia Photographer*:

> Muybridge's celebrated pictures of the horse have excited photographers here to emulation. Unlike Muybridge, they employ gelatine plates instead of wet collodion. Herr Anschutz has obtained, in this manner, some charming results. They are seven by nine inches in size. Our Society has square-shaped pictures, and their sharpness is remarkable, considering that they are thirty times enlarged, and that the horses have been taken while on a leap, or during some other rapid movement. They are regarded as the best productions of instantaneous pictures that have as yet been taken. I presume that Mr. Muybridge intends to make use of the improved gelatine plates in his new investigations, and, judging by the ripe experience he already possesses, the results promise to be extraordinary.[4]

Meanwhile, a number of Philadelphia gentlemen had decided to sponsor a new, elaborate series of experiments. At a meeting in the provost's office of the University of Pennsylvania on August 7, 1883, attended by, among others, Joseph Harrison, who was later to give the university half a million dollars for its expansion program; George Barker, the distinguished physicist; J. B. Lippincott; Coleman Sellers; and the provost himself, William Pepper, it was decided to grant Muybridge the use of the grounds of the Veterinary Hospital

* Marey's photographic gun was now being described in the press. Muybridge, back in New York on July 17, 1882, sent Marey sketches of an apparatus with two slotted wheels moving in opposite directions—Marey's gun had one such wheel, which moved in front of a starting-and-stopping photographic plate. The new apparatus, with more slots, Muybridge thought, would be faster and more regular in its movements. A "Marey wheel," with a starting-and-stopping plate, was used in early work at the University of Pennsylvania. Eakins' use of it gave uneven results. Later work with a modified version incorporating Muybridge's wheels moving in opposite directions gave better results (see page 159).

"for the prosecution of his work on the investigation of animal motion."[5] The next day Pepper wrote Muybridge the news and things were off to a flying start. Muybridge, in Boston on the way to visit his friend William Bradford, the New Bedford marine painter, wrote Pepper that the conditions for the $5,000 advance were "entirely reasonable":

> My dear Sir.
> I received your kind letter of the 9th Aug. yesterday only, it having been delayed in New York in consequence of the absence of Mr Bradford and finally reached here during my own absence in Maine.
> I will now merely thank you for having so favorably consummated the arrangements for the advance of the $5000 I estimate as necessary to complete the photographic investigations of the "Attitudes of Animals in Motion" and will reserve for a more fitting opportunity my acknowledgment of your appreciation of the value of the proposed work.
> The conditions imposed in consideration of the money being advanced are entirely reasonable, and are such as I should have voluntarily accorded, I therefore accept them without qualification. viz.
> "That the work is to be done in the enclosure of the Veterinary Department of the University of Pennsylvania during the spring and summer of 84; the publication is to be made as 'under the auspices of the University of Pennsylvania' and that the money thus to be advanced is to be secured by the subscription list of the proposed publication which I am to bring up to the point where it will cover the amount advanced." . . .
> I agree with you as to the desirability of a consultation as early as convenient with Mr Rogers and yourself. . . . In a few days I am going to New Bedford to make some experiments at Mr Bradford's studio. . . .
> Regretting the delay of my reply. . . .[6]

The $5,000 was to prove woefully inadequate for the work that was finally done—the final cost ran to more than $40,000—and it is not unlikely that Muybridge knew that it would not be enough, and simply wanted to get his foot in the door. The address, incidentally, was that of Charles Scribner's Sons, the publishers, upon whose letterhead Muybridge wrote this letter to Pepper. Perhaps, since subscribers for his new book had not come forth, he was looking for a publisher and happened to be in the Scribner office when he decided to write Pepper.

He stayed with Bradford at least until the end of September, and while in New Bedford gave a lecture on September 26. I have found no record of further lectures until the one he gave at Association Hall in Philadelphia on February 8, but that lecture had been planned several months earlier, and so it is clear that Muybridge was keeping in close contact with the Phila-

131

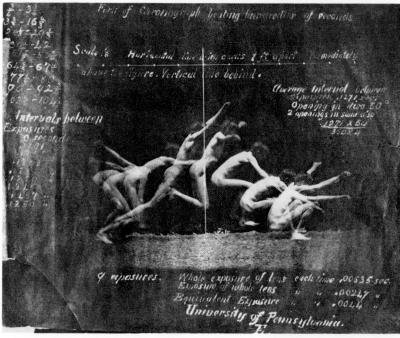

132

Fig. 131. Thomas Eakins at thirty-five to forty.
1879–84. Photographer unknown. Collection
Mr. and Mrs. Daniel Dietrich, II, Philadelphia.

Fig. 132. Thomas Eakins' *History of a Jump,*
with Muybridge's notations. 1884. From *The
Burlington Magazine,* September 1962.

Fig. 133. Thomas Eakins' photographs of
Jesse Godley taken with apparatus suggested by
Muybridge. 1884. The Philadelphia Museum of
Art, gift of Charles Bregler.

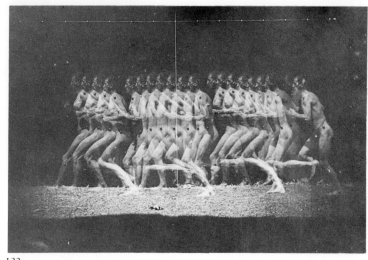

133

delphia sponsors of his work, and making plans to commence it as soon as it got warm the following spring. Thomas Eakins was a member of the commission the university set up to supervise Muybridge's work, and had himself now taken up instantaneous photography; he even demonstrated a new rapid shutter he had devised before the Photographic Society of Philadelphia.*

On January 7, 1884, Osgood answered Muybridge's complaint of the previous September. The papers in this suit may be seen in the records of the court. Stillman in California heard of the Osgood suit and wrote Stanford, who had sailed for Europe on the *Britannic* with his wife and son on May 26. Should he file suit against Osgood? Stanford was not well but, because Mrs. Stanford wanted to stay, he had no plans for returning, and wrote Stillman to wait until he got back. Meanwhile, Leland Jr. became ill in Naples and, despite every effort to save him, died in Rome on March 13, 1884. An *In Memoriam* for the occasion exceeds most such documents in sentimentality, even in that sentimental era:

> He was well enough to leave Naples for Rome, but his health did not improve and it was deemed advisable to take him to a more bracing climate. So Florence was reached the 20th of February, and there the fever which had been smouldering within him broke out in all its malignity. For three weeks alternate hope and fear reigned in the darkened room, while the silver cord was loosening day by day. His mind was lucid at times and at times wandering, but even in his delirium he was always the pure-hearted youth that he had been in health. Not one word did he utter in all that time that he would not have spoken before his mother. He would wander to his horses and his museum, go over his studies and his pleasures, but in delirium and weakness his lips were what his thoughts had been in his strength—clear and untarnished. But the God who sees not as man seeth had decided that the spirit should return to him who gave it, and on the 13th of March, fifteen years and ten months after his birth to a transitory life of care and trouble, Leland Stanford, Jr., was born again to the higher life of eternity.[7]

Stanford himself lived on until 1893, and his wife died in 1906—not, however, in the San Francisco earthquake and fire of that year, but in Hawaii, where she had gone for her health. Nevertheless, by 1884, when Muybridge's work for the University of Pennsylvania began, the Stanfords had effectively passed out of his life.

*I have described Eakins' work in photography in my book *The Photographs of Thomas Eakins* (New York, 1972). It is further discussed in my biography of the painter, *The Life and Work of Thomas Eakins* (New York, 1974).

In the reports of the February 8 lecture at Association Hall in Philadelphia the Philadelphia public was first informed of the impending work at the University of Pennsylvania. The same report also gave a glimpse into Muybridge's personality:

By means of the zoopraxiscope—a new invention—Mr. Muybridge was enabled to portray on the canvas the movements of different animals, going at all gaits. One interesting picture was that of a horse jumping hurdles, another was that of a man turning somersaults on the back of a horse going at full speed. These innovations in the art of the magic lantern displays were received with admiration. Mr. Muybridge will make further study of his theory this summer under the auspices of the University.

The only unpleasant feature of the evening was the presence of a number of students who felt called upon to interrupt the lecturer whenever the name of the University was mentioned. The caliber of the crowd was pretty well shown by the applause which followed an incidental remark of Mr. Muybridge to the effect that some of the students "had more muscle than brain."[8]

The *Press* added the further intelligence that the lenses were then being manufactured in England, and that "although each volume is to be sold for $100, and, although not a single picture has yet been taken," there were already 120 subscriptions.[9] J. B. Lippincott had advanced the money for the lenses, and Pepper wrote him that after the work was done the lenses would be sold and Lippincott would get his money back with 5 per cent interest. The Muybridge Commission was appointed by Pepper in March, and had its first "meeting for organization" in April. Seven of the nine members were on the faculty of the University of Pennsylvania: Provost William Pepper; Joseph Leidy, Professor of Anatomy; George F. Barker, Professor of Physics; Rush Shippen Huidekoper, Professor of Veterinary Anatomy and Pathology; William D. Marks, Whitney Professor of Dynamical Engineering; Harrison Allen, Emeritus Professor of Physiology; and Lewis M. Haupt, Professor of Civil Engineering. The other two members were from the Academy: Edward H. Coates, its president, and, of course, Eakins.

Eakins, with his genius for investigation and his particular relationship to Muybridge, may have put Muybridge on to photographing humans in motion, and may indeed have persuaded Fairman Rogers to encourage the new University of Pennsylvania work. Of all the commission members, he took the greatest interest in the work. Besides his tremendous work load at the Academy and in his own studio, Eakins collaborated with Muybridge at the university from the beginning of the summer of 1884 until at least the end

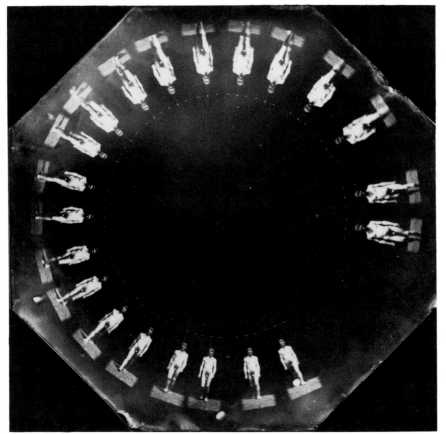

134

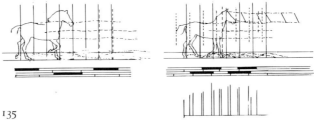

135

Fig. 134. Thomas Eakins' photographs of his pupil, J. Laurie Wallace. 1884. The Franklin Institute, Philadelphia.

Fig. 135. Glass slide from Muybridge's photographs used by Eakins in his Pennsylvania Academy of the Fine Arts classes. 1883. The Franklin Institute, Philadelphia. The drawings are by Eakins' pupil, Ellen Wetherald Ahrens.

Fig. 136. Thomas Eakins astride his horse Billy in an attempt, possibly by Eakins' pupil Samuel Murray, to stop motion. *Ca.*1892. The Philadelphia Museum of Art, gift of Charles Bregler.

136

of the year. With a camera based largely on a design by Muybridge, he himself took a number of attractive—even beautiful—motion studies. (Figs. 132 and 133).* Thomas Anshutz, another Eakins pupil, described the Muybridge-Eakins work in a letter to a friend:

> But instead of talking art I will tell you what is going on in photography. Muybridge as you know is carrying on his scheme over at the University. He has a small enclosure . . . also a machine for taking views on one plate, of moving objects, by opening and closing the camera rapidly at the rate of about 100 exposures per second. This shows the moving object not as a continuous smear but shows one clear view at every 2 or 3 inches of advance. The exposures are made by two large discs with openings cut around their circumferences. They run in opposite directions and are geared to run very fast, the exposure is while the two openings meet. The lens remains uncapped until the object has reached the edge of the plate.
>
> Eakins, Godley and I were out there yesterday trying a machine. Eakins had made one of the above design except he had only one wheel. We sewed some bright balls on Godley and ran him down the track. The result was not very good although you could see the position of the buttons at every part of the step [Fig. 133].
>
> But afterwards Muybridge took him with his machine and got a very good result even showing his black clothes.
>
> Eakins is on the committee which superintends Muybridge. He is of course much interested in the experiments. Muybridge has not made very rapid progress and the University people seem to be losing faith in him. But he showed a good result yesterday on the machine. . . .[10]

Muybridge's photographic setup is illustrated in a book published after the work was done, *Animal Locomotion, The Muybridge Work at the University of Pennsylvania* (Fig. 138). He also photographed animals in the Philadelphia Zoo (Figs. 140 and 141) and in the Gentlemen's Driving Park (Fig. 142). But his principal location, where the large majority of his photographs were taken, was on the grounds behind the University Hospital, within a stone's throw of the operating amphitheater of the Veterinary Hospital (Fig. 143). His method was similar to that used in Palo Alto, but the background, instead of being a glaring white, was now black with white strings stretched in front of it (*e.g.*, Figs. 144 and 145). This was because he could now use dry plates, which required less light for a good exposure.†

* I have published all of Eakins' known motion studies in *The Photographs of Thomas Eakins*.
† This is not to say that wet collodion plates did not occasionally equal the new dry plate in speed. The manipulation of chemicals that Muybridge himself accomplished at Palo Alto astonished many in the photographic world as being beyond anything they thought possible in wet-plate photography.

137

He also contrived, with the help of his University of Pennsylvania colleagues, a new electro-exposing device, by means of which the camera shutters were released automatically and independently of the subject. The Palo Alto horses had first broken the release strings themselves, and later had caused the release when a sulky wheel passed over wires laid on the ground. The new apparatus made the release process much more regular and reliable.

The lenses were by Dallmeyer with 2½″ or 3″ apertures and 12″ and 8″ focus. The twenty-four cameras in the camera shed used 4″ x 5″ plates. Later, for diagonal photography, 8″ x 10″ Cramer glass plates were cut into strips 10″ long and from about 2¼″ to 3¼″ wide, enabling Muybridge to get two and sometimes three strips of glass from one plate. These strips were again cut into tiny pieces and each piece was then placed in the series camera (Figs. 146 and 147). Exposures were made electrically and the plates removed and developed. This resulted in glass positives, or diapositives as they were then called. These small positives were then mounted on a large glass plate in proper sequence and a gelatine negative was made from them by contact. These gelatine negatives, of which a number still exist, were used for printing.

In some of these prints part of Muybridge's apparatus can be seen (Fig. 148). Others are remarkable for both their scientific interest and beauty (Figs. 149–163). Today, after nearly a hundred years, they are still unequaled.

Three of Muybridge's University of Pennsylvania workbooks are now

160

Fig. 137. Movement of the hand; hands changing pencil, plate 536 of the University of Pennsylvania series. Photographs by Muybridge. The Philadelphia Civic Center Museum. The model was Thomas Eakins, called "a well-known instructor in art" in the catalogue.

Fig. 138. The camera house for the University of Pennsylvania work. From Marks *et al., Animal Locomotion: The Muybridge Work* . . . (Philadelphia, 1888). Author's collection. This building contained twenty-four 4″ x 5″ cameras for lateral photography. The recently built amphitheater of the university's veterinary school is in the right background. (See *Fig. 141.*)

138

in the George Eastman House in Rochester, New York. Two of these are either in Muybridge's hand or contain emendations by him, and cover the work from May 2 to October 28, 1885, when much of the university work was done. Dates, the number of the series being shot, the name of the model, the motion being photographed, the number of lateral exposures, the number of frontal exposures, the time that elapsed between exposures, and any remarks that were thought necessary—all are recorded. Much the same material is given in the *Prospectus and Catalogue of Plates* (Fig. 164), where the time is expressed in such numbers as 350, 165, 532, 92, etc., indicating thousandths of a second. Thus, if the figure is 532, this means that the exposures occurred slightly more than half a second apart; if 92, slightly less than one-tenth of a second apart. Occasionally "4 x 5 plates" appears, indicating that the series was taken with the 4″ x 5″ cameras in the camera shed.

The third Eastman House workbook is titled "Transcript/Positives B," and is a record of the work of collating the many thousands of glass positives that Muybridge began about November 6, 1885, and continued for a year or so. Now it was necessary to look over what had been done and to decide whether or not any of it needed to be repeated. A total of 781 plates were finally printed, each containing up to 24 photographs. Thousands more were rejected. It has been said that 30,000 photographs were taken by Muybridge during his University of Pennsylvania work. Henry Bell, who did most of

Muybridge's darkroom work, later wrote that he himself had processed 1800 dozen—or 21,600.

Among the unconventional photographs taken were cases of abnormal movements. Muybridge tried, with the aid of Dr. Francis X. Dercum, a distinguished specialist, to arrange for the photographing of "interesting cases" from Blockley Hospital for the Poor, across the street from the university. But at first the photography of actual patients was not permitted, so that the photographs were taken of a normal woman who allowed herself to be given shocks (Figs. 165 and 166).

> Yesterday afternoon at the almshouse, Edward Muybridge, photographer, and Dr. Dercum, of the University of Pennsylvania, appeared before the Hospital Committee of the Poor Guardians, and asked consent to the removal of interesting cases from the Philadelphia Hospital to that of the University, in order that they might be instantaneously photographed by Mr. Muybridge. Application was made at a previous meeting, and the Committee postponed action until yesterday. The physician stated that Muybridge had facilities and materials for the work which would probably never again be presented.
>
> The Committee previously thought that their institution would derive no credit from the work, and that lives would be endangered in removing patients. It was stated that the plan was backed by members of the alumni of the University, and that the art work would be the sole property of Mr. Muybridge, while the Philadelphia Hospital would not reap the benefit of the clinics. Guardian Daly's motion to accord Muybridge the privilege of photographing cases without removing them from the hospital was unanimously adopted.[11]

Later, however, the Board of Guardians changed its mind about using patients, and Dercum was allowed to bring certain cases over to Muybridge's outdoor studio (Figs. 167 and 186). A total of twenty-three such models were photographed (Plates 537–41, 546–62). The artificially induced abnormal movements by the volunteer model were published as Plates 544 and 545.[*] Years later Dercum, taking umbrage at an article by George E. Nitzsche, wrote an interesting account of his association with Muybridge:

> . . . the members of the Commission which had been appointed to assist him, left on their various vacations and poor Muybridge was left alone.[†] . . . I voluntarily gave up my summer vacation for two successive years; and

[*] Curious punctuation in the *Prospectus and Catalogue of Plates* confuses the issue, although the numbers of the plates are clear: "17, 19, 21; 74 to 91, inclusive; 92 and 94 were patients of the University and Philadelphia Hospitals"—the numbers referring to models.

[†] Always excepting, of course, Thomas Eakins, who regularly gave up much of his summer vacations for work.

due to my connection with various athletic societies and various trotting organizations, I was able to furnish him with abundant material. Much of our work was done in the studio back of the University Hospital; much also was done at what was then known as the Gentlemen's Driving Track [Park] and which is now part of the West Fairmount Park.

Among the studies which I made [*sic*] were also photographs of convulsions in the human being. Such photographs had never been made before. The photographs were the more interesting because they were induced by myself *artificially* in the person of an artist model who willingly gave her consent to the experiments. . . . Such patients of the Nervous Wards as I selected were brought over. . . . I also worked with Mr. Muybridge at the Zoo. . . .

the test . . . was made . . . to determine . . . the possibility of obtaining pictures in the shortest possible time with . . . apparatus which consisted in part of an old large sulky wheel which I combined with apparatus borrowed from the physiological laboratory of the University. The exposure consisted of a rapid series of pictures taken on *one* plate, Mr. Muybridge himself acting as the subject ascending a stairway [Fig. 169]. . . . From the data furnished, I calculated the exposure as 1/4800 part of a second. The calculation, you will recall, was confirmed by yourself; at that time you were connected with the laboratory of physics.*. . .

Besides, I knew Mr. Muybridge intimately and well. He frequently dined at my house. He was an Englishman by birth. He possessed strong and regular features and a most attractive personality. In his mental make-up, he was more like Thomas A. Edison than any other man whom I ever knew. He called on me after he made his trip to Europe of which he gave me a most interesting account. Subsequently he went west. The disposal and placing of his wonderful plates occupied much of his time and attention. I saw him also at the Great World's Fair in Chicago in 1893 at which he displayed his motion picture, the first of the kind ever exhibited. Both he and I were very busy afterward and in time our correspondence lapsed. . . .[12]

In the midst of this schedule Muybridge still found time occasionally to talk to the students and faculty about his work, which was now beginning to cost more money than had been anticipated—at least by the university authorities. One such lecture occurred during early August, and was described by Eakins' pupil Thomas Anshutz, one of several Academy students to attend:

We were all out to the University to hear Muybridge lecture. It was the same he gave us last year but not so well given as his lights would not work well, and the University boys were too anxious to exhibit their

* Dercum is writing to Dr. Arthur W. Goodspeed, for many years head of the Physics Department of the university. The Eastman House workbooks indicate that these sulky-wheel photographs were taken on October 5, 1885.

Fig. 139. The electric release mechanism used in the University of Pennsylvania experiments. The Smithsonian Institution, Washington, D.C.

Fig. 140. Fold-out from Marks *et al., Animal Locomotion: The Muybridge Work....* Based on Plate 733 of the University of Pennsylvania series; photographs by Muybridge. Muybridge had "the good fortune," his colleague Harrison Allen wrote, "to dissect the limbs of an elephant."

Fig. 141. Map of the University of Pennsylvania campus, showing Muybridge's photographic installation. 1885. From *University of Pennsylvania Catalogue and Announcements, 1885–86.* University of Pennsylvania archives.

Fig. 142. The extreme right, bottom-row photograph of plate 750 of the University of Pennsylvania series. August–September 1884 or August 1885. Photograph by Muybridge. Lantern slide. The Kingston-on-Thames Library and Museum, Kingston-on-Thames, England. The sloth was photographed in the Philadelphia zoo. Muybridge must have had trouble with projectionists' putting this slide in upside down—thus the emphatic inscription.

Fig. 143. *Trotting; sulky; bay horse,* plate 605 of the University of Pennsylvania series. Photographs by Muybridge. Author's collection. The horse was called Reuben. A comparison with Fig. 104, for example, shows considerable technical advance from the Palo Alto days—thanks in part to the new dry-plate method.

139

141

142

140

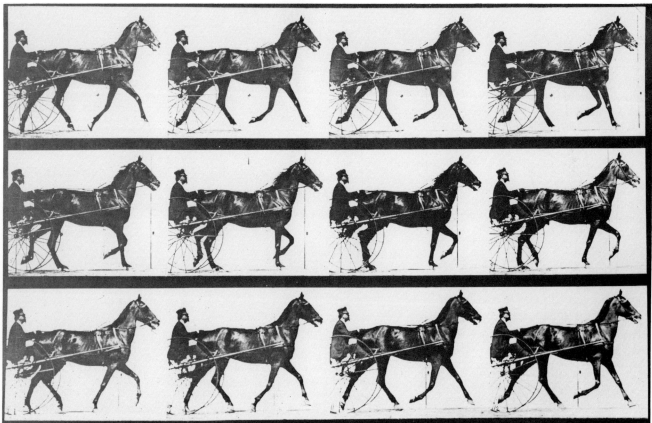

143

tricks which desire also seized our boys and quite a laugh was raised by some one saying, "O mom, there goes our Willie," as Fromuth escorted a lady across the hall.

Muybridge has done no new work but he says he will this summer. . . .[13]

During August and September 1884 and August 1885 Muybridge and his assistants visited the Philadelphia Zoo and took a number of photographs of wild animals, including birds. "In photographing objects at the Zoological Gardens," the *Inquirer* of March 24, 1885, reported, "no material difficulty was encountered till the carnivora were reached." They could not be taken out of their cages—that "was not to be thought of"—and going into the cages was "equally open to objection." So the lion, for example, had to be photographed through the bars of his enclosure, and the shadows of the bars made him look like "a tiger or a zebra."

Later in August Anshutz described the difficulty Muybridge had in the first summer's work with his overlapping images. At the same time he spoke of Eakins' work:

> You want to be kept posted on the Muybridge business. Well he is making some very nice photographs of men and women doing things. Such as throwing, jumping, stepping down and up etc.
>
> These are all made as I crudely explained on one plate. So that it shows the figure at intervals of a few inches as it goes through the movement. These images, of course frequently over-lap but do not seem to confuse on that account. This work is, of course, done with one lense.
>
> He has not yet done any work with his series of lenses and I hear they do not work. The shutters are too clumsy and slow. The university people are dissatisfied with the affair as he cannot give them the result they expected. Which was to photograph the walk of diseased people, paralytics etc. so that by means of the zoopraxiscope (help!!!) they could show their peculiarities to the medical student. This it seems however cannot be done even with the best known contrivances. So they would like to fire the whole concern but they have gone too far to back out.* Eakins is still interested in it. . . .†[14]

New Cramer "Lightning" plates were announced in October, said to be twenty times as sensitive as the old wet collodion.

* Anshutz is unfair here. He must have seen the report of the Poor Hospital's refusal to allow their patients to be photographed in Muybridge's studio. The difficulty of doing the work in the hospital itself would have been nearly insuperable.

† See my *The Photographs of Thomas Eakins* for a fuller discussion of Eakins' interest in the Muybridge work at the University of Pennsylvania at this time.

Just before Christmas, far away in California, little Florado Muybridge, now aged nine, was discharged from the Protestant Orphan Asylum and given into the charge of a harness maker's wife near Sacramento. Evidently it was thought that Christmas would be pleasanter in a home than in the asylum. Whether or not Muybridge was responsible for this action or even knew of it we do not know.

Another question also remains: did the University of Pennsylvania people know of the Larkyns murder when they hired Muybridge to do this work? It is likely they did: it was a *cause célèbre*, and eastern papers carried accounts of it. The story was well known in photographic circles, and many Philadelphians were active in that field. It must have been common gossip at the Photographic Society of Philadelphia, insofar as that body's sense of propriety would have allowed. Surely everyone knew about it but went out of their way to avoid mentioning anything embarrassing to their distinguished visitor.

This same winter of 1884–85 saw the construction of the new diagonal apparatus, cameras with twelve shutters that could be fitted with the twelve small negatives cut from larger plates. The new apparatus, *The Philadelphia Inquirer* reported, "now forms a light load for two men."[15] Previously it had been very cumbersome. This winter, too, Queen and Company of Philadelphia had constructed, under the direction of William D. Marks, a member of the Muybridge Commission, a chronograph, a remarkable instrument designed to measure Muybridge's rapid exposures. This instrument can be seen in Eakins' portrait of Marks.

The season of 1885 was partly spent in an occasional retaking of photographs of the previous summer. Return visits were made to the zoo and to the racetrack. Muybridge was now using half a dozen assistants. Some of these were photographed at the University Hospital site (Fig. 170). One, L. F. Rondinella, was later to write an interesting, firsthand account of his part in the Muybridge work:

> As I am the man who (more than forty years ago) was the undergraduate student at our University who served as "chief of staff" for Eadweard Muybridge during the two summers that he made his photographic investigations of animal motion, I had a personal part in the making of all his pictures and scientific records. . . .
>
> The photographs and scientific records of normal and abnormal, human and animal movements which Mr. Muybridge made under the auspices of our University were taken during the summers of 1884 and '85—the human subjects and domestic animals in an outdoor studio built

on the back part of the ground now covered by the Maloney Hospital*—
the wild animals and birds in our Zoological Gardens,—and the racing
horses in the Gentlemen's Driving Park at Fairmount. In the University
Studio there was a permanent horizontal battery of twenty-four cameras
under cover and placed about six inches between centers, each contained
in a portable box so that it could be set up anywhere with its line of
successive centers either horizontal or vertical. At the Studio, 12 or 24
of the large cameras were used,—sometimes in conjunction with 12 or 24
of the small ones when simultaneous views of the subject were taken
from perpendicular (and sometimes also from intervening oblique) points
of view. For outside work, all of the actuating and recording apparatus
were used with the two portable batteries of cameras,—the latter placed
end-to-end when it was desired to analyze the complete movement into 24
component parts, or with the two batteries viewing the subject at right-
angles when it was desired to show the corresponding forward and side-
wise motions for 12 component parts of the complete movement. . . . There
were . . . large portable backgrounds . . . and others of white with black-
line squares to be substituted with dark colored subjects, and these were
used in the work at the Driving Park. . . .

All of [the electrical work] was done by me, with Mr. Wm. A. Bigler,
'86 (now deceased) acting as my substitute during a week's absence the
first summer. In addition to us and [Thomas C. and Edward R. Grier] a
very important member of the working staff was Mr. Henry Ball [actually
Henry Bell], to whose skillful manipulations in the dark-room was due the
fact that very few of the sensitive photographic plates were spoiled before
or after their exposure. Mr. J. Liberty Tadd, artist and first principal of the
public School of Industrial Art, was very helpful in obtaining suitable
models, and Dr. Horace Jayne of the University School of Biology, assisted
in the later calculation and tabulation of the scientific records. . . .

During one of the earlier two summers of Muybridge's experiments we
devised a carriage to which a large snapping turtle was strapped on his
back, his under shell removed, his heart was exposed, and as his carriage
was drawn under one of the portable batteries of twelve cameras pointed
downward, we made successful series of twelve photographs each, ana-
lysing his heart beats. . . .[16]

Thomas Eakins must also have been useful in arranging for models—he
himself posed for Muybridge, as Muybridge may have done for him (Figs.
137 and 171). Tadd's widow later wrote that both she and Tadd as well as
their daughter, "the child seen in most of the photos," posed for Muybridge.
She "spent the greater part of three days a week for nearly three months with

* Now called the Maloney Memorial Clinic, on Spruce Street between 34th and 36th.

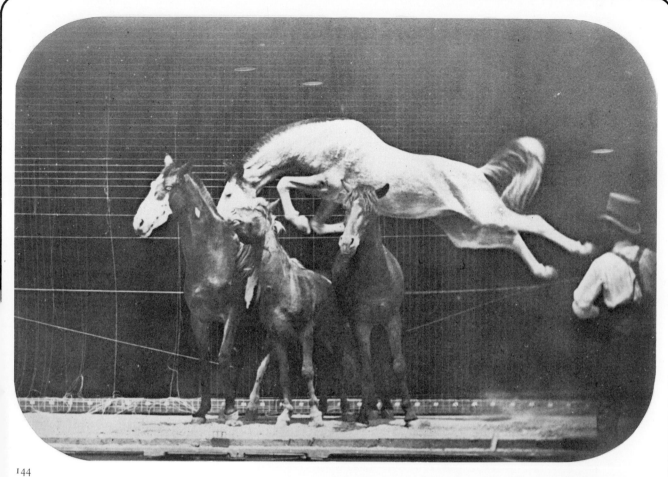

144

*Fig. 144. Jumping over three horses
...chestnut horse Hornet,* second
photograph from right, top row, of
plate 648 of the University of Pennsyl-
vania series. Photograph by Muybridge.
Lantern Slide. The Kingston-on-
Thames Library, Kingston-on-Thames,
England. A more nearly complete print
than was published on the plate.

Fig. 145. The second photograph
from the left, bottom row, of plate 758
of the University of Pennsylvania
series. Photograph by Muybridge.
Lantern slide. The Kingston-on-Thames
Library and Museum, Kingston-on-
Thames, England. This was a favorite
with Muybridge's lecture audiences.

145

[Muybridge] and saw the true worth of the man."[17] The open-heart pictures have not been found.

Another Philadelphian who knew Muybridge during his time at the University of Pennsylvania was Edward T. Reichert, a physiologist who worked on the open-heart photographs. He described the photographer as follows:

> He took luncheon with me quite frequently. From the time I began my researches in the University, I had my lunch in the laboratory and always kept "open house" and a spare "cover" for any one who might drop in. It was during these mid-day hours we discussed almost countless matters connected with his work, and I became intimately acquainted with the most eccentric man I ever knew intimately. He was very much of a recluse, so that very few got to know the man, and likely no one ever learned hidden secrets that must have radically influenced his life.[18]

Later, when Muybridge had finished his work at the university and went out lecturing and soliciting subscriptions, Reichert saw him again on a return visit to the campus:

> He dropped in at lunch time. . . . He appeared to be oppressed even morose, said very little about his experiences in endeavoring to dispose of his pictures, and said nothing about a resumption of his work, or of any plan for the immediate future. I never saw or heard of him, directly or indirectly, since. He surely was a strange character, but withal very like-able when you knew him well.

One of Muybridge's student assistants, Edward R. Grier, thought he was "a peculiar man. . . . I have seen him with only shirt, pants and shoes on and pants so decrepit that it was not safe for him to go outside of the studio."[19]

A conversation about Muybridge's clothing with Provost Pepper is also recorded. Now that Muybridge was connected with a great institution, Pepper told him, he must be more careful about his dress. "What's the matter with my dress?" Muybridge asked. "Take for example your hat," Pepper replied; "it has a large hole in it through which your hair is protruding." Muybridge then looked at his hat and said, "Why, it *does* have a hole in it."[20]

Erwin F. Faber, who drew the figures for the zoopraxiscope discs, also remembered the photographer:

> I well remember the impression Muybridge made. He was a man of about 5 feet, 8 inches, in height, with long flowing beard and his hair stood out from under his black felt hat almost to the width of his shoulders. He so resembled Santa Claus that often the children on the street stopped him. . . .

While working with him I had occasion to go to his room. It was in the second floor of a house on 33rd Street, south of Woodland Avenue. . . . Muybridge lived very modestly . . . cooking most of his very simple meals. He had one curious idea—that was that lemons were good for him, and he certainly consumed them by the dozen. He smoked a pipe and occasionally cigars. On one occasion he handed me one to try. I couldn't refuse—and had to take it. It took some courage to go on smoking it, for one or two puffs made me positively dizzy. He watched my face for some expression of approval of the brand—and then—"Faber, what do you suppose I paid for them?" "Well," I answered, "I shouldn't say less than $5.00 per hundred." Awfully pleased, Muybridge said, "No, sir, sixty-five cents for fifty.". . .[21]

Another colleague remembered that a lunch specialty was cheese—for which he shopped way down on South Street—with live maggots in the holes. The maggots, Muybridge explained, were simply large "cheese germs."

By December 15, 1885, Muybridge had nearly finished his work, and he now began the enormous task of collating his photographs, mounting them on the cumbersome glass carriers, and sending them off for reproduction. This work was completed by the following January 19. The secretary of the university wrote to Charles Harrison, one of the Muybridge guarantors, about the lenses Muybridge had used. Evidently J. B. Lippincott had put up the money for the first set of lenses, and Harrison the money for a second set:

Now that the Muybridge work is over and he has given his camera boxes to the University, what are you going to do about those valuable lenses? Morally they belong to you who advanced the money, but legally to the U. They were imported free in her name and for her use. It is time to meditate thereon. They are very valuable, and too numerous to be kept for any possible use hereafter.[22]

The following year, Muybridge himself began selling the lenses in order to reimburse the investors.

While he was collating his work, Muybridge apparently continued to make additional motion studies: *The Pennsylvanian* reported on May 5, 1886, that one of the students had "again been successfully photographed." During this period Muybridge made himself available for other campus photographic work. One such venture was his photographs of the cast of *The Acharnians,* a Greek play the students produced in May 1886. These were taken in the foyer of the Academy of Music (Figs. 173 and 174). Although some, including the *Pennsylvanian* reporter, did not think the photographs successful, three of them were published in *Harper's Weekly* late in the year (Fig. 175).

146

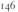

147

Fig. 146. The front of one of the series cameras used at the University of Pennsylvania for diagonal photography. From the original negative by Muybridge, courtesy of the University of Pennsylvania archives. The plate holder is at the top; the lens at the left was used for focusing.

Fig. 147. The back of the preceding, showing the electromagnetically released shutters, in back of which the plate holder (preceding illustration) was fixed. From the original negative by Muybridge, courtesy of the University of Pennsylvania archives.

Muybridge offered to take instantaneous shots of the Greek play in the football field, since his Academy of Music photographs were not generally liked. But plans for these were abandoned, "owing to the difficulty of arranging the scenery."[23] There is also some evidence that he photographed Eakins' great painting *The Agnew Clinic.*

By August 25, 1886, the plates to be published had evidently been chosen, for on that date Muybridge wrote a note to the Academy of the Fine Arts on an announcement of the *Prospectus and Catalogue.* A letter of September 27, 1886, from Edward H. Coates to William Pepper, indicates that by this time 781 of the plates had been selected for publication. The original plan was to publish along with the plates three treatises on the work by Harrison Allen,

George Barker, and Thomas Eakins. This was abandoned, however, and the two projects were presented separately to the public: the 781 plates in a multivolume set, selections of 100 plates, or an Author's Edition of 20 plates; and the accounts of the work in a small book entitled *Animal Locomotion, The Muybridge Work at the University of Pennsylvania,* with essays by William D. Marks (almost totally written by Eakins, whose manuscript is now in the Philadelphia Museum of Art), Francis X. Dercum, and Harrison Allen. The catalogue itself had been printed by the end of the year: the Library of Congress copyright deposit stamp is dated January 5, 1887 (Fig. 164).

The Coates letter describes Muybridge's work in some detail:

Your favor of the 22nd was duly received and remarks have full attention. Of the Series of photographs by Muybridge there are in all 781, roughly classed as follows.

<div align="center">

Figures 562

Horses 100 about

various animals 120

</div>

Mr. Muybridge is at work upon a catalogue on a system of his own which may or may not be best. The proof will be ready in about a week. Am I correct in supposing that all printing should be done by the J. B. Lippincott press? The human figure series should I think be carefully examined [and] considered. If the work is to be published at all the usual questions as to the study of the nude in art and science must be answered yes. Otherwise the greater number of the 561 [*sic*] series would be excluded. At the same time there are *probably* some lines to be drawn with regard to some of the plates.* That there will be objection in some quarter to the publication would seem to be most likely if not inevitable. Mr. Dickson [a lawyer] may be quite right as to the undesirability of conciliating one enemy but I am inclined to think this point worthy of consideration.

It will take 3 months to have 25 or 50 complete sets of the plates printed by the Photogravure Co. In that event Mr. Muybridge could take his copyright and in England [*sic*] in January 1887. He proposes then to canvass for subscriptions issuing a new circular or prospectus and taking all names anew conditional upon 500 subscribers being obtained for a first edition. Question—Would it be desirable to give up in this way the names now held which are without condition? To avoid any improper use of any plate I think no subscriber should be allowed more than one copy of each series even though more than 100 are selected. As I understand you will write the preface to the work. It was stated at one time that Dr. Allen would write a history of the undertaking giving diagrams and description

*It should be remembered that the writer of this letter, Edward H. Coates, president of the Academy of the Fine Arts, had just presided over the dismissal of Thomas Eakins over this very question: is the "absolute" nude acceptable? In Muybridge's case, unlike Eakins', he did not prevail in his belief that some of the new photographs should be suppressed.

of instruments used. Will this be covered by the paper which Mr. Muy-
bridge has in hand and of which nothing has heretofore been said? Will
Dr. Barker give a scientific account of the work and will this be possible
until the plates are entirely completed by the Photogravure Co.? Will Mr.
Eakins be ready with his treatise and the plates made? The latter are cer-
tainly of value in themselves. The negatives to be furnished as specimens
will be ready . . . in about 10 days.

It is desirable that the letter press for the work shall be upon large paper
the same size as the plates or upon an octavo or small quarto page so that
it may be used as a separate publication. Although I have used interrogation
points I have suggested the several matters only as items to be taken up
whenever the meeting of the guarantors is had and without intending to
give you the labor of reply at the present moment.

<div style="text-align: right">Very faithfully yours.
Edward H. Coates[24]</div>

Craig Lippincott, J. B. Lippincott's son, then wrote Pepper reminding
him that Lippincott had been promised "the privilege" of publishing Muy-
bridge's work in return for advancing the money for the lenses. Lippincott
proposed to publish the book in either octavo (page size 5¾″ x 8¾″) or
folio size (page size 18″ x 24″). The folio size would allow the use of the
large plates. Lippincott, however, thought the smaller size would be more
suitable, and it may have been this opinion that resulted in the separate publi-
cation of the written material and the plates.

By April 23, 1887, a hundred local subscriptions had been secured,
evidently for groups of a hundred plates each. They made their selections
in the front library room of the Academy of the Fine Arts late in April
and through May, with Muybridge in attendance to help with the selection.
Muybridge continuously and laboriously solicited subscriptions. One such letter,
written to Ferdinand J. Dreer, is in the Historical Society of Pennsylvania:

During the very agreeable interview I had with you last week, you
generously avowed your disposition to encourage the publication of my
work on Animal Locomotion by contributing for the purchase of a series
of the plates to be deposited in some Institution where they might be of
service to those who were unable to personally obtain so expensive a work.
Since I had the pleasure of talking with you on the subject, several ideas
have presented themselves to me, one of which I think you will approve of.

I have now a complete series of the plates, (781 in number) at the
Academy of the Fine Arts, I shall be much gratified if you can spare the
time to call there, when I will suggest a disposition of the work, which
while of great present advantage to a very large number of persons, will
be a permanent record of your beneficence. . . .[25]

At this time Muybridge began to develop plans for a trip to Europe to lecture and drum up sales for his new work. His plans were first reported by *The Pennsylvanian* on June 7, and by June 19 Muybridge, on his way, was staying with William Bradford, who then had a studio at 42 East 14th Street in New York. He did not actually make it to Europe, however, until the spring of 1889.

In 1887 Muybridge's plates were being printed at the Photogravure Company of Ernest Edwards in Brooklyn. The correspondent of *The Photographic News* had seen them there and thought that "few things [were] likely to be more useful to artists and others."[26]

Before he set off for Europe, Muybridge scouted about the East soliciting subscriptions. "Business is not very lively," he wrote Burk on July 10,[27] and in October he was back at the university working on his plates, though he continued to send out notices of the publication of his work. A letter he wrote from Pittsburgh on December 27 told Pepper that he had been entertained by the governor of Pennsylvania the previous evening and expected to get twenty new subscribers in Pittsburgh. He had been selling his lenses, and had already sent Lippincott $642.20 on account. He did not use his zoopraxiscope on these lectures, but for lectures early the following year, in New York and vicinity, he decided to do so and wrote Burk on February 7 from Bradford's address asking that the apparatus be sent. He would not be paid for the lectures but thought they might help the sale of the plates. The university had paid out a lot more than had been bargained for, and he was doing his best to make it up to them.

On February 25, 1888, and again on May 4 he lectured in Orange, New Jersey. After the first talk he called on Thomas Edison in his laboratory in nearby West Orange, and it was said that their discussion related to joining Muybridge's photographs to Edison's phonograph. But the state of the art of motion pictures at that time would have precluded this. It was not until 1891 that motion pictures of any reasonable practicability were achieved. Still the discussion, tentative as it must have been, was natural. Edison was even more famous for his phonograph than Muybridge was for his photographs, and both men were exquisitely aware of the value of the publicity resulting from the meeting. Years later Edison denied having talked about the phonograph-photograph combination, in spite of the fact that he said at the time that the two *had* talked about it.*

The first week in March 1888 the university sent a complete eleven-volume

* I have discussed the Edison-Muybridge relationship in *The Edison Motion Picture Myth* (Berkeley, 1961).

set of the photographs to the sultan of Turkey. The university was undertaking extensive archaeological diggings in the sultan's domain, and eager for his favor.

Lectures at the Union League Club in New York, at the Art Institute of Chicago, and Milwaukee College followed soon. A lecture in Boston and possibly another in Philadelphia (according to *The Pennsylvanian* of October 17, 1888) brought Muybridge up to his departure for Europe in the spring of 1889.

Fig. 154. Base-ball; catching and throwing, detail of plate 284 of the University of Pennsylvania series. Photographs by Muybridge. Author's collection. The lateral shots are out of focus.

Fig. 155. Heaving 75-lb. rock, plate 311 of the University of Pennsylvania series. Photographs by Muybridge. Author's collection. The catalogue of plates describes the model as "a mulatto and professional pugilist." In the third photograph from the left, top row, the camera was jarred. The two right-hand photographs are dark, indicating unevenness in processing or printing.

Fig. 156. *Wrestling; lock*, plate 345 of the University of Pennsylvania series. Photographs by Muybridge. Author's collection. A damaged emulsion can be seen in the second photograph from the left, top row, and a prolonged interval between photographs six and seven.

Fig. 157. *First ballet action*, plate 369 of the University of Pennsylvania series. Photographs by Muybridge. Author's collection. A line was drawn along the spine to show its movement. Note the little foreground "take" number, 1357.

156

157

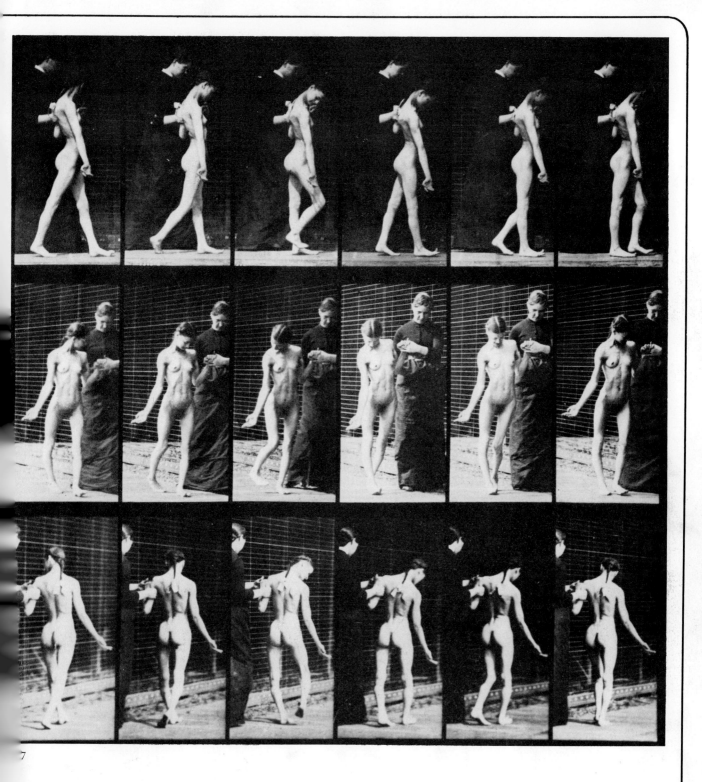

7

*Fig. 167. Multiple cerebral-spinal
.sclerosis (choreic); walking,* detail of
plate 541 of the University of Pennsylvania
series. Photographs by Muybridge. Phil-
adelphia Civic Center Museum. This
woman was a patient at Blockley Hospital
for the Poor and is attended by a nurse
from the hospital.

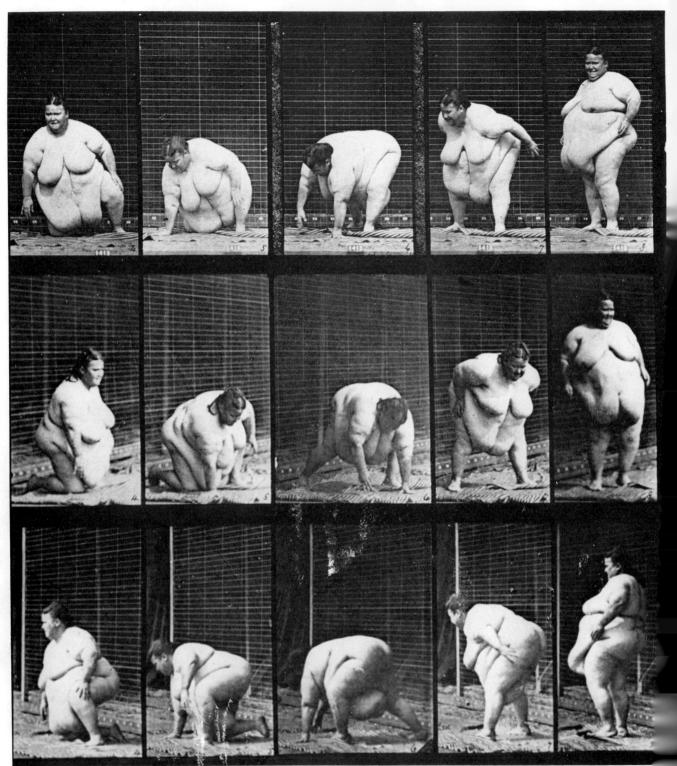

Fig. 168. Arising from the ground, detail of plate 268 of the University of Pennsylvania series. Photographs by Muybridge. Philadelphia Civic Center Museum. According to the catalogue, this woman was twenty years old, unmarried, and weighed 340 pounds.

Fig. 169. The sulky-wheel series, with Muybridge (lower right), described by Francis Dercum (page 163). October 5, 1885. The George Eastman House, Rochester, New York. A careful examination of these photographs, beginning at upper left and reading to the right in each row, reveals the progress of the small projection from the inner rim of the wheel (indicated by an arrow added in the third photograph from the upper left). An analysis of this movement showed that exposures of 1/4800 second were possible. The wheel alone was photographed in front of a black backdrop—see extreme right photograph in second row from the top. The photograph containing Muybridge was shot on the regular set, as is obvious from the string background.

170

171

Fig. 170. Muybridge's staff of assistants at the University of Pennsylvania. 1884? Photograph by Muybridge. The University of Pennsylvania archives. A series camera (Figs. 146 and 147) is behind them, and the background wall at the left.

Fig. 171. Muybridge at about fifty-four. 1884? Photographs by Thomas Eakins or Thomas Anshutz? The Archives of American Art, Washington, D.C.

Fig. 172. Muybridge outside his workroom at the University of Pennsylvania. 1884–87. The University of Pennsylvania archives.

173

174

THE WORSHIPPERS OF DIONYSOS DISPERSED BY THE ACHARNIANS.

PROCESSION OF DIONYSOS.

FINALE
"THE ACHARNIANS" OF ARISTOPHANES AT THE ACADEMY OF MUSIC.—Drawn from Photographs.—[See Page 747.]

Fig. 173. The finale of Aristophanes' *The Acharnians,* produced by students of the University of Pennsylvania. Apparently May 15, 1886. Photograph by Muybridge. The University of Pennsylvania archives. Shot in the foyer of the Academy of Music, Philadelphia, probably the morning after the performance.

Fig. 174. Another scene from *The Acharnians.* Apparently May 15, 1886. Photograph by Muybridge. The University of Pennsylvania archives.

Fig. 175. Page 744 of *Harper's Weekly,* November 20, 1886. Three of Muybridge's May 15 photographs are reproduced, with Fig. 173 at the bottom. Modern architectural elements have been excluded and antique ones added. The center figure in dark clothing is George Wharton Pepper, who became conspicuous in Pennsylvania politics.

175

Photography
and Painting

During Muybridge's time in Philadelphia, the impact of his work on realistic painting became widely apparent. In May 1887 it was reported that Meissonier intended to repaint his famous *1807* and reposition the horses in accordance with Muybridge's photographs. This new version is now in the Huntington Hartford Collection. *1807* had recently sold at the Stewart sale for a very high figure and was getting much attention. *The New York Evening Post* reported that Muybridge had received a letter from Meissonier saying that he was redoing *1807* to accord with the new photographs. After he had seen Muybridge's work at the *soirée* in 1881 he "vowed, in the presence of several of his brother artists, that he had been entirely mistaken in his past observation of horses in motion."[1]

The later version of *1807* is so different from the older in ways unrelated to the problem of faulty animal motion that it is difficult to decide the extent of Muybridge's influence. And the differences in the new version that may be attributable to his photographs are so slight that only by a careful comparison of the two paintings can they be discerned. Perhaps Muybridge was exaggerating—such details as the shifting of a horse's hoof through an angle of fifteen degrees would not have justified a complex new painting, even for so meticulous a painter as Meissonier.

But not everyone agreed with Meissonier. Some thought animals should not be shown as they actually are, but in such a way as to *suggest* motion, whatever the artist and his public thought that to be. Such a position had been taken by a reviewer of Thomas Eakins' *A May Morning in the Park* (*The Fairman Rogers Four-in-hand*, Fig. 176) back in 1880:

> That Mr. Eakins is a colorist, no one, we think, has ever claimed; but that he is a strong artist, with a strange power of fascination, will be more readily admitted. And yet [*A May Morning in the Park*] is not only utterly without color, but utterly lifeless. . . . It is said that the artist studied the motion of the horses from the instantaneous photographs taken lately on race-courses. The result is that each limb is motionless, while the spokes of the wheel of the vehicle whirl about so rapidly that they cannot be seen. As a demonstration of the fact that the artist must fail when he attempts to depict what *is*, instead of what *seems to be*, this picture is of great value. . . .[2]

Now, in 1887, with Muybridge's University of Pennsylvania work being circulated, others took the same position:

> It is a common remark that instantaneous pictures very often fail to convey the idea of motion, although we know very well from the nature

of the subject that the object must have been moving at the time it was photographed. Dr. Eugen Dreher, in *Die Natur*, has some very pertinent remarks on this point in an article of "The Appearance and Reality in Pictures." Dr. Dreher maintains that "it is clearly impossible for an artist to give the exact appearance of motion. He can only seize a given instant or stage, and so manage that it shall represent itself as the effect of the preceding stage and the cause of the following one. A sword-blow must be represented at a decisive point, not at a stage in the descent of the weapon, else the illusion will be destroyed; a pendulum in motion, not at the bottom of its course, where it would seem to be at rest. In painting a galloping horse, no stage of the exact motion is reproduced. The instantaneous photographs have demonstrated that; and also if the artist should attempt a reproduction of the kind he would give any but the effect desired." Some ardent enthusiasts would have the artist paint a horse as Muybridge has photographed it, but this most certainly would be wrong, for the artist can only paint what the eye sees, and we suppose no photographer would seriously maintain that the eye can, in a hundredth part of a second, pick one particular movement out of a succession. The instantaneous photographer, to be thoroughly successful, must do as the artist does—select a point which will suggest motion.[3]

European painters such as Meissonier, de Neuville, and Detaille (although Detaille used incorrect postures even after he saw Muybridge's work), and Frederick Remington* in America, continued to produce work in accordance with what Muybridge had shown them in his photographs.

Remington's devotion to the new truths of photography was noted by *The Brooklyn Eagle* early in 1888, shortly after the artist had seen the University of Pennsylvania work:

> At least one Brooklyn artist, Frederick Remington, who has lived among the cowboys and knows a horse as he knows his master, has foresworn conventions and has accepted the statement of the camera as his guide in the future. He does not find that his art is in any way compromised, but says, on the contrary, that he gets a higher satisfaction out of his work, now that he is doing it right, than he could by continuing in the beaten path.[4]

It has been said that Degas modeled some of his horse sculptures after Muybridge photographs, and this may be true—although the examples usually chosen as evidence are weak. Degas's dancers are convincingly lifelike, but

* A remarkable transcription by Remington of a Muybridge photograph, *Stampeded by Lightning*, has been pointed out by Van Deren Coke in his catalogue, *The Painter and the Photograph* (University of New Mexico Art Gallery, 1964).

176

Fig. 176. Thomas Eakins' *A May Morning in the Park (The Fairman Rogers Four-in-hand)*. 1900. Oil on canvas, 24″ x 36″. The St. Louis Art Museum, St. Louis, Missouri. A black-and-white copy by Eakins himself of his 1879 original, which resulted from his study of the Muybridge 1878 photographs.

Fig. 177. Lantern slide made by Muybridge from an unlocated source showing animals' movements he considered incorrect. The Kingston-on-Thames Library and Museum, Kingston-on-Thames, England. Used for comic effect in his lectures.

177

CONVENTIONAL POSITIONS OF QUADRUPEDS IN MOTION

178

Fig. 178. Plate XXV of *The Horse in Motion* (1882), showing conventional—incorrect—positions of a trotting and running horse. Author's collection.

Fig. 179. The cover of *Andrews' American Queen*, July 29, 1882. The Library of Congress, Washington, D.C. Drawing by Gray Parker after Muybridge photographs and classical animal motion postures.

the horse sculptures cited by most writers on the subject either vary from Muybridge in significant details, or cannot be shown to have been impossible without Muybridge's work. Such examples are reproduced in the Coke catalogue cited above and in John Rewald, *Degas, Works in Sculpture: A Complete Catalogue* (New York, 1944). Rewald further confuses the issue by writing that Degas could have first seen the Muybridge photographs in September 1881, when, according to Rewald, they were first reproduced in a European publication. But we know that they were in fact first reproduced in *La Nature,* December 14, 1878, which is an earlier possible date for the Degas work than had been thought.

Aaron Scharf, in *Art and Photography* (London, 1968), reproduces two Degas charcoals that correspond exactly to Muybridge photographs of cantering Annie G. of the University of Pennsylvania series. Scharf treats the subject of Muybridge's influence on art at considerable length and with several examples, mostly European, that many American readers will find new. Chapter 9 of his book is replete with original, interesting, and valuable information on the effect of Muybridge's work on painting and sculpture. But Scharf's European point of view has led him into error. For example, he refers to "the mysterious five years between 1872 and 1877" in Muybridge's life, when only slight research in America or in the Kingston library would have eliminated the "mystery." His discussion of the Muybridge-Eakins relationship is substantially incorrect, resting as it does on the mistaken idea that the Pennsylvania Academy of the Fine Arts was attached to the university; Muybridge's failure to give Eakins credit when he was "rendering thanks to the University of Pennsylvania" is therefore irrelevant. He ascribes the invention of apparatus to Eakins, whereas we know that Eakins' apparatus was suggested to him by Muybridge. Scharf's description of the Stanford-Meissonier contacts is uncertain, and his statement that Marey's work stimulated Muybridge to begin his own is incorrect. His dates for the University of Pennsylvania work, the Muybridge and Eakins lecture dates, and the Muybridge shutter speeds are also incorrect; and, contrary to his statement, the 1887 series contains no photographs earlier than 1884.

Illustrations in periodicals generally began to show moving horses correctly after the 1878–79 Palo Alto photographs had had wide distribution. But the effect of Muybridge's work—whether his California or Philadelphia photographs—was seen chiefly in the work of painters who continued to concern themselves with objective reality. And their number was being decimated by the onslaught of Impressionism. All artists who saw Muybridge's photographs found them interesting, but fewer and fewer utilized them. This was

partly because horse painters were becoming scarce, and animals in motion correspondingly rare as subjects of paintings.

But it was chiefly because art had turned in another direction. The facts of nature as revealed by Muybridge's work were there for anyone to see—and nearly everyone saw them. But the invention of photography itself had helped to force painting onto a new path, and no longer did art function as a depicter of objective reality.

The following year *The Photographic News*, quoting *The London Globe*, summed up the matter for most observers:

> Mr. Muybridge's photographs are, perhaps, rather of indirect importance to the artist, as showing him what actually takes place, than as a direct means of assisting him to represent what the eye sees. The eye certainly does not see an instantaneous phase, such as is shown by one of Mr. Muybridge's photographs, but it sees a resultant of many motions, and it is this resultant which the artist generally aims at reproducing.
>
> The *Globe* sums up the case as follows:—"Scientifically the inquiry is most interesting, but though Mr. Muybridge's labour has been watched with much attention . . . we doubt whether the contribution to art will be of much importance. Art for the purpose of representation does not require to give to the eye more than the eye can see; and when Mr. Sturgess gives us a picture of a close finish for the Gold Cup, we do not want Mr. Muybridge to tell us that no horses ever strode in the fashion shown in the picture. It may indeed be fairly contended that the incorrect position (according to science) is the correct position (according to art). Nor is this a paradox; for only extremists contend that art must discard every other consideration in an endeavour to represent merely the True."[5]

Twenty years later the Futurists expanded on Muybridge's work. "We affirm that the world's magnificence has been enriched by a new beauty: the beauty of speed," their 1909 Manifesto exulted. "We already live in the absolute, because we have created eternal, omnipresent speed."

It may be chauvinistic to give Muybridge a considerable part of the credit for achievements of such painters as Umberto Boccioni, Giacomo Balla, or Gino Severini. But it is not too much to say that the paintings of these artists, concentrating on the analysis of speed in movement, were forecast in Muybridge's and Marey's work, and were likely, as most historians believe, inspired by it. Parallels are obvious in such works as Marcel Duchamp's *Nude Descending a Staircase* (Fig. 183); Giacomo Balla's *Study Related to "Abstract Velocity"* (Fig. 181); and Kasimir Malevich's *The Scissors Grinder* (Fig. 182).

In more recent years, the English painter Francis Bacon has produced a remarkable series of works directly related to Muybridge's photographs. "These

remarkable Victorian classics," his biographer writes, ". . . are to Bacon what his breviary is to a priest."[6] Poring over the Muybridge prints in the Victoria and Albert Museum, Bacon was inspired to create some of his most compelling works (Figs. 185, 187, and 188).

Fig. 180. Elizabeth Thompson, Lady Butler, *The Roll Call*. Oil on canvas. The Royal Collection, London, England. The horse, supporting itself on its laterals, was praised by Muybridge as a rare example of correctness, although it was derided when it was first shown.

181

182

183

184

Fig. 181. Giacomo Balla, *Study Related to "Abstract Velocity."* Ca.1913. Gouache on paper, 11″ x 17″. Collection of Dr. and Mrs. Barnett Malbin (formerly Lydia and Harry Lewis Winston Collection).

Fig. 182. Kasimir Malevich, *Scissor Grinder*. 1912. Oil on canvas, 31⅜″ x 31⅜″. Yale University Art Gallery, gift of Collection Société Anonyme.

Fig. 183. Marcel Duchamp, *Nude Descending a Staircase, No. 2.* 1912. Oil on canvas, 58″ x 35″. The Philadelphia Museum of Art.

Fig. 184. *Dog; walking; mastiff*, detail of plate 703 of the University of Pennsylvania series. Photograph by Muybridge. Author's collection.

Fig. 185. Francis Bacon, *Dog.* 1952. Oil on canvas, 78⅜″ x 54⁵⁄₁₆″. The Museum of Modern Art, New York, New York. Photograph courtesy the Marlborough Gallery, London.

186

187

188

The
Last Years

From now until the end of his life Muybridge was engaged in promoting the sale of his work. In the spring of 1889 he returned to England for lectures at the Royal Institution in London, and at a convention of British photographers in Saint James Hall during the third week in August. He spoke in Liverpool on January 8, 1890, gave two lectures in Manchester in January and February, and was back in London by June for sales promotion of the Lippincott book *Animal Locomotion: The Muybridge Work.* . . . By August 22, 1890, he was again in New York at Bradford's studio. He stayed in America only briefly, traveling back to Dundee, Scotland, for a lecture in November.

Ernest Webster, Muybridge's projectionist for these lectures, later gave an interesting account of his experiences:

> I had a great respect for Muybridge's versatility and his forceful personality.
>
> I operated the Zoopraxiscope for him over sixty times and we never had a breakdown. . . .
>
> We had to travel all over England, also to Scotland and Ireland with much delicate apparatus and a quantity of compressed gas in tubes, about eight feet long. If the quick lime cylinders got damp . . . they would crack and crumble, perhaps melt the supporting pin and endanger the show but we always kept going somehow.
>
> The operating was a very strenuous job, for between the *moving* photos Muybridge introduced a very large number of *still* photos and these had to be put through at a very rapid rate.
>
> Muybridge during the show walked about the stage with a little steel "clicker" in his hand and this he used as a signal when he wanted a slide changed.
>
> Sometimes for some of the slides he had no "patter" and . . . he "clicked" faster and faster. . . .
>
> This is not to imply that he was not a good lecturer. On the contrary he was a very voluble speaker and he told me that he never suffered from nervousness.
>
> Muybridge was extremely vain and intolerant of contradiction. He was a handsome man with dark flashing eyes, white bushy eyebrows, hair and beard. . . .
>
> He was very impatient if everything was not exactly to his previous instructions by post at the Hall when we arrived and he was very dictatorial to Hall porters & caretakers.
>
> He was always announced as Professor Eadweard Muybridge and woe betide any one who spelt his Christian name "Edward."
>
> To *me* he was always considerate. I suppose at this lapse of time I may be excused for saying that I was a very expert and careful operator and I knew he did not want to lose my services. . . .

He left all his slides and the Zoopraxiscope at my home during the summer months when there were no dates for lectures and although we parted quite amicably, I think he must have been annoyed, as, from that day I never saw or heard from him again.

He came to my home to supper on more than one occasion. When on tour if a prominent individual or a committee invited him to supper after the show he never forgot to ask for an invitation for me also. . . .

I seem to recall that the secretary of one of the learned societies told me that Muybridge had killed a man. . . .

Although we sat side by side on our long railway journeys also at meals at the hotels Muybridge never told me anything of his private affairs.

I never knew who financed him but I did know that he had a ten guinea book of his photographs. He was very keen on finding purchasers for the books.

[The Zoopraxiscope] did not flicker painfully like the early cinematograph did. . . . Muybridge's pictures . . . moved smoothly and certainly no one who had witnessed his show would describe it as painful. . . .

<div align="right">Yours sincerely
Ernest Webster[1]</div>

The Optical Magic Lantern Journal and Photographic Enlarger of February 1890 has an interesting article on the production details of Muybridge's lectures.

Now Muybridge was off on a swing through Europe with his subscription book. He was in Berlin on March 21 for several lectures and got Field Marshal von Moltke to a lecture and onto his subscription list only a month before von Moltke died. The Berlin audience was a "very select" one, and the photographer enjoyed a good reception:

Mr. Muybridge, from the Pennsylvania University, has been here in Berlin, and has given an exhibition of his animals in motion before a very select audience.

The first exhibition of Muybridge (by invitation) . . . was one of the most original exhibitions of its kind ever given to the public, and was richly applauded. . . . One of his performances was also visited by the genial old war-horse General Field Marshal Moltke. The general gave also to Mr. Muybridge an invitation to call at his office for the purpose of studying his big album.

A chief point by which Muybridge differs from his competitors, whose merits are not to be overlooked, is that he is not satisfied to take the running animals from the side only (vertically from the direction of their rear), but that he takes them simultaneously from the front and from behind by placing twelve cameras sideways of the track in front, and twelve cameras behind the running animals. . . . This admits a study of

the anatomy of motion, which can never be accomplished by a simple side view, and particularly the study of abbreviations [aberrations?], is for artists of the greatest interest.

This was a novelty even for Berlin, and was greatly admired by all our prominent artists. . . .[2]

In Munich in May "the royal princes and the first artists and men of science honored his exhibition with their presence."[3] Back in Berlin on July 15 after a long tour through southern Germany, Switzerland, Austria-Hungary, and Italy—where he took two days off to go sightseeing—Muybridge needed copies of the *Catalogue of Plates* and wrote Burk for them. In the process he gave this account of his journey:

My dear Mr Burk

It is so long since I wrote. . . .

From the time I left Berlin in the spring I have sent you newspapers containing [accounts] of my Lectures. . . . From [Munich] I went direct to Rome,—where to my surprise I found but few painters of any great distinction but secured the French Academy and the International Society of Artists, as subscribers. Being in Rome on Sunday I deemed it the proper thing to go to St Peters and reverentially kiss the black image of blessed apostles toe, as is the custom of all true believers in his papal descendant. From Rome to Naples is not a very difficult journey. . . . I decided at Naples, that as I had not devoted much time to pleasure since I left the US, to have two days holiday, so duly ascended to the summit of Vesuvius and examined the workings of the craterial interior; and also wandered through the once animated streets of Pompeii. . . . It will interest you more to know that I have visited nearly all the universities in Italy, Switzerland and South Germany, and have everywhere obtained for the University of Pennsylvania a recognition of its enlightened and liberal policy. At Turin . . . I gave a discourse. As, of course, a man cannot travel without picking up some knowledge of the language I am happy to say that I now speak Italian, German, and French with equal fluency. Professor Mosso, however, very kindly rendered my remarks to the audience in his own admirable style, as I was not quite familiar with the *Turin* dialect. To sum up. The Universities now on the subscription list are the following Oxford, Berlin, Paris, Munich, Naples, Leipzig, Rome, Bologna, Turin, Bern, Tübingen, Würzburg, Geneva, Freiburg, Basel, Halle, Jena, Göttingen, Bonn, Strasbourg, Vienna, Heidelburg, Prag, Genoa, Zurich, Pisa, Innsbruck, Budapest, Florence, Padua. . . . In addition to these, the Royal and other Academies of Art of Paris, Berlin, Munich, Rome, Naples, Florence, Turin, Venice, Milan, Genoa, Vienna, Budapest, Düsseldorf, Nurnburg, Leipzig, Dresden, and other places. . . . I write all of this for your personal information and would prefer nothing being said about it in

190

189

the papers at present when it will do no good. But when I return its publication will I have no doubt materially assist in filling up the subscription book....[4]

In London, on his way back to America, he issued *The Science of Animal Locomotion,* a short pamphlet promoting his large University of Pennsylvania work.

Back at the university by the end of the year, he wrote Edison again, sending him the pamphlet and mentioning the subject of photographing flying insects. The Wizard of Menlo Park gave Muybridge what he apparently wanted, a letter of recommendation and encouragement:

I note what you say relative to undertaking an investigation of the flight of insects. . . . I am glad [because it] would be a great aid in solving the

problem of aerial navigation . . . [it] would also be of the utmost practical value in many other ways . . . no one would be more competent than yourself to undertake such an investigation and I hope you will find it possible to do so.[5]

There is no record that Muybridge ever really intended to photograph the flight of insects, and there are no such photographs in existence. Perhaps he was stimulated by the announcement the previous May that Marey had photographed a fly at forty to sixty exposures a second.*

Muybridge left for California early in 1892, and, while "preparing for a Lecturing tour through Australia and India," as he later claimed, wrote a long letter to Leland Stanford, a reprise of the trouble that had occurred between them, and what must be assumed to have been a veiled appeal for assistance (see pages 141–144). He described the 1882 imbroglio at the Royal Society of Arts in London, told how this had damaged both his reputation and financial standing, and how the University of Pennsylvania had finally come through. "I have patiently waited during eleven years without bringing this matter to your attention, but I think that the time has arrived when in justice both to you and to myself I ought to do so."[6]

Quite possibly Stanford had not known all along of the embarrassing circumstances in London that led Muybridge to his suit. Certainly Stanford was much occupied with other matters when the suit was in progress—matters both personal (his idolized son Leland, Jr., had died) and professional. He had set about building the magnificent Leland Stanford, Jr., University as a memorial to his son, and must have been thinking little indeed about the photographic experiments he had supported back in 1878–79. He was now serving in the United States Senate, and when Muybridge wrote his letter, on May 2, 1892, was in Washington, about to leave for a European vacation. His health was not good. According to his biographer he was back in San Francisco in October, and stayed there, ill, the whole winter. He may have seen Muybridge during this time, or they may have met the following spring when Stanford visited the 1893 World's Columbian Exposition in Chicago on his way back to California from the Senate session. Muybridge was then in Chicago lecturing at the Art Institute and preparing for his stint in the "Zoopraxographical Hall" on the fair's Midway (Fig. 190).

By an agreement he had signed the previous October 19, Muybridge undertook to build a fifty-by-eighty-foot building on the Midway, to remain

* Marey's work with his new "chrono-photographic apparatus" is described in interesting detail in *The Year-Book of Photography and Photographic News Almanac for 1892.*

open during regular fair hours. He was to give the fair authorities a third of his gross and, perhaps most significantly, put up a $5,000 bond for the fulfillment of the contract and another $1,000 bond that would be returned to him when he had erected the building. Here he was to give lectures on animal loco-motion, besides selling his photographs and a new novelty, the zoopraxographic fan (Figs. 191 and 192). That Muybridge had $6,000 at this time to put into any venture at all seems unlikely. It is possible that he got the money from Stanford. In the fall of this year, 1893, the Muybridge vs. Osgood suit was dismissed, and it is also possible that the money was put up to induce Muybridge to drop the proceedings.

In connection with his World's Fair venture, Muybridge published a little booklet called *Descriptive Zoopraxography*, which he may have intended to sell. It turned out that he could not even give it away. His lectures on the Midway Plaisance, if he ever, indeed, gave any, were disastrously ill-attended. Midway visitors were not in the mood to listen to lectures on a subject that had fascinated learned societies throughout the world. Muybridge, moreover, had to compete with a next-door attraction that left his brand of entertain-ment in the cold: the Street of Cairo, where Little Egypt was performing her sensational gyrations. Photographs of his Zoopraxographical Hall show it to be somewhat less pretentious than the woodcut in his little booklet sug-gests (Figs. 193 and 194). They also indicate that little, if anything, ever went on there. *The Daily Columbian* of May 5, before the fair opened, listed the place as the Muybridge Lecture Hall, and by May 10 listed Muybridge in Jackson Park, lecturing with no admission charge.

He seems to have continued in Chicago through the summer, for on September 5 he wrote to Stanford's executors—Stanford had died on June 21—for several boxes of material he had left at Palo Alto. It is an interesting list:

> To the executors of the will of the late Hon. Leland Stanford.
> Gentlemen,
> When I completed my investigations of animal locomotion at Palo Alto, I left in the building occupied by me, several boxes, containing appa-ratus and personal property. . . .
> I have now occasion to use some of the articles and shall feel obliged if you will deliver all the boxes to the order of Mr. John T. Doyle,* and oblige . . .

* Doyle left much of his Muybridge material to the San Francisco College for Women, including five albums of photographs, easily the largest such collection known. These have since been acquired by Bancroft Library of the University of California in Berkeley. Other Muybridge mate-rial at the Doyles' were numerous glass plates which, I have been told, were used by the Doyle children for target practice. (See Fig. 195.)

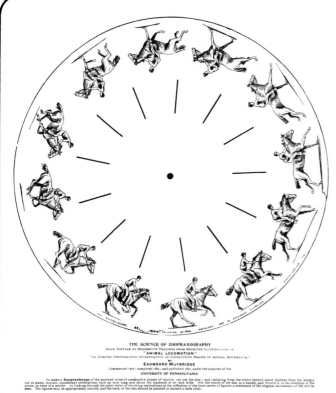

THE SCIENCE OF ZOOPRAXOGRAPHY
MADE POPULAR BY SUGGESTIVE TRACINGS FROM SELECTED ILLUSTRATIONS OF
"ANIMAL LOCOMOTION"
"AN ELECTRO PHOTOGRAPHIC INVESTIGATION OF CONSECUTIVE PHASES OF ANIMAL MOVEMENTS,"
BY
EADWEARD MUYBRIDGE
Commenced 1872; completed 1885; and published 1887, under the auspices of the
UNIVERSITY OF PENNSYLVANIA

To make a Zoopraxiscope of the annexed series of consecutive phases of motion, cut out the disc; and radiating from the centre thereof, about midway from the margin cut or stamp thirteen equidistant perforations, each an inch long, and about the sixteenth of an inch wide. Pin the centre of the disc to a handle, and revolve it in the direction of the arrow, in front of a mirror my looking through the upper series of revolving perforations at the reflection of the lower series of figures, a semblance of the original movements of life will be seen. The figures may be appropriately colored, and the back of the disc should be painted or stained a dark color.

PUBLISHED AT THE ZOOPRAXOGRAPHICAL HALL OF THE WORLD'S COLUMBIAN EXPOSITION, 1893

191

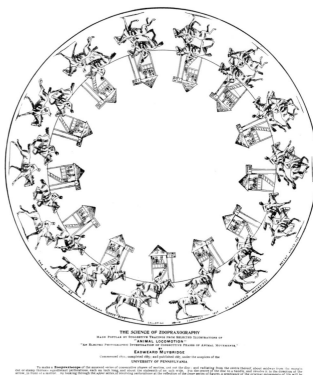

THE SCIENCE OF ZOOPRAXOGRAPHY
MADE POPULAR BY SUGGESTIVE TRACINGS FROM SELECTED ILLUSTRATIONS OF
"ANIMAL LOCOMOTION"
"AN ELECTRO PHOTOGRAPHIC INVESTIGATION OF CONSECUTIVE PHASES OF ANIMAL MOVEMENTS,"
BY
EADWEARD MUYBRIDGE
Commenced 1872; completed 1885; and published 1887, under the auspices of the
UNIVERSITY OF PENNSYLVANIA

To make a Zoopraxiscope of the annexed series of consecutive phases of motion, cut out the disc; and radiating from the centre thereof, about midway from the margin cut or stamp thirteen equidistant perforations, each an inch long, and about the sixteenth of an inch wide. Pin the centre of the disc to a handle, and revolve it in the direction of the arrow, in front of a mirror my looking through the upper series of revolving perforations at the reflection of the lower series of figures, a semblance of the original movements of life will be seen. The figures may be appropriately colored, and the back of the disc should be painted or stained a dark color.

PUBLISHED AT THE ZOOPRAXOGRAPHICAL HALL OF THE WORLD'S COLUMBIAN EXPOSITION, 1893

192

193

Fig. 191. A zoopraxographic fan sold by Muybridge in Chicago. 1893. Rare Book Room, the University of Pennsylvania, Philadelphia. A handle was attached through the hole in the center and the cardboard circle could be waved like a fan. If it were held with the illustrated side toward a mirror and spun, a zoetrope effect would result.

Fig. 192. *A Columbian Horse Race.* 1893. Rare Book Room, the University of Pennsylvania, Philadelphia. Two series of running horses have been used here, with an officials' box added.

Fig. 193. The Midway at the Columbian Exposition in Chicago in 1893 as seen from the Ferris wheel. Author's collection. The white arrow at lower left has been added to point out the Zoopraxographical Hall. The lack of activity in front of the building in this picture and the following one, both believed to have been taken early in the fair's run, supports the idea that Muybridge's lectures here were, at best, short lived.

Fig. 194. The Zoopraxographical Hall at the left of this view of the competition that probably vanquished Muybridge—the Street of Cairo, which thousands thronged to see its star Little Egypt, and her belly dance. 1893. Author's collection.

194

Among other goods left by me at Palo Alto, were

1 large white box containing a 24 x 24 Camera.
4 boxes of size about 30 inches long 15 x 15 inches, containing some landscape and other negatives, stereoscopic views of California, and other effects.
A framework and gearing being a model for a Zoopraxiscope.
A small Camera with plate holder and 6 lenses.
A canvas tent in a tarred canvas cover, size of bundle about 24 x 18 x 18 inches.
Some other bundles containing a photographic tent, and framework and poles for the same, etc.
And some boxes of miscellaneous articles.

The probability is that Charlie or Tom, or perhaps MacLean will know all about them, they were left in the little house near MacLean's boarding house, but I believe were afterwards moved over to the great barn. . . .[7]

Back in Philadelphia on February 8, 1894, Muybridge again wrote Edison about taking photographs of a fly, this time asking for Edison's help in making such photographs commercial, an area in which Edison excelled. If Edison could give him twenty minutes he would come up to Orange and talk it over. He was told that Edison would be glad to make an appointment, but so far as we know the meeting never took place. Edison wrote Muybridge on February 21 that he had "built a little instrument which I call a kinetograph with a nickel & slot but I am very doubtful if there is any commercial feature in it & fear they will not earn their cost. These Zootropic devices are of too sentimental a character to get the public to invest in."[8]

Edison's "kinetograph," of course, was the famous kinetoscope, which was shortly to embark on a brief but brilliant career. On April 14 the world's first kinetoscope parlor opened at 1155 Broadway in New York City. It was an immediate success, and soon there were kinetoscope parlors throughout the country and in Europe. Talk of a "screen machine," however, soon whetted the public appetite for projection, and by the end of a few years, and with projection general by the end of 1896, there was scarcely a kinetoscope to be found.*

In the summer of 1894 Muybridge went back to England, where, with the exception of one visit to America in 1896–97, he was to remain for the rest of his life. In September 1894 thirteen packages of material were sent to him in care of his mother's brother, John Plow Smith of Hampton Wick, Middle-

* For a detailed discussion of the career of the kinetoscope see my book *The Kinetoscope* (New York, 1966).

sex, adjacent to his home town of Kingston. He was settling down for good, and he wanted his precious belongings with him.

By the following January he had moved into The Chestnuts in Kingston, a boarding house not far down High Street from where he had been born at No. 30. Still at The Chestnuts in August, he wrote Burk at the University of Pennsylvania that he was now preparing a book to be called *The Motion of the Horse and Other Animals in Nature and in Art*, and that he was offering it to Coates at the Academy of the Fine Arts. It was "for the guarantors providing they will pay the expense of publication."[9] He was willing to go about and try to sell it for a 40 per cent commission. If the guarantors did not agree, he would raise the money among friends and publish it himself, "under the auspices of the University *if it is agreeable to the Trustees.*"[10]

In this rambling letter he continues by saying that he considers himself "under an obligation to the University to do all in my power to add to its fame, if I cannot add to its material of solid possessions." He went on to tell Burk what he thought of Pepper—whom he ranked among the great college presidents of America. He thought that the guarantors might not think very highly of himself, but he had done his best, "and if I did not succeed in making the work pay for itself I cannot bring myself to believe that I am to blame." The only thing to do now was to get the plates from the printer and distribute them gratuitously.

But the printer did not give up the plates without a struggle. Muybridge spoke of the "fraudulent designs" of the printing company. He came to New York in possibly June 1896, having wired Pepper for expense money and "authority"—evidently to take charge of the plates. He had seen the opposing lawyer and the sheriff had taken possession of the plates. Muybridge wrote Pepper that he was going to give to him all his rights in the 33,000 or so plates that were then at the New York printer's, the New York Photogravure Company, provided Pepper would pay what was still owing to the printer and provided that the other guarantors would give Pepper their interests also. The negatives were also to go to Pepper to use as he saw fit. The guarantors then available—Samuel Dickson, Charles C. Harrison, and Edward H. Coates—agreed to this. Muybridge was sent $500, presumably for his expenses. He saw to it that the prints and negatives were packed and sent to the Philadelphia Museum (later the Commercial Museum). He could only do this with difficulty, however, because the New York Photogravure Company had gone into receivership, and the negatives were being held at the Garfield Trust Company. Pepper intended to use the negatives to fill out any incomplete sets. Muybridge then went off to the Boston Public Library to work on his new

book. In Philadelphia in April 1897, he borrowed a number of negatives from Pepper to make discs for his projection machine. Pepper evidently got relatively few of these—J. B. Colt was later reported to have bought "the Muybridge collection of negatives,"[11] which were to be used for lantern slides.

In May 1897 Muybridge dropped into the office of *The Photographic Times*. This time he was on his way to Europe for good:

> Prof. Edweard Muybridge [*sic*], formerly of Pennsylvania University, gave us the pleasure of a personal call the other day. Prof. Muybridge is about to start for the other side on his annual lecturing tour on "Animal Loco-motion" amongst the English colleges and schools. He does very little photographing at present, confining his efforts mainly to lecturing and writing. Although in his seventy-second year* he looks and feels, as he

* A curious error. Muybridge was only sixty-seven in 1897.

himself says, "as young as he did twenty years ago," taking a ten mile walk every Sunday, and enjoying it as much as he ever did.[12]

Muybridge took a number of negatives back to England with him. His new book, *Animals in Motion*, finished in December 1898, contained a number of the Philadelphia plates. This book was published by Chapman and Hall in London, and went through five editions. The later Chapman and Hall book, *The Human Figure in Motion*, was published in 1901 and went through seven editions. It was probably on the sale of these books that their author largely sustained himself in his remaining years.

Muybridge moved from The Chestnuts into a complex called Parade Villas, and from there negotiated with G. W. Wilson, an Aberdeen photographic concern, for the use of his photographs in slides. These plans apparently came to nothing.

Back with his relative Plow Smith in Hampton Wick in June 1899, Muybridge wrote Erwin F. Faber, who had drawn the attenuated figures for the zoopraxiscope.* Now Muybridge wanted the negatives of these glass discs, which were at J. B. Colt's, destroyed as being unworthy. He also wanted negatives of the motion series sent to him for G. W. Wilson. He had also left a thousand plates with Colt. Would Faber go to Colt's, pick up the plates, and, while there, destroy the zoopraxiscope negatives?

> Colts also have in their possession a lot of negatives made from the drawings which you and I made of elongated animals arranged in a circle for the zoopraxiscopic lantern. These I would like to be so utterly destroyed, that no remnants of them will remain. I do not care for any lantern discs ever to be made from them, and I do not think it advisable that they should be any longer existant. If you will be going to New York some time this summer will you do me the favor of calling at Colts place and *personally* smash them into very small pieces. . . . To save trouble of packing and shipping to Philadelphia the Colts, I have no doubt, will allow you to break them up at their store. I now much regret having ever made them, as they are not calculated to enhance my reputation, the original figures photographed from life, are those I prefer to leave behind me, and I shall feel more comfortable when you write me of your having completely destroyed them. I think there are some forty of them altogether. . . .[13]

* It was quickly discovered, in work on the persistence of vision, that to make animals in motion look normal when they were twirled around in devices such as the phenakistoscope of Plateau, a predecessor of the zoetrope (Fig. 118), they would have to be stretched out. See my *Edison Motion Picture Myth*, Berkeley, California, 1961; Terry Ramsaye, *A Million and One Nights*, New York, 1926; H. L. F. von Helmholtz, *Physics*; and Wachter's work on the galloping horse in the phenakistoscope in 1862. Fairman Rogers discussed Wachter's work in his *Art Interchange* article (see page 114).

Fig. 195. John P. Doyle and family at home in Palo Alto, California. 1877-79? From the original negative by Muybridge in the Stanford University archives, Stanford, California. Muybridge left some of his equipment and photographs with Doyle when he left California in 1881.

Nearly two years later the Fabers had a daughter, and Muybridge wrote a sentimental note:

> Before we proceed to business allow me to offer you my sincere congratulations to you and to Mrs Faber upon the advent of a little daughter; she will during her infancy serve to fill up the time, and bring joy and pleasure to your wife, and to alleviate the troubles and anxieties of your artistic labors, cheer up your evenings—especially if she is not too much given to squalling, which I don't suppose she is, and will unquestionably grow up to be a comfort and blessing to both of you. I think nothing tends to make a home comfortable and happy as a few "children to run to meet their dads return, and climb his knees the envied kiss to share". . . .[14]

The business Muybridge was writing Faber about was again J. B. Colt business. He now revealed that he had *sold* Pepper the 30,000 plates and had sold Colt "all the sets of transparencies (mounted on large sheets of glass) from which the large gelatine negatives for printing were made." He wanted Faber to try to sell some of the plates at 75¢ each to artists. There should not be any competition from the University of Pennsylvania because the understanding was that they were to give their plates away.

The Human Figure in Motion was now at the printer's, and Muybridge was reading proof. It would probably be out "this coming summer or fall"— it was indeed, but the author was getting impatient—"they are terribly slow in this country." When both books were out Muybridge planned to come over and try to sell them.

The March 11, 1901, letter to Faber was written from 161 King's Road in Kingston, where Muybridge stayed briefly before settling down at 2 Liverpool Road (Park View) with his cousin Catherine Edith Smith and George Lawrence, Miss Smith's half-brother, whom Muybridge called a "friend" in his will (Fig. 198).

From King's Road on May 19, 1902, came Muybridge's last known public statement. A new edition of the *Encyclopaedia Britannica* had just come out, and comments on an Egyptian First Dynasty tablet were in order:

> Sir,—In the new volumes of the "Encyclopaedia Britannica" is reproduced in the article "Egyptology" a tablet of Mena dating from the first dynasty, or about 4700 B.C., and is the oldest written sentence yet discovered.
>
> In "A History of Egypt, by W. M. Flinders Petrie," the author, referring to the Egyptian artists of the fourth dynasty, says:—"They did not make a work of art as such, but they rivalled nature as closely as possible."
>
> Two figures—a bull and a deer—on the tablet of Mena afford a

196

197

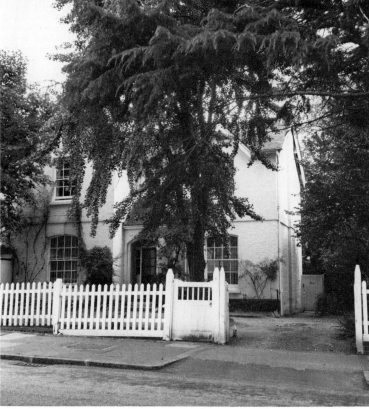

Fig. 196. Muybridge at sixty-five. 1895. From a photograph by Landy of Cincinnati, reproduced as the frontispiece of *Anthony's Photographic Bulletin,* March 1, 1895. As in Fig. 197, the sitter was not identified, but *Anthony's* readers were sure to know who it was.

Fig. 197. Muybridge at sixty-five. 1895. From a photograph by Gutekunst of Philadelphia, reproduced as the frontispiece of *Wilson's Photographic Magazine,* October 1895.

Fig. 198. 2 Liverpool Road, Kingston-on-Thames, England, where Muybridge lived at the time of his death on May 8, 1904. October 1972. Author's collection.

198

remarkable confirmation of the professor's statement, in regard to the knowledge and expression of motion by the sculptor of this age. . . .

The phase employed by the Egyptian artist has been, until recent years, very rarely used in art. . . . This distinctive method of galloping was unknown, and, indeed, unsuspected by us moderns, until revealed by photographic investigation of animal locomotion; but it was apparently well known to the early artists of Egypt.

EADWEARD MUYBRIDGE[15]

The Photographic Times of December 1902 commented on this correspondence, and this is the last the world at large heard of Eadweard Muybridge during his lifetime.

Still energetic, and nostalgic for the country that had given him the greatest opportunity, Muybridge constructed a model of the Great Lakes in his back yard.

By the following June Muybridge was so feeble that a letter offering his two Chapman and Hall books to the California State Library had to be dictated, though he signed the letter with his usual flourish. In October he inscribed copies of the two books to the State Library and to the library of the University of California.

On the following March 14 he made his will. Catherine Smith and George Lawrence were to share his estate. After Miss Smith's death much of his photographic material, his books, and the income from £2919 3*s* 7*d* were to go to the Kingston Library. The will revealed that Muybridge had lent his cousin Catherine £672 in about 1900 to build some cottages and to finish paying for Canbury Villa, Woodside Road, Kingston. Lawrence got a gold watch and various photographic items which are now unlocated. There was money in a San Francisco bank in trust for Margaret and Catherine Plow Smith, but the trust had never been executed.

Eadweard Muybridge, the father of the motion picture, died on May 8, 1904, in the house at 2 Liverpool Road. Death was due to a four-months' disease of the prostate gland, and was certified by F. C. Goodwin, M.D., Kingston. He was cremated at Woking, Surrey, on May 11, and his ashes placed in the earth in plot 4296. No photographic periodical noted his death.

Notes

1
THE EARLY YEARS

1 Robert Bartlett Haas, *Eadweard Muybridge, 1830–1904*, a biographical sketch accompanying an exhibition of Muybridge's work opening at the Stanford Museum, Stanford, California, on October 7, 1972.

2 *The San Francisco Daily Evening Bulletin*, April 28, 1856.

3 *The San Francisco Examiner*, February 6, 1881.

4 *The San Francisco Daily Evening Bulletin*, August 13, 1856.

5 *Ibid.*, September 1, 1856.

6 *Ibid.*, October 23, 1856.

7 *Ibid.*, September 27, 1856.

8 *Ibid.*, September 11, 1857.

9 *Ibid.*, March 11, 1858.

10 *Ibid.*, June 22, 1858.

11 *Ibid.*, July 21, 1859.

12 *Ibid.*, March 16, 1860.

13 *Ibid.*, May 15, 1860.

14 *Ibid.*, July 2, 1860.

15 *Ibid.*, May 28, 1860.

16 *Ibid.*, August 7, 1860.

17 *The San Francisco Chronicle*, February 6, 1875.

18 *The Philadelphia Photographer*, October 1865.

2
CELEBRITY IN SAN FRANCISCO

1 This phrase is taken from the flyer Muybridge issued when he published the 1867 photographs in May 1868. The complete text is on page 231.

2 February 12, 1868. Muybridge's flyer is dated simply February 1868, thus it must have been issued early in the month.

3 *The Daily Morning Call*, February 17, 1868.

4 *The Daily Alta California*, February 19, 1868.

5 *The Philadelphia Photographer*, April 1868.

6 *The San Francisco Daily Evening Bulletin*, April 22, 1868.

7 *The Philadelphia Photographer*, August 1868.

8 *The San Francisco Daily Evening Bulletin*, October 9, 1868.

9 Halleck letter book, Record Group 94, War Department, AGO, General Papers and Books, National Archives, Washington. Letter is dated October 13, 1868, and appears on p. 450 of the letter book.

10 *The San Francisco Daily Evening Bulletin*, October 21, 1868.

11 *Ibid.*, January 5, 1869.

12 *Anthony's Photographic Bulletin*, September 1878.

13 *The San Francisco Daily Evening Bulletin*, May 25, 1870.

14 *Ibid.*, August 10, 1870.

15 Letter of about November 21, 1870, in letter book of the Light House Board, National Archives.

16 Letter of December 20, 1870, in letter book of the Light House Board, National Archives.

17 Letter of January 13, 1871, in letter book of the Light House Board, National Archives.

18 *The San Francisco Daily Evening Post*, February 3, 1875. The *Chronicle* used the same language the following day.

19 A detailed study of Gordon and his part in early California is being prepared by Albert Shumate. Shumate has published a monograph of the architect of South Park, *The Life of George Henry Goddard* (Berkeley, 1969). Gordon was the original of Randolph in Gertrude Atherton's *The Randolphs of Redwood*, published as a six-part series in *The Argonaut* of 1883. Atherton's *A Daughter of the Vine* (New York, 1899) also makes substantial reference to Gordon, the real-life Randolph.

3
SUCCESS AND MARRIAGE

1 *The Sacramento Union*, April 26, 1872.

2 *The Sacramento Daily Record*, June 5, 1872.

3 *The Daily Alta California*, April 7, 1873.

4 *The San Francisco Chronicle*, April 29, 1873.

5 *The Yreka Union*, May 17, 1873.

6 *The Philadelphia Photographer*, September 1873.

7 *Anthony's Photographic Bulletin*, October 1873.

8 *The San Francisco Daily Evening Bulletin*, November 26, 1873.

9 *Ibid.*, November 29, 1873.

4

THE LARKYNS AFFAIR

1 This and the following quotations are from the *Chronicle* of March 14, 1873.

2 *The San Francisco Chronicle*, March 15, 1873.

3 *The San Francisco Daily Morning Call*, February 4, 1875.

4 *Ibid.*

5 *The San Francisco Chronicle*, February 4, 1875.

6 *The San Francisco Daily Evening Post*, February 4, 1875.

7 *Ibid.*

8 *The San Francisco Daily Morning Call*, February 5, 1875.

9 *The San Francisco Chronicle*, February 5, 1875.

10 A number of newspapers quoted this letter. This text taken from the *Post*, February 5, 1875.

11 *The San Francisco Daily Examiner*, February 5, 1875.

12 *The Napa Reporter*, February 6, 1875.

13 *Ibid.*

14 Several of the newspapers already cited reported on these conversations. There is some disagreement as to the exact wording, but the essentials, as nearly as they can be determined, are as presented here.

15 *The San Francisco Daily Examiner*, October 20, 1874.

16 *The San Francisco Chronicle*, October 21, 1874.

17 *Ibid.*, December 21, 1874.

18 *The San Francisco Daily Morning Call*, March 27, 1875.

19 *The Calistoga Free Press,* January 16, 1875.

20 *The Daily Alta California*, July 19, 1875.

21 *The San Francisco Daily Evening Post*, February 3, 1875.

22 *Ibid.*, February 2, 1875.

23 *The San Francisco Daily Evening Bulletin*, February 6, 1875.

24 Terry Ramsaye, *A Million and One Nights* (New York, 1926), p. 30.

25 *The San Francisco Chronicle*, February 7, 1875.

5

CENTRAL AMERICA

1 *The Panama Star*, May 5, 1875.

2 John Whetham Boddam-Whetham, *Across Central America* (London, 1877).

3 *Beyond the Mexique Bay* (New York, 1960).

4 In introduction to *Animals in Motion* (London, 1899).

5 *The Panama Star*, November 1, 1875.

6 *Ibid.*, November 1875. The day of the month is illegible in the clippings book.

7 *The San Francisco Daily Evening Bulletin*, January 18, 1876.

8 *The Philadelphia Photographer*, February 1876.

9 See p. 232 for the text of the accompanying flyer.

10 This inscription was written—in green ink—on the reverse of the title page of one of the Central America albums in the museum, which the writer called "historically priceless."

11 This letter is in the California State Library in Sacramento. Mrs. Pendegast's father lived in San Francisco, and Muybridge had suggested to the widow that her father make a choice of the photographs and he would have them bound and sent to her. Mrs. Pendegast thanked the photographer, and this note followed on May 25, 1876.

6

OCCIDENT IN MOTION

1 From caption of the illustration in *The Spirit of the Times*, August 11, 1877.

2 *The Resources of California*, August 1877.

3 *The Daily Alta California*, August 11, 1877.

4 Manuscript of a letter dated May 2, 1892, in the Bancroft Library, the University of California, Berkeley, California.

5 From Stanford's deposition in *Muybridge vs. Stanford*, No. 3418, Suffolk County (Mass.) Superior Court, January term 1883. These papers are in the Collis P. Huntington Collection, George Arents Research Library, Syracuse University, Syracuse, New York.

6 J. D. B. Stillman, *The Horse in Motion* (Boston, 1882).

7 From Isaacs's deposition in the case cited in Note 5.

8 *The San Francisco Chronicle*, June 16, 1878.

9 *Ibid.*, July 9, 1878.

10 *The San Francisco Examiner*, July 13, 1878.

11 *The San Francisco Chronicle*, July 14, 1878.

12 *The Philadelphia Photographer*, August 1878. Rulofson's letter is taken from the same issue.

13 *The Photographic News*, July 26, 1878.

14 *The Photographic Times,* September 1878.

15 *La Nature*, December 28, 1878.

16 Quoted by courtesy of Lloyd Goodrich.

17 *The Art Interchange*, July 9, 1879.

18 *The Daily Alta California*, May 5, 1880.

7

SUCCESS AND SCANDAL IN EUROPE

1 This information is taken from Shay's deposition in the subsequent lawsuit of July 23–27, 1883, in the Collis P. Huntington Collection, George Arents Library, Syracuse University, Syracuse, New York.

2 *Ibid.*

3 September 27, 1881. The translation is that of *The Daily Alta California*, where the article was quoted on November 16, 1881.

4 A letter dated November 28, 1881, in the Collis P. Huntington Collection at Syracuse University.

5 November 28, 1881. The London papers praised Muybridge highly, but his home-town paper, *The Surrey Comet*, evidently still horrified by the Larkyns affair, ignored all these celebrations.

6 *Le Temps*, November 29, 1881.

7 From the Collis P. Huntington Collection, Syracuse University.

8 *The Photographic News*, April 6, 1882.

9 From transcription of a manuscript dated May 2, 1892, in the Bancroft Library, University of California, Berkeley, California.

10 From transcription of a letter of March 7, 1882, in the Huntington Collection at Syracuse University.

11 *La Nature*, April 27, 1882.

8

THE PHILADELPHIA YEARS

1 *Anthony's Photographic Bulletin*, July 1882.

2 Archives of the Pennsylvania Academy of the Fine Arts, Philadelphia.

3 *Ibid.* He sent another sketch.

4 *The Philadelphia Photographer*, June 1883. Vogel's letter was written from Berlin on April 28, 1883.

5 The Minutes of the Trustees, University of Pennsylvania.

6 Letter of September 3, 1883, from the Pepper manuscripts at the University of Pennsylvania.

7 Quoted by George T. Clark in his *Leland Stanford* (Stanford, 1931).

8 *The Philadelphia Evening Bulletin*, February 9, 1884.

9 *The Philadelphia Press*, February 9, 1884.

10 Anshutz to J. Laurie Wallace, June 18, 1884. Archives, the Pennsylvania Academy of the Fine Arts.

11 *The Philadelphia Press*, August 2, 1884.

12 From transcription of a letter from Dercum to Dr. Arthur W. Goodspeed, April 23, 1929, University of Pennsylvania archives. In answer to an article by George E. Nitzsche, "The Muybridge Moving Picture Experiments," *The General Magazine of the University of Pennsylvania*, Vol. XXXI, No. 3.

13 Letter of August 7, 1884, from Thomas Anshutz to J. Laurie Wallace, archives of Pennsylvania Academy of the Fine Arts.

14 From an undated, but probably late August 1884 letter from Thomas Anshutz to J. Laurie Wallace, archives of Pennsylvania Academy of the Fine Arts.

15 *The Philadelphia Inquirer*, March 24, 1885.

16 "More About Muybridge's Work," *The General Magazine and Historical Chronicle* (Philadelphia) July 1929.

17 From a letter of July 17, 1917, to George E. Nitzsche, in the University of Pennsylvania archives.

18 This and the following quotation are from undated letters—presumably 1929—in the University of Pennsylvania archives.

19 Letter of April 11, 1929, from Grier to George E. Nitzsche, University of Pennsylvania archives.

20 From an undated memorandum—presumably 1929—in the University of Pennsylvania archives.

21 From transcription of an undated letter from Faber to, probably, George E. Nitzsche, about 1929, in the University of Pennsylvania archives.

22 Jesse I. Burk to Charles Harrison, July 19, 1886, the University of Pennsylvania archives.

23 *The Pennsylvanian,* June 15, 1886. *The Pennsylvanian* was a student newspaper.

24 Letter from Coates to Pepper, Pepper manuscript collection in University of Pennsylvania library.

25 Letter of May 18, 1887, from Muybridge to Dreer, Historical Society of Pennsylvania, Philadelphia.

26 *The Photographic News,* June 24, 1887.

27 University of Pennsylvania archives.

9
PHOTOGRAPHY AND PAINTING

1 *The New York Evening Post*, May 20, 1887.

2 *Bulletin* of Philadelphia Museum of Art, Spring 1965. See this article for a fuller discussion of the Eakins-Muybridge relationship before the University of Pennsylvania days.

3 *The Photographic News*, June 10, 1887.

4 *The Brooklyn Eagle*, January 29, 1888.

5 *The Photographic News*, March 29, 1889.

6 Ronald Alley, *Francis Bacon* (New York, 1964).

10
THE LAST YEARS

1 From a letter of November 18, 1931, to Janet Leigh, W. W. Pendegast's daughter, California State Library, Sacramento. Mrs. Leigh spent much of the latter part of her life vigorously supporting claims for Muybridge as an important innovator. Her letters are in many libraries and museums, and the historian owes her a great debt of gratitude for searching out many now unavailable sources of information. These reminiscences by Ernest Webster were one such item.

2 *Anthony's Photographic Bulletin*, May 9, 1891.

3 *Ibid.*, May 23, 1891.

4 Letter dated July 15, 1891, University of Pennsylvania archives.

5 Letter of December 19, 1891, in Edison Laboratory National Monument, West Orange, New Jersey.

6 From transcription of the manuscript in Bancroft Library, University of California, Berkeley, California.

7 *Ibid.*

8 Edison Laboratory National Monument, West Orange, New Jersey.

9 Letter of August 5, 1895, University of Pennsylvania archives.

10 *Ibid.*

11 *Wilson's Photographic Magazine*, July 1897.

12 *The Photographic Times*, June 1897.

13 Letter of June 16, 1899, University of Pennsylvania archives.

14 Letter of March 11, 1901, University of Pennsylvania archives.

15 *The Times* (London) May 22, 1902.

Appendix

Main text of flyer issued by Muybridge announcing his 1867 Yosemite photographs. May 1868. From clippings book, Kingston-on-Thames Library and Museum, Kingston, England:

EDW. J. MUYBRIDGE

Has now ready for sale the most comprehensive and beautiful series of Photographic Views, illustrating the wonderful

SCENERY OF THE YOSEMITE VALLEY

ever executed. They comprise

260 VIEWS

of the various falls, precipices, and most picturesque points of sight in the valley.

100, 6 x 8 inches, mounted on tinted boards, 14 ·x 18 inches, price $1.25 each, or $1 each in quantities of 20 and upwards.

160 Views for the Stereoscope price $1.50 per dozen

" Card size for the album " 2.50 "

All of these can be had unmounted, for the convenience of those wishing to forward them by mail. A complete series of the same various sizes, illustrating the most noted

MAMMOTH TREES

in the State.

These views are by HELIOS, and are justly celebrated as being the most artistic and remarkable photographs ever produced on this coast.

Also preparing for publication, a complete series of

SAN FRANCISCO VIEWS!

and a series illustrating MINING SCENES, and the Principal Places of Interest on this Coast

*

HELIOS is prepared to accept commissions to photograph Private Residences, Views, Animals, Ships, etc., anywhere in the city, or any portion of the Pacific Coast.

Address, care of EDW. J. MUYBRIDGE,
Cosmopolitan Gallery of Photographic Art
415 Montgomery Street, San Francisco.

*

Text of Bradley and Rulofson flyer announcing their association with Muybridge. June 1873. From clippings book, Kingston-on-Thames Library and Museum, Kingston, England:

BRADLEY & RULOFSON
429 MONTGOMERY STREET,
San Francisco, Cal.

Have the largest and most complete Portrait Gallery upon the Pacific Coast.

In every department we avail ourselves of the assistance of the most

accomplished artists and most skillful operatives. For many years the work issued from our establishment has been unapproached in this city and has enjoyed a most flattering comparison with that of the most celebrated galleries of the Eastern States and of Europe.

We have recently effected arrangements for the publication of the remarkable series of Photographic Views illustrating the Far West, by

MUYBRIDGE

To most persons in California the name of this artist is as familiar as those of the majestic scenes he illustrates. The careful execution and surpassing excellence of his work has occasioned his being employed during several years by the U. S. Government in the production of the numerous views upon this Coast, required by the Treasury and War Departments.

For judicious selection of subject, artistic treatment, and skillful manipulation, he is unrivaled in America, and the exquisite views produced by him of the sublime and beautiful scenery of the Pacific States, are marvelous examples of the perfection to which open air photography has attained.

The list of subscribers for his recent magnificent series of Yosemite Photographs includes the names of every prominent artist and nearly all the principal citizens and patrons of art in California. The amount of the subscription list, exceeding twenty thousand dollars, included one thousand dollars each from the Central and Union Pacific Railroad Companies, and five hundred dollars from the Pacific Mail Steamship Company. A sufficient evidence of the estimation in which the works of this eminent artist are held, without a reprint of any American or European "opinions", and a result we think unprecedented in the history of Photographic publication.

Muybridge will be constantly making additions to his superb and comprehensive collection of negatives, which will be published by us as soon after their receipt as possible.

Among his projected trips for this season for a series of views, 20 x 24 inches in size, is one along the line of the Transcontinental Railroad, and another to the Columbia River.

June, 1873.

BRADLEY & RULOFSON,
429 Montgomery Street, S. F.

Text of Muybridge flyer announcing his Central America photographs. 1876. From clippings book, Kingston-on-Thames Library and Museum, Kingston, England:

The following is a list of Photographic illustrations of Panama and Central America executed by instructions from the

PACIFIC MAIL STEAMSHIP COMPANY.

The object of the Company in having these views executed, was to stimulate commercial intercourse, by exhibiting to the Merchant and to the Capitalist in a convenient and popular manner, the ports and facilities of commerce of a country which presents such vast fields of profitable enterprise; and the principal industries of a people with whom until recently we have had comparatively little intercourse. And at the same time to gratify the tourist and lovers of the

picturesque with a glimpse of the wonderfully beautiful scenes that have hitherto remained unexplored.

The many expeditions I had conducted, as

Chief Photographer of the U. S. Government,

in illustrating Alaska, California, etc., have given me every necessary experience, and the result of my present labors has been a series of Two Hundred and Sixty Photographs, which in artistic treatment and skillful manipulation, are, in the opinion of our best art critics, at least equal to those I executed for the

CALIFORNIA INTERNATIONAL COMMISSIONERS.

For exhibition by them at *Vienna*, and which gained for me the

GRAND PRIZE MEDAL

for Landscape Work, in competition with the most eminent artists of all nations.

The series comprises all the ports of call on the Pacific Coast of Central America, and the most important of Mexico.—The ruins of Panama.—The remarkable volcanoes, lakes, mountain scenery, and luxuriant vegetation of Guatemala.—The ancient splendors of the ruined city of Antigua. The picturesque costumes and dwellings of the Indians, and the cultivation and preparation of Coffee, from the planting of the seed to its shipment in surf boats on board the steamer. The subjects are nearly all original, and have never been photographed before.

The great interest manifested in the expedition by the

SUPREME GOVERNMENT OF GUATEMALA.

and its valuable assistance, enabled me to obtain many picturesque views, which, under other circumstances, would have been impossible. And through the liberal enterprise of the Pacific Mail Steamship Company I am enabled to publish a series at less than one-half the price than would have been possible had the work been undertaken upon my own responsibility.

The subscription price will be

ONE HUNDRED DOLLARS IN GOLD.

Payable upon delivery of One Hundred and Twenty Photographs, selected at discretion from the entire series, and embracing as many duplicates of any of the subjects as may be preferred.

I have made arrangements for the publication of these views in *Europe*, and propose sending on the negatives immediately the home subscribers are supplied. I shall feel pleasure in sending a complete series of the views anywhere in the city for inspection and selection.

Non-residents subscribers can send their orders through some house in this city, or if they please remit me twenty-five per cent of their subscription, with full assurance that the photographs forwarded will be first class in every particular.

EDWARD J. MUYBRIDGE.
618 & 620 Clay Street,
San Francisco.

Text of lecture given by Muybridge to the Royal Society of Arts. April 4, 1882. From the *Journal of the Society of Arts,* **June 23, 1882.**

Proceedings of the Society.
EXTRA MEETING.
Tuesday, April 4th; Dr. R. J. MANN,
F.R.C.S., in the chair.
The lecture delivered was on—

THE ATTITUDES OF ANIMALS IN MOTION.
By MR. MUYBRIDGE.

GENTLEMEN—The honour which has been conferred upon me scarcely exceeds the pleasure I feel in coming before you this evening, but I think you will agree with me, that it will be unadvisable to detain you by a long lecture on animal mechanism. I think you will prefer seeing the result of my investigations to hearing a discourse on anatomy and physiology.

The attempts to depict the attitudes of animals in motion probably originated with art itself, if, indeed, it was not the origin of art; and upon the walls of the ancient temples of Egypt we still find pictures of, perhaps, the very earliest attempts to illustrate animal motion. But artists of all ages seem to have followed peculiar grooves in this matter, and to have adopted uniform notions as to the movement of animals. How inaccurate these notions have been, I shall endeavour to demonstrate to you this evening. I will commence, however, by showing you the apparatus by which the photographs were made; you will then better understand the pictures themselves. Here is the apparatus, consisting of an ordinary camera, in front of which is a strong framework, enclosing a couple of panels, each with an opening in the centre, sliding, one up and one down. In connexion with it is an electro magnet, which, on completion of a circuit of electricity, causes a hammer to strike and release a catch which holds the shutters in position; the back shutter is then drawn upwards by a strong india-rubber spring, and the front shutter is simultaneously drawn downwards. Here is a photograph of three shutters in position, one showing the panels before exposure, one during exposure, and a third after exposure. The next picture shows the arrangement in front of the cameras. Here are a series of strong threads stretched across the track, each of which being pressed forward, causes two metal springs to touch, and thereby completes the electric circuit. These threads are arranged at a distance of 12 in. from each other, and as the horse passes along he thrusts the strings, one after the other, completes an electric circuit, which operates the shutter of the particular camera which he is passing at the moment.

Twenty-four cameras are arranged parallel with the direction of the animal. The next picture shows the entire photographic arrangements. The track is covered with india-rubber, to prevent dust flying from the horse's hoofs; and there are here five cameras arranged in a semicircle, the object of which I will explain presently. The result is this:—A horse, in his progress over the track, comes in contact with these threads successively, and is photographed in the position in which he happens to be when he strikes the thread; then he moves 12 inches, and of course assumes another position, and is photographed, then

another 12 inches, and so on; in this way we have several positions assumed by an animal during an entire stride. The time of exposure, I may say, is the 1/5000 of a second.

Here is a scale I have drawn out, but which it would take me nearly an hour to explain, illustrating the position of a horse's feet during the various strides, the walk, the trot, the gallop, and the pace; if any one feels sufficient interest in the subject to inquire more thoroughly into it by-and-by, it will afford me a great deal of pleasure to explain it.

Now, as I have spoken of the faults of artists, I must show you what those faults are. Here are some pictures of horses walking, from different sources, with some of which you are all no doubt familiar. One is from Egypt, where they seem to have had two modes only of illustrating the motion of an animal, one the walk, the other the gallop. Here is one walking, with all four feet on the ground at once. As a general rule, indeed almost always, they are going from left to right. You will notice that the lateral legs are represented as moving synchronously, both left legs touch the ground at the same time, and both right legs. Here are other examples of Assyrian and Greek art; a Roman of the 1st century and one of the 8th century, also a Norman horse from the Bayeux tapestry, a German horse, and one by Flaxman, which is the only correct one of the series. I would particularly call your attention to a representation from the column of Theodosius, where you see two mules, in one of which the hind legs are precisely in the same position as those of the mule in the next illustration, whilst the fore legs are totally different. Now, a mule or a horse walks in the same way, so that if one is right the other must be wrong.

Here are photographs of a horse in the act of walking. A horse, while walking, is alternately supported on three feet and on two, and the two are alternately diagonals and laterals. Some very eminent authorities have asserted that a horse, while walking, has never more than two feet on the ground at the same time; but he has always two—this is the characteristic of the walk—and invariably three, four times during each stride, two hind legs and a fore leg, alternately with two fore legs and a hind leg. This horse, you observe, is standing on the right laterals. The most common fault of artists in representing the walk is to mistake the laterals for the diagonals: it arises, I am satisfied, from carelessness and lack of observation. Whenever a horse or any other animal has two suspended feet between two supporting legs, those two suspended feet are laterals, never diagonals. You find them in pictures, engravings, and even in sculpture, quite as frequently represented one way as the other; but they are invariably laterals—that is, when they are suspended *between* two supporting legs. When supported on diagonals, suspended feet are outside the supporting legs. Here is a horse walking, photographed simultaneously from five points of views, according to the arrangement of the cameras I referred to just now. Next, we have a photograph showing the regular series of position taken by a horse while walking. Of course, in every thousandth part of an inch, a horse really gets into a different position, but these are all the positions of a stride which are worth illustrating.

Next we have the amble; and first I show you some speciments of Egyptian, Assyrian, Etruscan, and Modern Italian art. They are none quite correct, but they approach more nearly to the gait which is ordinarily called the amble than any others I have found. I do not know whether this gait is properly under-

stood or appreciated in this country, because horses are not trained to it, but Spanish horses are invariably taught it. It is faster than a walk, but not quite so fast as a trot, and is an easy, sliding motion, alternately on one foot and on two feet. In this, as in the walk, the horse is never entirely off the ground; in all other gaits the weight is off the ground entirely during a portion of the stride, but in these two he is never clear of the ground. He is alternately on one hind foot, then on two laterals, then upon one fore foot, then on the diagonals, then on a hind foot again. The succession is very curious: first on one foot, then on two; the two feet being alternately diagonals and laterals.

When these photographs were first made, some experts had doubts as to their accuracy. We have here a little instrument called the zoöpraxiscope, with which we can throw the various positions in rapid succession on the same spot on the screen, and thus produce apparently the real motion, and you will readily understand that if any of the positions were incorrect, it would upset the experiment altogether.

Next we come to the trot, and as before, I first show you some examples of ancient and modern art. There is Marcus Aurelius on horseback, but that is not a real trot, because in a trot the motion of the diagonals is more synchronous than is here represented. The best example of a trot I have been able to discover of mediæval times is from a stained glass window in the Cathedral of Chartres. There are two from the Louvre, representing Louis XIV. and Louis XV.; none of them are quite correct, but none have such glaring faults as one by a very celebrated artist, Rosa Bonheur. She is, perhaps, one of the greatest artists of modern times; grand in colouring, splendid in drawing, a great observer of nature, but, unfortunately, she did not pay sufficient strict attention to the positions of animals in motion. This is a very celebrated picture, and the horse is supposed to be trotting pretty fast. Now, one fore leg is extended backwards, really beyond the centre of gravity of the horse. It would be utterly impossible for him to bring it forward in time, at the rate he is going, to support his body, and he would be obliged to fall down—he could not help it.

Here are a series of photographs of a horse trotting at about ten miles an hour, showing all the various positions at the different periods of the stride. Now, to me it seems almost incomprehensible, but until these experiments were made, it was a question with some very experienced horse drivers whether a horse was entirely clear of the ground during a trot. Some imagined that he always had one foot on the ground, though I cannot see how it was possible for them to come to that conclusion. Even at a moderate rate, in trotting, the weight of the body is entirely unsupported by the feet, though they may drag along the ground at a certain portion of the stride, no matter how slow the pace. This being about ten miles an hour, the horse is entirely clear. Here, again, is a horse trotting at the rate of a mile in 2 min. 20 secs. One thing I would call attention to is this, that when a horse's foot strikes the ground, the leg is always straight; it is never in a bent position. Though you find some eminent artists illustrate a horse striking the ground with his leg bent, it simply is not possible. Another thing is, that he always strikes the ground with his heel first, never with his toe. Here is another horse performing a moderately fast trot, about 8 miles an hour, and making a stride of 6 ft. 6 in. Here is another trotting very fast—1 mile in 2 min. 18 sec.; the fastest time ever accomplished being a mile

in 2 min. 10 secs. There is also a peculiarity observable with regard to the position of the pastern. When striking the ground it is vertical, but it immediately sinks so as to become almost horizontal. Now, we will try the trot with the zoöpraxiscope, and you will find the motion is perfectly produced.

Next we come to the canter, which is rather a peculiar gait. It differs from the gallop in many respects, and notably in this, that whereas in the gallop the horse will leave the ground with the fore feet, as also he does in the canter, in landing in the gallop he lands first on one hind foot and then brings down the other hind foot, so that he will be on two hind feet at the same time, and throwing his fore feet forward; in a canter he will land on one hind foot, and the next foot to touch the ground will be a fore foot; then he will bring down the other hind foot, and then the next fore foot. That is the invariable order of succession in the canter, but the hind foot will follow the fore foot so rapidly that it is utterly impossible for the eye to follow the succession of movements. Here we have a series illustrating the canter. You see he leaves the ground on the fore foot, as is invariably the case with either the canter or the gallop. That is another singular fact that artists have not noticed, and they have been led into the very egregious error of imagining that a horse, while galloping, left the ground with the hind foot and landed on the fore feet. A horse, while galloping, is always in the air for a certain portion of time, but it was always supposed that in galloping he would leave the ground with the hind feet and land with the fore feet, whereas the reverse is always the case.

We now come to the fastest of all gaits—the gallop. Here is the Egyptian representation which, with very slight variations, is the way in which Egyptian horses galloping are always represented; the hind feet are down, and the fore feet in the air. The Assyrian is not much better, but the Greeks evidently understood the motion of a horse better than a great many of the moderns; and this is very nearly the position in which a horse would be, having just landed after a flight through the air. He has struck the ground with his hind feet, one hind foot being behind the other. Here is another from the column of Theodosius; here is a Norman example from the Bayeux tapestry, and here is one by some Italian artist of the 4th century, in which we find a position of the gallop exactly reproduced. Here is one by Albert Durer; this is the conventional gallop; and, with all due deference to the artists who have palmed it off on the public as being a representation of a galloping horse, I must say it is really absurd, because it is utterly impossible for a horse to get into that position. Here are some ancient pictures, one from the ruins of Angar Wat, in Cochin China; a Japanese, which is tolerably correct; and a very curious one, copied from a painting on the rocks on the banks of the Yenisi by the Tartars. This shows how artists of different ages and different countries have all agreed in representing nearly the same conventional position of the gallop.

While on the question of the absurdity of this position, I may remark that where there are ten horses it is a concentrated absurdity—it is ten times as absurd—because if it were possible even for one horse to get into that position, it would be certainly the height of improbability for ten horses, at the same instant of time, all to be in the very same position; yet here is a picture by a distinguished artist, Mr. Herring, a very celebrated painter of horses. He has painted ten horses all fully extended in that conventional position. The public may have demanded that, and he painted that picture in that way. It is necessary

that the public and the artist be educated together. Here we see a photograph of a free gallop, with a horse just about alighting on the ground still in the air. When the horse is in the air, it is not with his feet stretched out as far forward as they will go, and the two hindmost in the same way, but they are curled up invariably in the way you see them in this photograph. That horse is now in the air, about to alight on the hind foot. In another one, you see him alighting on the hind feet, and, of course, there are intermediary positions between these; and this where he is about to leave the ground with one forward foot. Those connected with the turf are well aware that, when horses break down, they always break down with the fore feet, and never with the hind feet, or very rarely. It was a mystery why that should be so, but here is the key to it; the immense amount of work that a race-horse has to perform with his fore legs is fully equal, in my judgment, to that with the hind legs. Here are all the important positions which a galloping horse will assume in making a complete stride. In its particular features each stride really differs from another. If you take one of the swiftest race-horses, and measure his stride, you sometimes find one inch, sometimes two, and sometimes half-an-inch variation in the length of the stride; it depends on various little things, but this is a representative stride. Here is another, with a little longer stride—19 ft. 9 in.—in a stride of 25 or 26 feet. We might have information different to that we have obtained.

Now we come to the leap. This is the horse rising preparatory to clearing the hurdle. The hind feet are on the ground for the last time before making the spring, and you notice that one is much in advance of the other—a few inches; sometimes it is more than that. They are hardly ever at precisely equal distances from the hurdle, and on coming down, you find a greater variation. I may say that these pictures are entirely untouched; they are exactly as they were made in the camera; there is no interpolation by any artist, or any imagination. Here the horse is coming down; one fore leg you see is nearly straight, the other is somewhat curved, because he has not had time to bring it out probably; it will be perfectly straight when he touches the ground. Here he is landed, and you notice that one pastern is almost horizontal. That is the position in which a horse invariably strikes the ground. Here we have an entire consecutive series taken from a distance of about twenty feet in front of the hurdle. There is more variation in the leap of the horse than in almost any other movement. Sometimes he will leave the ground at a distance of twelve feet from a hurdle 3 ft. 6 in. high; at other times he may probably not leave the ground until 3, 4, or 5 ft. of the hurdle. It depends a great deal on the disposition of the horse. Here is a series illustrating his position after he has cleared the hurdle, showing the method by which he picks up his feet, and regains the gallop, after having made the jump. This is a complete stride, and we can follow the horse here from the time he leaves the ground with his feet until he lands on his fore feet. I will now illustrate this movement with the zoöpraxiscope. Here are some photographs of the dog. In fact, some people might mistake that for a horse, because the position is somewhat like the conventional horse gallop. The motion of the dog is very peculiar. Here he has alighted on one foot, changed it to the next fore foot, and then he leaves the ground with the fore feet. In the next you find him entirely in the air, his feet all doubled up under him; he then comes down on his hind feet. Then he brings the next hind foot down, and leaves the ground again, so that he is in the air twice during a single stride—once with his body curled up, and

the other when perfectly extended. I do not think that fact has ever been commented on by a writer on natural history. Here is a photograph of two dogs running a race; they were photographed together; one was a faster dog than the other, and you see how he gradually overtakes his competitor.

Next we have the ox; here are two oxen from the column of Theodosius, and they are both correct. There is one peculiar feature in the walk, of which I should like to tell you. Artists ought really to be close observers of animal movements, but it is rare to find an artist who can tell you the manner in which an animal will walk. There are two artists here, and they have not been able to tell me. There is one invariable rule with regard to the walk, so far as my observation has extended, and that is that the succession of footfallings are with any animal precisely the same; whether a dog, a horse, a monkey, or the giraffe, they are all the same. Assuming you commence your observation with the left hind foot, the next foot to touch the ground would be the left fore foot, followed by the right hind foot, and that again by the right fore foot. That order, so far as I am aware, is universal. I would not be positive so far as all animals are concerned, the hippopotamus for instance, but, so far as I have had an opportunity of judging—certainly, so far as I have photographed—it is so. You may think it a very easy thing to watch an animal, and see how it walks, but it is very difficult. There is as much difficulty in watching the massive movements of an elephant as the more light and rapid movements of the horse. I am not quite satisfied in my own mind yet whether an elephant is upon diagonals during a walk or not; I know he is on laterals, but during half an hour's observation I could not really positively say whether he was supported by the diagonals alone or not. With the hippopotamus I know that to be the case, but I almost question really whether an elephant in walking is supported entirely by diagonals. Here again we have a picture of an ox, by Rosa Bonheur. This is a very celebrated picture in the Luxembourg. Those two oxen are represented in a manner that no oxen would ever think of getting into. You might get a cord, and pull their feet into that position, but it would be strongly against their will. There is another one here by the same artist which is more nearly correct, but not quite.

Next we have a series of photographs of an ox walking, and the same principle holds good. The succession is the same. The trot of the ox is pretty much the same as that of the horse. The next is a wild bull; he was really wild enough for a Spanish bull fight; we had to build a long lane in order to get him to run straight, and we had three or four men ready to catch him in case he should make for the cameras. The bull gallops pretty much like a horse. Next we have a set of photographs of the pig. I thought I would attempt the pig, not that I hoped to gather much information from his movements. The principal event of our experiment was the difficulty we had in inducing him to go forward; of course we followed the old principle of drawing him backwards.

Next I have a set of photographs of the deer. Some writers on animal movements have compared the gallop of a horse to that of the deer, but there is really a considerable difference. We see that the deer takes somewhat the conventional style of the horse in galloping. The gallop of the deer is hardly a gallop, it is almost a series of bounds. The deer does leave the ground with the hind foot, and lands on the fore foot, which the horse does not.

Now, we come to the movements of mankind. This man is walking pretty fast, a seven foot stride. With regard to the walker, we all know that he lands

on the heel; but in taking a run, if you ask any athlete in what manner he runs, I think he would tell you that he would not alight on the heel, that he would alight on the ball of the foot. They are generally very confident that in running they never come down on the heel. That is the opinion of the runner himself, I think, in nine times out of ten, and it was with very great difficulty, after this man had run, and had seen these pictures, that he could convince himself of the fact that in running he always came down in this manner. It is the same with the man as with all other animals, as far as I am aware, they always come down on the heel. Here is a photograph of a long jump of 16 feet, without any particular attempt to jump high. Here is one of a man clearing a hurdle four feet high. You would think that clearing a hurdle of that height, if it were possible for him to come down on his toes, and so break the force of the concussion by springing, that he would do so. But you see here where that man's toes are. He comes right down on the heel, and that is the only way in which he could come down. The man finds his springs in his knees when jumping; the horse finds them in his pasterns. [The various movements in running and jumping were then exhibited in the zoöpraxiscope.]

In the next photograph we see men performing athletic feats, particularly feats of strength. They are on too small a scale to show the play of the muscles. But I have a series on a larger scale of men wrestling, in which the action of the muscles is very well shown. This series of exposures was made in a slightly different way. Of course, the men in wrestling were pretty much in a small circle, and, therefore, different means had to be adopted for regulating the successive exposures. The cameras were all concentrated on one point, and an apparatus was constructed to cause them to receive the exposure at stated intervals of time, instead of distance. Here are photographs of a twisting somersault; next a flip-flap, the movement which is made preparatory to making a back somersault, and here is a back somersault. I will show these in the zoöpraxiscope. Of course, the construction of this instrument requires the movements to be effected more rapidly than a man in performing the same result would naturally do. The horse on which he is standing, instead of making two strides, would probably make three or four before he turned the second somersault. But in order to show that, it would require a disc of 10 feet circumference.

At the request of my friend, Professor Marey, of Paris, I gave some attention to illustrating the position of birds, but I cannot say I was very successful. The movement of the wing are so extremely rapid, and it is a small object any way, so that the information we have obtained from the movements of birds I cannot congratulate myself upon; however, here are a few of the results. There are only two nations, that I am aware of, in which the artists have ever thought of illustrating birds with their wings downwards; of course, artists must know that birds' wings go down, but I suppose they imagine it is inartistic to draw them in that way. The ancient Egyptians would frequently illustrate their birds with the wings downwards, and the other nation is the modern Japanese. You frequently find, in Japanese books, birds illustrated with their wings downwards. I show you these few photographs of birds, but perhaps, they are of more value for art than for science.

I have now some illustrations of groups of horses galloping. These really are more difficult to make, because they were made in the open fields without any of the apparatus which I have described. There are also a few picture subjects,

showing groups of horses, which are, perhaps, more interesting to the artist. Lastly, I will show with the zoöpraxiscope a picture, which we may call Rotten-row. [This was a picture of a number of horses, dogs, and men, showing the various motions of running and trotting].

In conclusion, I have only to say that, if there is anyone who desires to investigate the subject further, it will afford me great pleasure to give every information in my power.

*

The CHAIRMAN said he was quite sure it would be unnecessary for him to say that all members present must feel as he did himself, greatly indebted for the kindness with which these processes had been placed before them; and he might also say that very many would feel great admiration for the perseverance and skill with which this matter had been developed. There was no doubt at all but that there were very few who were even aware of the movements of their own limbs. He confessed it was a matter he had thought a good deal about at times, but had never been able to realise to his own satisfaction how it was he was able to walk. He was, himself, some years ago, made aware that the amble was particularly well developed, not only amongst mules in Spain, but was a very favourite gait amongst the Dutch of South Africa. Every man there taught his horse to amble. He had a horse himself which was a very good ambler indeed. He had studied the movements, he might say, for years, but he could not make head or tail out of them. He had watched the horse again and again in a most close way—as an anatomist, as an observer, and as, he should imagine, an artist would—but he did not know how it was that the amble was got out. He referred to this in order to bring before the meeting how valuable, on scientific grounds, was the apparatus they had had displayed. If that apparatus were made use of to study the movements of a horse or any other animal, it was possible, by careful observation, to ascertain exactly what the animal did, and he could prove that in an admirable way. In the amble there was a peculiar sense to the rider; it was a movement, as they had heard, in which the back of the horse moved very little indeed out of one plane, but the rider was conscious of a singularly slight oscillation from side to side in the same plane; it was a very easy gait. You simply felt a slight jerk sideways, and when you once got accustomed to it, you could never forget it. Now, he had noticed on the screen that the man on the ambling horse had distinctly that sideways motion, which he had himself felt in riding. He mentioned that to show how exact this apparatus was. He was sure they would all join in a hearty vote of thanks to Mr. Muybridge, and he was sure they would all be willing to express their admiration, not only for the skill and scientific accuracy with which this had been developed, but for the interesting way in which it had been brought forward.

The vote of thanks having been passed,

Mr. MUYBRIDGE, in returning thanks, said he might illustrate what Dr. Mann had said with regard to observing the peculiarities of the amble. An able article recently appeared in the *Builder*, upon the physiognomy of motion, stating that every man had a motion peculiarly his own, as much so as his features; so that although a man wore garments with which they were unacquainted, his friends would recognise him at a distance by his gait. Now, he could illustrate that with regard to the gait of horses. In the first series he made, showing a

horse in the act of galloping, he showed it in triumph in the zoöpraxiscope, to the owner of the horse, Mr. Stanford, and said he supposed he would recognise his horse, Florence Anderson. "Well," said Mr. Stanford, "You have got a galloping horse there, but it is not Florence Anderson." He replied that it was, that the trainer had sent it out to him, and that was a picture of it. Mr. Stanford said he was quite satisfied that it was not Florence Anderson, and on the man being sent for, it turned out to be another horse. That showed that not merely a galloping horse could be illustrated in this way, but that even a horse's peculiar gait could be so rendered by the instrument that it should be recognized by anyone familiar with the animal. He could not, perhaps, distinguish the gait of one from the other, but the owner could at once. Another thing he should like to remark was that he did not by any means exhibit these as perfect pictures, but simply as experiments, and next year he should hope to be able to show experiments more worthy of approval.

Chronology

April 9, 1830 Eadweard James Muybridge born Edward James Muggeridge in Kingston-on-Thames, England

1852 Emigrates to America

Autumn 1855 Settles in San Francisco and goes into book business

May 10, 1860 Brothers Thomas and George join in book business

May 1860 Visits Yosemite Valley for first time

July 2, 1860 Leaves San Francisco by stage for East

October(?) 1860 Leaves New York for England

1861–62(?) Begins study of photography

c. 1866 Returns to San Francisco and joins Silas Selleck in photography business

June–November 1867 Second visit to Yosemite, numerous photographs

February 1868 Offers Yosemite photographs under new pseudonym, "Helios"

April 1868 Offers numerous Bay Area photographs

July 29–September 4, 1868 Takes many Alaska photographs

April 1869 Joins Arthur and Christian Nahl at 121 Montgomery Street

March–August 1871 Photographs lighthouses on Pacific Coast for U.S. Light House Board

March, or May 20, 1871 Marries Flora Shallcross Stone

April 1872 Becomes friendly with the Leland Stanfords. Apparent beginning of motion photography

Summer 1872 Visits Yosemite again and takes numerous 18″ x 22″ glass negatives

April 1873 Photograph of horse Occident in motion announced

May 2–11, 1873 Photographs Modoc Indians and U.S. soldiers in Lava Beds in northern California

1873 Begins association with Bradley and Rulofson

1873 Photographs Central Pacific and Union Pacific Railroads

April 15, 1874 Birth of son, Florado Helios

October 16, 1874 Discovers that Florado is the son of Harry Larkyns

October 17, 1874 Kills Harry Larkyns at Yellow Jacket Mine in Napa County

c. December 7, 1874 Wife files for divorce and alimony

February 2–5, 1875 Goes on trial for murder of Larkyns and is acquitted.

February 27, 1875 Leaves on Central America photographic assignment

July 18, 1875 Wife dies; Florado put into Protestant Orphan Asylum

November 27, 1875 Leaves Panama for San Francisco

July 1877 Publishes *San Francisco Panorama #1*

July 1877 Takes motion photograph of Occident

August 11, 1877 Publishes motion photograph-painting of Occident

October–November 1877 Produces *San Francisco Panorama #2*

November 1877 Proposes microphotography of San Jose official records

June 11, 1878 First motion photographs in 1878–79 Palo Alto series

Autumn 1878 Five series photographs of horses in motion published

May 1879 Begins second season at Palo Alto

Not later than August 7, 1879 Photographs of human motions, possibly on suggestion of Thomas Eakins

Autumn 1879 Adapts drawings made from motion photographs to a projection machine, the zoopraxiscope, and begins exhibitions of motion pictures on the screen

May 1880 Series of motion-picture exhibitions in San Francisco

c. May 1881 Publishes results of 1878–79 work in *The Attitudes of Animals in Motion*

August 1881 Travels to Europe for exhibitions

September 26, 1881 Exhibition at house of Jules Etienne Marey, physiologist

November 26, 1881 Exhibition at house of Jean Louis Ernest Meissonier, French academic realistic painter

March–June 1882 Series of lectures in England

April 1882 Publication of *The Horse in Motion*, which causes professional and financial embarrassment

June 1882 Returns to United States

August 1882–February 1883 Lectures in eastern United States

August 1883 Files suit against Osgood and Company, publishers of *The Horse in Motion*

May(?) 1884 Begins Philadelphia work at University of Pennsylvania

May 1884–c. January 1, 1886 Takes perhaps 30,000 motion photographs

Not later than April 1887 *Animal Locomotion,* 781 plates, published

Spring 1889 Travels to Europe for lectures

Summer 1890 Returns to United States

Autumn 1890 Travels again to Europe

Autumn 1891 Returns to America

1891 Publishes *The Science of Animal Locomotion*

October 1892 Arranges to give lectures in specially built hall at World's Columbian Exposition

Spring 1893 Publishes *Descriptive Zoopraxography*

Summer 1894 Returns to England

June 1896–May 1897 Final visit to United States to assist in final disposition of University of Pennsylvania work

1899 Publishes *Animals in Motion*, five printings

1901 Publishes *The Human Figure in Motion*, seven printings

May 8, 1904 Dies at 2 Liverpool Road, Kingston-on-Thames

Bibliography

The Bibliography is arranged as follows:
1. Works by Muybridge are arranged chronologically;
2. Books, foreign and domestic, with the exception of general reference works, are arranged alphabetically by author;
3. General reference works are arranged alphabetically by title, and, when this was not possible, by author or editor;
4. Miscellaneous works, such as catalogues and pamphlets, are arranged chronologically;
5. Periodicals are arranged alphabetically by title, with foreign and domestic works separated. Articles are arranged chronologically, and separated into photographic and nonphotographic works;
6. Principal newspapers are arranged alphabetically by city, and then alphabetically by state; foreign ones are grouped together.

1. Works by Muybridge, including reprints

I have excluded from this list of Muybridge's "official" works all photographs that were customarily or often published separately, even though groups of these were sometimes bound and distributed as a separate publication, either singly or in editions of several. Such publications as Muybridge's Central America albums, his *San Francisco Panorama #2*, and his presentation copies of the University of Pennsylvania plates are therefore not listed. Works are listed chronologically in order of appearance.

The Attitudes of Animals in Motion (San Francisco: 1881).

Panoramic San Francisco (San Francisco: 1884?). A reprint of *San Francisco Panorama #1*.

Animal Locomotion / An Electro-Photographic Investigation of Consecutive Phases of Animal Movements . . . Prospectus and Catalogue of Plates (Philadelphia: 1887). A second printing of this pamphlet had slight changes.

Animal Locomotion / An Electro-Photographic Investigation of Consecutive Phases of Animal Movements. 781 plates (Philadelphia: 1887).

The Science of Animal Locomotion (Zoopraxography): an Electro-Photographic Investigation of Consecutive Phases of Animal Movements (Philadelphia: 1891). Another edition of this pamphlet was called *Zoopraxography or the Science of Animal Locomotion.*

Descriptive Zoopraxography (Chicago?: 1893?).

Animals in Motion (London: 1899, 1902, 1907, 1918, 1925).

The Human Figure in Motion (London: 1901, 1904, 1907, 1913, 1919, 192–, 1931).

The Human Figure in Motion / Eadweard Muybridge, Robert Taft, ed. (New York: 1955).

Animals in Motion / Eadweard Muybridge, Lewis S. Brown, ed. (New York: 1957).

Animal Locomotion, Vol. 1, "Males (nude)," (New York: 1969). Includes facsimile reprint of the 1887 *Prospectus and Catalogue of Plates.*

2. Books

Sir William De W. Abney, *Instantaneous Photography* (New York: 1895).

Gertrude Atherton, *The Californians* (New York: 1898).

Gertrude Atherton, *A Daughter of the Vine* (New York and London: 1899). Good background on life on the Peninsula. Muybridge photographed the Athertons—including Gertrude—and their home.

J. H. Beadle, *The Undeveloped West: or Five Years in the Territories* (Philadelphia: 1873).

L. L. D. Black, *Some Queer People* (London: 1931).

John Whetham Boddam-Whetham, *Across Central America* (London: 1877).

Samuel Bowles, *Across the Continent* (Springfield, Mass.: 1865).

John Walton Caughey, *California* (Englewood Cliffs, N.J.: 1953).

C. W. Ceram, *Archeology of the Cinema* (New York: 1965).

George T. Clark, *Leland Stanford* (Stanford, Calif.: 1931). A fawning book on a man who remains interesting in spite of this biographer.

R. P. Conkling and M. B. Conkling, *The Butterfield Overland Mail 1857–1869* (Glendale, Calif.: 1947).

Frederick A. Conningham, *Currier & Ives Prints / An Illustrated Check List* (New York: 1949).

Georges Demeny, *Les Origines du Cinematographe* (Paris: 1909). Demeny was Marey's assistant in the later years of the nineteenth century.

Theodore Ayrault Dodge, *Patroclus and Penelope* (Boston: 1885). Interesting because we know Muybridge read it and thought little of it.

E. Duhousset, *Le Cheval dans la Nature et dans l'art* (Paris: 1874 and 1902).

Josef Maria Eder, *History of Photography* (New York: 1945).

Francis P. Farquhar, *Place Names of the High Sierra* (San Francisco: 1926).

Charles A. François-Frank, *L'Oeuvre de E. J. Marey* (Paris: 1905).

Walter Fry and John R. White, *Big Trees* (Stanford: 1938).

Roger Fulford, *George the Fourth* (New York: 1935). The best of the biographies of the man who was king of England when Muybridge was born.

Edmund M. Gagey, *The San Francisco Stage / A History* (Berkeley: 1950).

Helmut and Alison Gernsheim, *The History of Photography* (New York: 1955). The most thorough general history to date.

Vallery K. O. Gréard, *Meissonier, His Life and His Work* (London: 1897). An obsequious "lady writer" book.

Horace Greeley, *An Overland Journey* (Charles T. Duncan, ed.) (New York: 1964).

Thomas Jefferson Gregory, *History of Solana and Napa Counties, California* (Los Angeles: 1912).

Wesley S. Griswold, *A Work of Giants* (New York: 1962). Much solid information in spite of a sycophantic approach.

Harry Lawrence Gunn, *History of Napa County* (Chicago: 1926).

The Hand-Book and Directory of The Pacific Coast . . . Napa, Lake, Sonoma and Mendocino (San Francisco: 1874).

Gordon Hendricks, *Albert Bierstadt* (New York: 1974).

Gordon Hendricks, *The Edison Motion Picture Myth* (Berkeley: 1961).

Gordon Hendricks, *The Kinetoscope* (New York: 1966).

Gordon Hendricks, *The Life and Works of Thomas Eakins* (New York: 1974).

Gordon Hendricks, *The Photographs of Thomas Eakins* (New York: 1972).

John S. Hittell, *Commerce and Industries of the Pacific Coast of North America* (San Francisco: 1882).

John S. Hittell, *The Resources of California* (San Francisco: 1866, 1869).

John S. Hittell, *Yosemite: Its Wonders and Its Beauties* (San Francisco: 1868). Illustrated by twenty of Muybridge's 1867 photographs.

Stewart H. Holbrook, *The Age of the Moguls* (New York: 1953).

Robert West Howard, *The Great Iron Trail* (New York: 1962).

James M. Hutchings, *Scenes of Wonder and Curiosity in California* (London: 1865).

Aldous Huxley, *Beyond the Mexique Bay* (New York: 1960).

An Illustrated History of Sonoma County, California (Chicago: 1889).

Illustrations of Napa County California with Historical Sketch (Oakland: 1878).

Helen Hunt Jackson, *Bits of Travel* (Boston: 1878).

Matthew Josephson, *The Robber Barons* (New York: 1934).

John Haskell Kemble, *San Francisco Bay / A Pictorial Maritime History* (New York: 1957).

Walter Barnes Lang, *The First Overland Mail* (East Aurora, N. Y.: 1945).

Oscar Lewis, *Bay Window Bohemia* (New York: 1956).

Oscar Lewis, *The Big Four* (New York: 1959).

Oscar Lewis, *Sea Routes to the Gold Fields* (New York: 1949). A good general bibliography of background material for Muybridge's first California years.

B. E. Lloyd, *Lights and Shades of San Francisco* (San Francisco: 1876).

Kevin MacDonnell, *Eadweard Muybridge: The Man Who Invented the Moving Picture* (Boston: 1972). Includes a number of illustrations incorrectly attributed to Muybridge.

Kenneth Macgowan, *Behind the Screen* (New York: 1965).

Etienne Jules Marey, *La Chronophotographie* (Paris: 1891).

Etienne Jules Marey, *Développement de la Methode Graphique* (Paris: 1892).

Etienne Jules Marey, *La Machine Animale* (Paris: 1873). Also published as *Animal Mechanism* in London and New York in 1874.

Etienne Jules Marey, *Mouvement* (New York: 1895).

Etienne Jules Marey, *Photographie du Mouvement* (Paris: 1892).

Etienne Jules Marey, *Le Vol des Oiseaux* (Paris: 1890).

William Dennis Marks, Harrison Allen, and Francis X. Dercum, *Animal Locomotion: The Muybridge Work at the University of Pennsylvania* (Philadelphia: 1888).

Charles Marvin, *Training the Trotting Horse* (Pennsylvania: 1893).

R. Guy McClellan, *The Golden State* (San Francisco: 1875).

C. A. Menefee, *Historical and Descriptive Sketch Book of Napa, Sonoma, Lake and Mendocino* (Napa: 1873).

Keith A. Murray, *The Modocs and Their War* (Norman: 1959).

Gustavus Meyers, *History of the Great American Fortunes* (New York: 1907 *et seq.*).

Beaumont Newhall, *The History of Photography* (New York: 1949).

Charles Nordhoff, *California: for Health, Pleasure, and Residence.* (New York: 1872).

Robert O'Brien, *This is San Francisco* (San Carlos, Calif.: 1948). A Journalistic account, with a frustrating lack of sources.

Waterman L. Ormsby, *The Butterfield Overland Mail* (eds.: Lyle H. Wright and Josephine M. Bynum) (San Marino, Calif.: 1942).

L. L. Palmer, *History of Napa and Lake County, California* (San Francisco: 1881).

DeWitt C. Peters, *Kit Carson's Life and Adventures* (Hartford: 1874).

J. Bell Pettigrew, *Animal Locomotion or Walking, Swimming, and Flying, with a Dissertation on Aeronautics* (New York: 1874).

The Pictorial Wide West (San Francisco: 1855).

T. C. Porter, *Impressions of America* (London: 1899).

Martin Quigley, Jr., *Magic Shadows* (Washington: 1948).

Terry Ramsaye, *A Million and One Nights* (New York: 1926). A journalistic account of Muybridge's work by one who thought little of it.

Albert D. Richardson, *Beyond the Mississippi* (Hartford: 1867).

Jeff C. Riddle, *The Indian History of the Modoc War* (San Francisco: 1914). A number of Muybridge's Modoc War photographs are used to illustrate the text.

Andrew F. Rolle, *California / A History* (New York: 1963). The best of the general histories of the state.

J. Rothenstein and R. Alley, *Francis Bacon* (London: 1964).

Carl Parcher Russell, *One Hundred Years in the Yosemite* (Berkeley: 1947).

Georges Sadoul, *L'Invention du Cinema* (Paris: 1945).

San Francisco / A Selection of Sixty-four Engravings of Representative Views (San Francisco: 1900?).

San Francisco View Book (San Francisco: 1905?).

Aaron Scharf, *Art and Photography* (London: 1968).

Edwin E. Slosson, *Great American Universities* (New York: 1910).

J. D. B. Stillman, *The Horse in Motion* (Boston: 1882). Based almost entirely on Muybridge's work, but with Muybridge's name omitted from the title page.

Robert Taft, *Photography and the American Scene* (New York: 1938). An excellent pioneering study by a careful student.

Frederick A. Talbot, *Moving Pictures / How They are Made and Worked* (London: 1914). A better-than-usual-for-a-motion-picture-historian account of Muybridge's work

Bernard Taper (ed.), *Mark Twain's San Francisco* (New York: 1963).

Edwin Way Teale (ed.), *The Wilderness World of John Muir* (Boston: 1954).

Rev. John Todd, *The Sunset Land; or, The Great Pacific Slope* (Boston: 1871).

Louis Rupert Wachter, *Aperçus Equestres* (Paris: 1862).

Henry R. Wagner, *California Imprints* (Berkeley: 1922).

Henry R. Wagner, *The Plains and the Rockies* (San Francisco: 1937).

Thurman Wilkins, *Clarence King* (New York: 1958).

John P. Young, *Journalism in California* (San Francisco: 1915).

ALSO:

Works by and about: Ambrose Bierce, Albert Bierstadt, Charles Farrar Browne, John Ross Browne, Bret Harte, Thomas Starr King, John Muir, Frank Norris, Robert Louis Stevenson, Mark Twain, *et al*.

3. General Reference

Bancroft's Tourist Guide / The Geysers / San Francisco and around the bay (North,) (San Francisco: 1871).

California Place Names (Berkeley: 1960).

City Guide, Map and Street Directory of San Francisco (San Francisco: 1870).

Frederic Taber Cooper (compiler) and Frémont Rider (editor), *Rider's California, A Guide-Book for Travelers* (New York: 1925). Although considerably postdating Muybridge's California years, still a valuable guide to place names, geography, etc.

Destournell's Strangers' Guide to San Francisco and Vicinity (San Francisco: 1883).

The Dictionary of American Biography, Vol. 13 (1934).

Dictionary of National Biography, 1912 and 1939 *Supplements*

Gordon Hendricks, "Eadweard Muybridge," *The Encyclopaedia Britannica*, 1966

James H. Lyles (compiler), *Official Railway Manual of the Railroads of North America for 1870–71* (New York: 1870).

The National Cyclopedia of American Biography, Vol. 19, 1926.

The New American Cyclopaedia (New York: 1857 and 1867).

The Pacific Coast Almanac and Year Book of Fact of 1868 (San Francisco: 1868).
Ibid, 1869.
The Pacific Coast Business Directory of 1867 (San Francisco: 1867, 1870).
Pocket Exchange Guide of San Francisco (San Francisco: 1875).
The San Francisco City Directory, 1850–82. Before 1858 these were published successively by: Charles P. Kimbal, A. W. Morgan, James M. Parker, Lecount & Strong, and Harris, Bogardus and Labatt. Beginning with 1858 they were published by Henry W. Langley.

4. Miscellaneous

Reports of the Mechanics' Institute Industrial Exhibition (San Francisco: 1868-plus).
Bradley & Rulofson Gallery of Portrait and Landscape Photographic Art, *Catalogue of Photographic Views Illustrating The Yosemite, Mammoth Trees, Geyser Springs, and other remarkable and Interesting Scenery of the Far West* (San Francisco: 1873).
Ninth Exhibition, 1876. San Francisco Art Association Catalogue (San Francisco: 1876).
Constitution. By-Laws, List of Members, Catalogue of Library . . . of the San Francisco Art Association (San Francisco: 1878).
World's Columbian Exposition, *Concession Agreements*, Vol. III (Chicago: 1892).
The Art Institute of Chicago, *Annual Report of the Trustees*, 1894 (Chicago: 1894).
Stanford University, *Semi-Centennial Celebration . . .*, May 8, 1929. (Stanford: 1929). This publication includes an address by Walter R. Miles, "Muybridge Semi-Centennial."
John H. Wood (compiler), *Seventy-five Years of History of the Mechanics' Institute of San Francisco* (San Francisco: 1930).
Mechanics' Institute of San Francisco, *100 Years of Mechanics' Institute of San Francisco 1855–1955* (San Francisco: 1955?)
The Olympic Club of San Francisco, *One Hundred Years / The Olympic Club Centennial* (San Francisco: 1960?).
Madie Brown, *California's Valley of the Moon . . . Valley of Sonoma* (Sonoma, California: 1961).
Gordon Hendricks, *Thomas Eakins: His Photographic Works*, exhibition catalogue (Philadelphia: 1969).
Wells Fargo Bank, *Panorama of San Francisco from California Street Hill by Eadweard Muybridge 1877* (San Francisco: 1971).
Anita Ventura Mozley, Robert Bartlett Haas and Françoise Forster-Hahn, *Eadweard Muybridge: The Stanford Years, 1872–1882*, exhibition catalogue (Stanford: 1972). Easily the best compendium of facts to date.

5. Periodicals

Periodicals have been defined as those published at intervals of a week or more.

PHOTOGRAPHIC; U.S. AND CANADA:
The American Amateur Photographer (Brunswick, Maine).
The American Annual of Photography and Photographic Times Almanac (Boston, Mass.).
The American Journal of Photography (Philadelphia, Pa.).
Anthony's Photographic Bulletin (New York, N.Y.).
The International Annual of Anthony's Photographic Bulletin (New York, N.Y.).

The Philadelphia Photographer (Philadelphia, Pa.).

The Photo-American (Stamford, Conn.).

Photographic Mosaics (Philadelphia, Pa.).

The Photographic News (London, England).

The Photographic Times and American Photographer (New York, N.Y.).

The St. Louis and Canadian Photographer (St. Louis, Mo.).

Wilson's Photographic Magazine (Philadelphia, Pa.).

The Year-Book of Photography and Photographic News Almanac (London, England).

ARTICLES:

Ernest Edwards, "The Art of Making Photo-Gravures," *Anthony's Photographic Bulletin* (New York), March 25, 1887. Edwards was president of the company that printed the University of Pennsylvania plates. The article was written when the plates were in production.

"The First Motion Pictures," *The Moving Picture World* (New York), 1916, page 145. Three photographs incorrectly purporting to have been taken by Muybridge at Palo Alto.

Beaumont Newhall, "Eadweard Muybridge," *The Complete Photographer* (New York), October 1942. Technical matters made lucid in this historian's characteristic style.

James Card, "Problems of Film History," *The Hollywood Quarterly* (Los Angeles), Spring 1950. First reference in contemporary literature to 1880 San Francisco motion picture exhibition.

Beaumont Newhall, "The Horse in Gallop," *Image* (Rochester, N.Y.), April 1952.

Beaumont Newhall, "Muybridge and the First Motion Picture: The Horse in the History of the Movies," *Image* (Rochester, N.Y.), January 1956.

Thom Anderson, "Eadweard Muybridge," *Film Culture* (New York), Summer 1966.

D. B. Thomas, "Eadweard Muybridge," *The British Journal of Photography Annual*, 1967. Illustrated with lantern slides from the Muybridge collection in the Science Museum, London, some of which were apparently not taken by Muybridge.

Harlan Hamilton, " 'Les Allures du Cheval,' Eadweard James Muybridge's contribution to the Motion Picture," *Film Comment* (New York), Fall 1969. An extensive bibliography.

Timo Tauno Pajunen, "Eadweard Muybridge," *Camera,* January and February 1973. Considerable subjective and objective error in a pseudo-scholarly setting.

PHOTOGRAPHIC; FOREIGN:

The Amateur Photographer and Cinematographer (London).

The Bioscope (London), March 20, May 15, July 17, and August 14, 1913. Exchange between B. Carter, who knew Muybridge in retirement, and Edmund Seal Donisthorpe, a pioneer inventor.

Joseph Maria Eder, *Jahrbuch für Photographie, 1887* (Halle).

Optical Magic Lantern Journal and Photographic Enlarger (London), February 1890. An interesting account of Muybridge's lecture techniques.

The Photographic Times (London).

Photography (London).

ARTICLES:

Theodore W. Froebe, "Photography in San Francisco and Honolulu," *The British Journal* (Liverpool), August 15, 1863.

Joseph Pennell, "Photography as a Hindrance and Help to Art," *The British Journal of Photography* (Liverpool), May 8, 1891.

Eadweard Muybridge, letter to *The Journal of the Camera Club* (London), November 9, 1897.

NONPHOTOGRAPHIC; U. S.:

Andrews' American Queen (New York), July 29, 1882. Cover of drawings after Muybridge photographs.

The Art Amateur (New York), February 1888.

The Art Interchange (New York).

The California Art Gallery (San Francisco).

The California Historical Society Quarterly (San Francisco).

The California Weekly Stock Report and California Street Journal (San Francisco).

The Californian (San Francisco).

The Century Magazine (New York), July 1882; July 1887.

The Electrician (New York), September 1883.

Frank Leslie's Illustrated Newspaper (New York), June 28, 1856. An account of the Vigilante disturbances in San Francisco with an illustration taken from a daguerreotype.

The General Magazine and Historical Chronicle (Philadelphia).

Harper's Weekly (New York). See, for example, June 21, 1873, for reproductions of Muybridge Modoc War photographs. Also November 20, 1886.

Hutching's Magazine (San Francisco).

Judge (New York), June 3, 1882.

The Journal of the Franklin Institute (Philadelphia).

The Literary Digest (New York).

The Mining and Scientific Press (San Francisco), June 22, 1878.

The Nation (New York). For example, January 19, 1888.

The Newport (Rhode Island) *Casino Bulletin,* August 23, 1882.

Our Continent (Philadelphia), November 29 and December 6, 1882.

The Overland Monthly (San Francisco).

Pacific Life (San Francisco).

The Pennsylvania Magazine of History and Biography (Philadelphia).

The Pennsylvanian (Philadelphia).

The Resources of California (San Francisco).

The San Francisco Weekly Examiner. The Sunday edition of *The San Francisco Examiner.*

The Scientific American (New York).

The Scientific American Supplement (New York).

The Society of California Pioneers Quarterly (San Francisco).

The Spirit of the Times (San Francisco).

The Spirit of the Times (New York).

The Stanford (California) *Illustrated Review,* June 1929.

Turf, Field and Farm (New York), May 20, 1872.

Wallace's Monthly (New York), August 7, 1878.

The Weekly and Steamer Bulletin (San Francisco).

Yosemite Nature Notes (Stockton, Calif.).

ARTICLES:

W. W. Pendegast, "The King of Clear Lake," *The Overland Monthly* (San Francisco), December 1869. A work of fiction by Muybridge's defense attorney which describes events similar to those of the Muybridge-Larkyns affair six years later.

Fairman Rogers, "The Zootrope," *The Art Interchange* (New York), July 9, 1879.

William H. Pickering, "A Method of Measuring the Absolute Sensitiveness of Photographic Dry Plates," *Proceedings of the American Academy of Arts and Sciences* (New York), January 14, 1885.

Francis X. Dercum, "The Walk and Some of its Phases in Disease; Together with Other Studies Based on the Muybridge Investigation," *Transactions of the College of Physicians of Philadelphia*, Vol. 10, 1888.

Jacques Passy, "Photography Applied to Moving Objects," *The Literary Digest* (New York), January 30, 1892.

George E. Nitzsche, "The Evolution of Moving Pictures . . . ," *Old Penn* (Philadelphia), April 19, 1913.

H. C. Peterson, "The Birthplace of the Motion Picture," *Sunset Magazine* (San Francisco), November 1915. A once-over-lightly account of the Palo Alto work by a Stanford protagonist, with interesting photographs.

R. G. W. Vail, "The Frederick Remington Collection," *The Bulletin of the New York Public Library* (New York), February 1929. Makes the remarkable statement that Remington anticipated Muybridge.

George E. Nitzsche, "The Muybridge Moving Picture Experiments at the University of Pennsylvania," *The General Magazine and Historical Chronicle* (Philadelphia), April 1929.

Henry Leffman, "The Invention of the Motion Picture," *The Journal of the Franklin Institute* (Philadelphia), June 1929.

Walter R. Miles, "Leland Stanford and Motion Pictures," *The Stanford Illustrated Review* (Stanford, Calif.), June 1929.

L. F. Rondinella, "More About Muybridge's Work," *The General Magazine and Historical Chronicle* (Philadelphia), July 1929.

Walter R. Miles, "The Stanford-Muybridge Motion Pictures of 1878-79," *The Bulletin of the Minnesota Federation of Architectural and Engineering Societies* (St. Paul), September 1929. A reprint of an address delivered at the May 8, 1929, celebration at Stanford University.

Hugh Sanford Baker, "The Book Trade in California, 1849-59," *The California Historical Society Quarterly,* Vol. 30, page 365. A useful over-all survey in which, however, Muybridge is specifically differentiated from Muygridge the bookseller!

L. F. Rondinella, "Muybridge's Motion Pictures," *The Journal of the Franklin Institute* (Philadelphia), September 1929. An answer to the Leffman article in *The Journal* of June 1929.

M. J. McCosker, "Philadelphia and the Genesis of the Motion picture," *The Pennsylvania Magazine of History and Biography* (Philadelphia), October 1941.

Beaumont Newhall, "Photography and the Development of Kinetic Visualization, *The Journal of the Warburg and Courtauld Institutes* (London), Vol. III, 1944.

Theron G. Cady, "Peninsula—Birthplace of the Movie," *Peninsula Life,* August 1946.

George E. Nitzsche, "Philadelphia: Birthplace of Moving Pictures," *The Germantown* (Pennsylvania) *Crier,* March 1950.

T. E. Keys and L. A. Julin, "The Development of the Medical Motion Picture," *Surgery, Gynecology and Obstetrics* (Chicago), November 1950.

Robert Bartlett Haas, "William Herman Rulofson," *The California Historical Society Quarterly* (San Francisco), March 1953.

J. W. Williams, "The Butterfield Overland Mail Road Across Texas," *The Southwestern Historical Society Quarterly* (Austin, Texas), July 1957.

Editorial Committee, "Report on Butterfield Overland Mail," *The Chronicles of Oklahoma,* Winter 1958–59.

Mary V. Hood, "Charles L. Weed, Yosemite's First Photographer," *Yosemite Nature Notes* (Stockton, Calif.), June 1959.

The Library Company of Philadelphia, "Muybridge and Zoopraxography," *The Annual Report . . . 1961* (Philadelphia), 1961.

Mary V. Jessup Hood and Robert Bartlett Haas, "Eadweard Muybridge's Yosemite Valley Photographs," *The California Historical Society Quarterly* (San Francisco), March 1963.

W. I. Homer and J. Talbot, "Eakins, Muybridge and the Motion Picture Process," *The Art Quarterly* (Detroit), Summer 1963.

E. M. Gombrich, "Moment and Movement in Art," *The Journal of the Warburg and Courtauld Institutes* (London), Vol. XXVII, 1964.

Gordon Hendricks, "A May Morning in the Park," *The Bulletin of the Philadelphia Museum of Art* (Philadelphia), Spring 1965.

NONPHOTOGRAPHIC; FOREIGN:

The Atheneum (London).

The Builder (London), March 18 and 25, April 1, 1882.

The English Mechanic and World of Science (London), July 18, 1879.

The Family Herald (London), November 19, 1881.

The Field (London), June 28, 1879.

Funny Folks (London), April 1, 1882.

The Illustrated London News (London), March 18, 1882; July 18, 1931—account of Muybridge celebration in Kingston.

The Journal of the Society of Arts (London), April 7 and June 23, 1882.

Knowledge (London), April 14 and October 13, 1882.

Land and Water (London), September 18, 1880.

Once a Week (London), September 13, 1877.

Punch (London), April 1, 1882.

The Scientific Canadian, April 1879.

ARTICLES:

Gaston Tissandier, "Les Allures du Cheval," *La Nature* (Paris), December 14, 1878.

Emile Duhousset, "Variétés: Reproduction instantanée des allures du cheval . . . ," *L'Illustration,* January 25, 1879.

Richard A. Proctor, "Photographs of a Galloping Horse," *The Gentleman's Magazine* (London), December 1881.

C. D. Crippen, "The Origin of Motion Picture Photography," *The Horse Review* (Chicago), December 11, 1929.

W. E. St. Lawrence Finney, "Eadweard James Muybridge: A Famous Kingstonian, Scientist, Inventor, Benefactor," *The Concentric* (Kingston), Summer 1931.

William I. Homer, letter to *The Burlington Magazine* (London), September 1962.

6. Newspapers

With the exception of two or three San Francisco papers, and two Philadelphia papers, newspapers were examined only for specific events; for example, when Muybridge was in Boston for lectures the Boston papers were examined for reports on these lectures.

But two or three San Francisco papers were examined daily for the twenty years or so of Muybridge's residence in the city, and Philadelphia papers were examined for the five years following late 1883.

BOSTON:

The Boston Daily Advertiser, The Boston Daily Evening Traveller, The Boston Daily Globe, The Boston Evening Star, The Boston Gazette, The Boston Herald, The Boston Journal, The Boston Post, The Boston Sunday Budget, The Boston Transcript.

NEW YORK CITY:

The New York Daily Tribune, The New York Herald, The New York Star, The New York Sun, The New York Times, The New York World (for example, a June 3, 1888, account of the Edison-Muybridge meeting).

PHILADELPHIA:

The Philadelphia Evening Bulletin, The Philadelphia Inquirer, The Philadelphia Press, The Philadelphia Public Ledger, The Philadelphia Record, The Philadelphia Times.

SAN FRANCISCO:

The San Francisco Chronicle, The San Francisco Daily Alta California, The San Francisco Daily Evening Bulletin, The San Francisco Daily Evening Post, The San Francisco Daily Herald, The San Francisco Daily Morning Call, The San Francisco Examiner, The San Francisco News Letter, The San Francisco Post, The San Francisco Union, The San Francisco Weekly Stock Report.

CALIFORNIA, OTHER:

The Albany Cultivator, The California Rural Press, The Calistoga Free Press, The Mariposa Gazette, The Napa Register, The Napa Reporter, The Oakland Transcript, The Sacramento Bee, The Sacramento Daily Record, The Sacramento Union (for example, a May 27, 1945, account of Florado Muybridge), *The St. Helena Star, The San Jose Mercury, The Stockton Independent, The Watsonville Pajaronian* (March 27, 1879, account of Muybridge visit), *The Watsonville Transcript* (March 21, 1879, account of Muybridge visit), *The Yreka Union.*

U.S., OTHER:

The Brooklyn Eagle, The Cincinnati Enquirer (April 2, 1882), *The Chicago Tribune* (October 19, 1874, account of Larkyns' murder), *The Cleveland Plain Dealer, The Daily Columbian* (Chicago, 1893), *The East Orange* (New Jersey) *Gazette, The Fairhaven* (Mass.) *Star, The Newport* (Rhode Island) *Record, The New Bedford* (Mass.) *Daily Mercury, The New Bedford* (Mass.) *Evening Standard, The Portland* (Oregon) *Daily Bulletin, The Territorial Enterprise* (Virginia City, Nevada).

FOREIGN:

The Alaska Herald (July 9, 1872, account of Muybridge's Alaska photographs), *The American Register* (Paris), *The Dundee* (Scotland) *Advertiser, Le Figaro* (Paris), *Le Globe* (Paris), *The Liverpool Mercury, The Liverpool Post, The London Daily Telegraph, The London Observer, The London Standard, The Panama Star, The Surrey Comet* (Kingston-on-Thames, England), *Le Temps* (Paris), *The Times* (London).

Muybridge Items in United States Public Collections

I have tried to describe all of the large collections of Muybridge material, as well as smaller significant ones. Although I have personally examined the large majority of these, I have also had to depend partly upon correspondence and telephone calls. Conflicting information, additions, transfers, and deletions make it virtually impossible to guarantee up-to-date accuracy.

I have listed published items chronologically within each collection. I have not listed holdings of *The Horse in Motion, Animal Locomotion, The Muybridge Work . . . ,* the several Chapman and Hall, and Dover, editions of *Animals in Motion* and *The Human Figure in Motion,* or the recent facsimile edition by Da Capo Press, New York, since these can be found in numerous libraries.

California

BERKELEY:

University of California Library: a number of the 1872 Yosemite photographs.

The University of California Bancroft Library: a very large number of stereographs (the largest known and including Muybridge's studio albums, bought recently from the San Francisco College for Women, which had acquired the collection Muybridge left with John J. Doyle), a number of the 1867 Yosemite photographs, three copies of *San Francisco Panorama #1, San Francisco Panorama #2,* numerous miscellaneous photographs, a number of the 1872 Yosemite photographs, manuscripts.

LOS ANGELES:

University of California at Los Angeles Library: *The Attitudes of Animals in Motion, The Science of Animal Locomotion, Descriptive Zoopraxography.*

The Los Angeles Public Library Central Reference Division: a number of the University of Pennsylvania plates.

OAKLAND:

Oakland Museum: a number of 1872 Yosemite photographs.

SACRAMENTO:

California State Library: a number of stereographs, a Central America sixty-photograph album (the copy Muybridge gave to the widow of W. W. Pendegast, the lawyer who defended him at the Napa trial), a number of 1872 Yosemite photographs, miscellaneous photographs, manuscripts.

SAN FRANCISCO:

California Historical Society: a large number of stereographs, a number of 1867 Yosemite photographs, several University of Pennsylvania plates, an album among the Frick Papers containing photographs of the Atherton family (and probably Gertrude).

San Francisco Public Library, Central Reference Division: stereographs, miscellaneous photographs, two copies of *San Francisco Panorama #2* (one of which is Mrs. Mark Hopkins' copy), an album of the Stanford San Francisco house photographs.

The Society of California Pioneers Library: stereographs, miscellaneous photographs, *San Francisco Panorama #2* (Frank Shay's copy).

Sutro Library: stereographs.

San Francisco Science Museum: stereographs.

SAN MARINO:

Henry E. Huntington Library and Art Gallery: a number of stereographs, two copies of *San Francisco Panorama #1*, a number of University of Pennsylvania plates, two copies of *Prospectus and Catalogue.*

STANFORD:

Stanford University Library: two albums of Central America photographs, an album of Stanford San Francisco house photographs (Mrs. Stanford's copy), *San Francisco Panorama #2* (Mrs. Stanford's copy), miscellaneous photographs, manuscripts.

Stanford University Museum: a number of stereographs, two copies of *The Attitudes of Animals in Motion* (one of which was Stanford's own copy), an album of photographs and prints possibly assembled by Mrs. Muybridge, miscellaneous photographs (including the Muybridge eclipse photographs and the photograph he took from the John Koch painting-collage), an album of the Stanford Sacramento house photographs, a number of 1872 Yosemite photographs, two copies of *San Francisco Panorama #1*, several University of Pennsylvania plates, apparatus (including Muybridge's July 1877 shutter, a zoopraxiscope replica, a University of Pennsylvania series-shutter), manuscripts.

YOSEMITE:

Yosemite National Park Museum: a number of 1872 Yosemite photographs.

District of Columbia

WASHINGTON:

Coast Guard Library: photographs of lighthouses.

Corcoran Gallery: a large number of the University of Pennsylvania plates.

Library of Congress: *San Francisco Panorama #1*, the six copyright deposit cabinet photographs of the 1878–79 Palo Alto series, two copies of *The Attitudes of Animals in Motion*, a large number of University of Pennsylvania plates, *Prospectus and Catalogue of Plates*, and *Descriptive Zoopraxography.*

National Archives: a number of the 1871 lighthouse photographs, manuscripts.

The Smithsonian Institution: a very large number of the University of Pennsylvania plates (including many duplicates), 50 glass lantern slides, 12 glass mounts for the University of Pennsylvania series, 18 gelatine diapositives from the University of Pennsylvania series, *Prospectus and Catalogue of Plates*, zoopraxiscope discs and negatives of them, *The Science of Animal Locomotion*, apparatus (including patent-office models of the Palo Alto arrangement and the electrical timing device, Fig. 140), manuscripts.

Illinois

CHICAGO:

Chicago Art Institute: a nearly complete set of University of Pennsylvania plates and *Descriptive Zoopraxography.*

University of Chicago: *The Science of Animal Locomotion* and *Descriptive Zoopraxography.*

Maryland

BALTIMORE:

Johns Hopkins University Library: a number of University of Pennsylvania plates, *Prospectus and Catalogue* and *The Science of Animal Locomotion*.

Maryland Institute Library: a number of University of Pennsylvania plates.

Peabody Institute Library: a complete set of University of Pennsylvania plates.

Massachusetts

BOSTON:

Boston Athenaeum: two-volume set of Central America photographs, a number of University of Pennsylvania plates, *Prospectus and Catalogue of Plates*.

Boston Museum of Fine Arts: a number of University of Pennsylvania plates.

Boston Public Library, Central Reference Division: *San Francisco Panorama #1*, a complete set of University of Pennsylvania plates, *The Science of Animal Locomotion*.

CAMBRIDGE:

Harvard University Library: *San Francisco Panorama #2* (with apparently one plate missing), *The Attitudes of Animals in Motion* (the copy Stanford gave Meissonier), a large number of the University of Pennsylvania plates), *Prospectus and Catalogue of Plates, The Science of Animal Locomotion, Descriptive Zoopraxography,* miscellaneous photographs.

Massachusetts Institute of Technology Library: an "author's edition" of twenty-one plates from the University of Pennsylvania series.*

WORCESTER:

The Worcester Art Museum: a number of the University of Pennsylvania plates (These were the plates owned by the sculptor John Rogers, creator of the famous "Rogers' groups").

New Jersey

WEST ORANGE:

Edison Laboratory National Monument: a number of University of Pennsylvania plates.

New York

NEW YORK CITY:

American Museum of Natural History: a nearly complete set of University of Pennsylvania plates, a *Prospectus and Catalogue of Plates,* and *Descriptive Zoopraxography.*

* Since these plates were chosen by Muybridge himself and were thus presumably his favorites, it might be interesting to list them as they are bound: 565, 616, 626, 647, 659, 710, 721, 739, 755, 3, 152, 174, 187, 214, 465, 471, 279, 289, 347, 133, 408.

Brooklyn Public Library, Central Reference Division: a number of University of Pennsylvania plates and two editions of the *Prospectus and Catalogue of Plates*.

City College Library: a number of University of Pennsylvania plates.

Columbia University Libraries: a mounted set of University of Pennsylvania glass diapositives and the *Prospectus and Catalogue of Plates*.

Cooper-Hewitt Museum: a large number of University of Pennsylvania plates.

Metropolitan Museum: a proof copy of *The Attitudes of Animals in Motion* (the only one known) with two pages missing, a complete set of University of Pennsylvania plates, and *Descriptive Zoopraxography*.

Museum of Modern Art: an album of 121 Central America photographs, a number of small glass diapositives from the University of Pennsylvania series, and a number of University of Pennsylvania plates.

National Academy of Design: *The Attitudes of Animals in Motion*, a number of University of Pennsylvania plates.

New York Academy of Medicine: *Prospectus and Catalogue of Plates*.

New-York Historical Society: a large number of stereographs, *San Francisco Panorama #2*, a number of University of Pennsylvania plates, *Prospectus and Catalogue of Plates*.

New York Public Library, Central Reference Division: a large number of stereographs, several of the large 1872 Yosemite photographs, *San Francisco Panorama #2*, a set of University of Pennsylvania plates (complete at one time but now lacking three volumes), *Prospectus and Catalogue of Plates, Descriptive Zoopraxography, The Science of Animal Locomotion*.

Pratt Institute, Brooklyn: a number of University of Pennsylvania plates, *Prospectus and Catalogue*.

Queens Public Library, Central Reference Division in Jamaica: an "author's edition" of twenty-one plates from the University of Pennsylvania series.

ROCHESTER:

George Eastman House: a large number of stereographs, a large number of the large 1872 Yosemite photographs, several Central America photographs, a large number of gelatine and celluloid negatives of the University of Pennsylvania plates, two sets of mounted glass diapositives and a number of loose glass diapositives of the University of Pennsylvania plates, a forty-one-page album of prints of the University of Pennsylvania series (apparently a Muybridge proof-book), a nearly complete set of the University of Pennsylvania plates, sixteen of an "author's edition" of twenty-one of the University of Pennsylvania plates, several miscellaneous photographs, a copy of T. A. Dodge's *Patroclus and Penelope* (see Bibliography) with marginal notes by Muybridge, several zoopraxiscopic fan cutouts in a folder, three University of Pennsylvania notebooks, correspondence.

Pennsylvania

BETHLEHEM:

Lehigh College Library: a virtually complete set of University of Pennsylvania plates.

PHILADELPHIA:

American Philosophical Society Library: a number of University of Pennsylvania plates and *Prospectus and Catalogue*.

Atwater Kent Museum: a number of University of Pennsylvania plates, small glass diapositives.

Franklin Institute Library: a number of University of Pennsylvania plates, *Prospectus and Catalogue*, manuscripts.

Hahnemann Medical College Library: *Prospectus and Catalogue*.

Historical Society of Pennsylvania: a number of University of Pennsylvania plates, *Prospectus and Catalogue, The Science of Animal Locomotion*.

Library Company of Philadelphia: a virtually complete set of University of Pennsylvania plates, *Prospectus and Catalogue, Descriptive Zoopraxography*.

Pennsylvania Academy of the Fine Arts: a complete set of the University of Pennsylvania plates plus a number of duplicates, *Prospectus and Catalogue, The Science of Animal Locomotion, Descriptive Zoopraxography*, manuscripts.

Philadelphia Academy of Natural Sciences Library: several University of Pennsylvania plates (selected by Dr. Harrison Allen, a Muybridge colleague), *Prospectus and Catalogue*, the two editions of *The Science of Animal Locomotion, Descriptive Zoopraxography*, manuscripts.

Philadelphia Civic Center Museum (formerly the Commercial Museum): very large number of University of Pennsylvania plates with many duplicates (given by William Pepper, who received them from the Photogravure Company).

The Philadelphia Free Public Library, Central Reference Division: *The Attitudes of Animals in Motion* (Muybridge's presentation copy to William Pepper, the University of Pennsylvania provost), a virtually complete set with a number of duplicates of the University of Pennsylvania plates, the two editions of *Prospectus and Catalogue, The Science of Animal Locomotion, Descriptive Zoopraxography*.

Philadelphia Museum of Art: a number of University of Pennsylvania plates.

University of Pennsylvania Archives: miscellaneous photographs, *Prospectus and Catalogue*, apparatus (including series-shutters), manuscripts.

University of Pennsylvania Library: a number of University of Pennsylvania plates with duplicates, two copies of *Descriptive Zoopraxography*, a fifty-one-plate set of zoopraxographic fans (belonging to William Pepper), manuscripts.

University of Pennsylvania Art Library: a number of University of Pennsylvania plates.

Wagner Free Institute of Science Library: *Prospectus and Catalogue*.

Foreign

The only significant foreign collection of Muybridge material is that in the Kingston-on-Thames Library and Museum in England. Being, however, the collection bequeathed by Muybridge himself, it is one of the most interesting and significant: a number of Muybridge's own lantern slides, nearly all unique, and including a large number of Central America views (on loan to the Kensington Science Museum) and a number of views of North America, some of which may have been taken by Muybridge, but a number of which were not; Muybridge's original zoopraxiscope; the clippings book frequently referred to; manuscripts.

Index

Q

R

T

U

V

W

Y

Z

The text of this book is set in linotype Granjon,
with Letragraphica Herkules display type.
The paper is Mead Matte.
The book was printed and bound by
Halliday Lithograph Corporation.
Designed by Jacqueline Schuman.